NEUROARTHISTORY

NEUROARTHISTORY

From
ARISTOTLE AND PLINY

To
BAXANDALL AND ZEKI

John Onians

Yale University Press
New Haven and London

For the
art historians of the future
who have the courage also to be
neuroarthistorians

First published by Yale University Press 2007
302 Temple Street, P.O. Box 209040, New Haven CT 06520-9040
47 Bedford Square, London WC1B 3DP
yalebooks.com / yalebooks.co.uk

2022 2021 2020 2019 2018 2017
10 9 8 7 6 5 4 3 2 1

ISBN: 9780300229547 PB
Library of Congress Control number:
2007040467

Designed by Sarah Faulks
Printed in China

Cover design by Paul Sloman, adapted from a
drawing by Leonardo da Vinci showing a head in section,
of around 1490 (Royal Library, Windsor).

Drawing: Royal Collection Trust / © Her Majesty Queen Elizabeth II 2017

Contents

Illustrations

1 Head, sagittal section, MRI scan, © Superstock, Inc.

2 Neuron, drawing by O. Deiters, *Untersuchungen über Gehirn und Rück-enmark des Menschen und der Säugtiere*, Braunschweig, 1865 (reproduced in J.-P. Changeux, *Neuronal Man*, New York, 1985, fig. 8)

3 Neuronal connections in the human brain: (from left to right) at birth, three months, fifteen months and two years. Adapted from Jesse LeRoy Conel, *Postnatal Development of the Human Cerebral Cortex*, Cambridge, Mass., 1959, vol. 1 (reproduced in Susan Greenfield, *Brain Story*, London, 2000, p. 55)

4. Diagram of banks of neurons that respond to lines of different orienta-tion in layer IV of area V1 of the brain with earlier pathway from the eyes, from *The Oxford Companion to the Mind*, ed. Richard Gregory, Oxford 1987, 802

5 Diagram illustrating the operation of 'mirror neurons', showing how a neuron in the ventral premotor cortex of a Macaque monkey fires both when the monkey performs an action and when he sees a human perform the same action, from J. Allman, *Evolving Brains*, New York, 2000, 153

6 Nerves as seen through an optical (single element lens) microscope, Antonie van Leeuwenhoek, 1718 (reproduced in J.-P., Changeux, *Neuronal Man*, New York, 1985, fig. 7)

7 Nerves made visible by staining method discovered by Camillo Golgi, as seen under an optical microscope (multiple element lens), S. Rámon y Cajal, *Histologie du Système nerveux de l'Homme et des Vertébrés*, Paris, 1909 (reproduced in J.-P. Changeux, *Neuronal Man*, New York, 1985, fig. 15)

8 Neuroadrenaline in a section of a rat's brain stem made visible by expo-sure to formalin vapours, as seen through an electron microscope, as illus-trated by A. Dahlström and K. Fuxe, L.Olson and U.Ungerstedt, *Acta Physiologica Scandinavica* 62, 1964 (reproduced in J.-P. Changeux, *Neuronal Man*, New York, 1985, fig. 11)

9 al-Haytham, drawing of eyes, brain and connecting nerves, Istanbul MS Fatih 3212 (reproduced in *The Book of Optics*, translated with commentary and introduction by A. I. Sabra, London, 1989, vol. 2, plate I)

10 Leonardo da Vinci, head in section, showing outer layers compared to an onion and diagram of interior ventricles of the brain, c. 1490, Royal Library, Windsor, 12603r. The Royal Collection © 2007 Her Majesty Queen Elizabeth II

11 William Hogarth, *Self-Portrait*, engraving, 1749

12 William Hogarth, *The Analysis of Beauty*, 1753, plate 1

13 Pineapple, from William Hogarth, *The Analysis of Beauty*, 1753, plate 1.10

14 Eye and line of letters, from William Hogarth, *The Analysis of Beauty*, 1753, plate 1.14

15 Mnemonic drawings (71) and tracks of dancers (122 and 123), from William Hogarth, *The Analysis of Beauty*, 1753, plates 2.71 and 2.123

16 Charles Louis de Montesquieu, map of the world, from *De l'esprit des lois*, 1748

17 Drawing of 'square', Heinrich Wölfflin, *Prolegomena zu einer Psychologie der Architektur*, 1886, manuscript, photocopy, Warburg Institute, London

18 Arcades with round and pointed arches, Heinrich Wölfflin, *Prolegomena zu einer Psychologie der Architektur*, 1886, drawing added at end of corrected proofs, Getty Research Institute, Los Angeles

19 Drawing after Leonardo's *Virgin and St Anne*, Musée du Louvre, Paris, showing vulture concealed in drapery, after Sigmund Freud, *Art and Literature*, Harmondsworth, 1985

20 Drawing of a 'network of cathected neurones', from *Project for a Scientific Psychology*, autumn 1895 (reproduced in Sigmund Freud, *The Origins of Psycho-analysis*, ed. M. Bonaparte, A. Freud and E.Kris, New York, 1954, fig. 14)

21 Diagram of the relationships between the perceptual system, the memory, the unconscious, the preconscious and the motor system, from Sigmund Freud, *The Interpretation of Dreams*, first edition, 1900 (reproduced in Sigmund Freud, *The Interpretation of Dreams*, with introduction and notes by R. Robertson, Oxford, 1999, fig. 2)

22 Müller-Lyer illusion diagram, from M. H. Segall, D. T. Campbell and M. J. Herskovits, *The Influence of Culture on Visual Perception*, Indianapolis, 1966, fig. 2

23 Horizontal-vertical illusion diagram, from M. H. Segall, D. T. Campbell and M. J. Herskovits, *The Influence of Culture on Visual Perception*, Indianapolis, 1966, fig. 4

24 Rank order of samples on each of five illusions, from M. H. Segall, D. T. Campbell and M. J. Herskovits, *The Influence of Culture on Visual Perception*, Indianapolis, 1966, table 10

25 'Rabbit or duck?', from E. H. Gombrich, *Art and Illusion*, London, 1960, fig. 2

26 Bonnet from Slovak folk costume, 19th century, from E. H. Gombrich, *The Sense of Order*, Oxford, 1979, plate I

27 The nest of the bower bird, from E. H. Gombrich, *The Sense of Order*, Oxford, 1979, plate 2

28 Oskar Kokoschka, *Thomas G. Masaryk*, 1934–6, Pittsburgh Museum of Art, Carnegie Institute (reproduced in E. H. Gombrich, *The Image and the Eye*, Oxford, 1982, fig. 115)

29 Photograph of Oskar Kokoschka (reproduced in E. H. Gombrich, *The Image and the Eye*, Oxford, 1982, fig. 113)

30 Diego Velázquez, *Infanta Maria Theresa*, c.1651, Musée du Louvre, Paris (reproduced in E. H. Gombrich, *The Image and the Eye*, Oxford, 1982, fig. 105)

31 Diego Velázquez, Infanta Maria Theresa, without coiffure, from E. H. Gombrich, *The Image and the Eye*, Oxford, 1982, fig. 106

32 Woodcut plan of Holy Sepulchre, Jerusalem, Santo Brasca, from *Itinerario…di Gerusalemme*, Milan, 1481, p. 58v (reproduced in Michael Baxandall, *Painting and Experience in Fifteenth-Century Italy*, Oxford, 1972, fig. 13)

33 Neural system of vertebrate retina, from *Proceedings of the Royal Society of London, Series B*, 170 (1968), fig. 16, p. 223, reproduced in Michael Baxandall, 'Fixation and Distraction: the Nail in Braque's *Violin and Pitcher* (1910)', in *Sight and Insight: Essays on Art and Culture in Honour of E. H. Gombrich at 85*, ed. J. Onians, London, 1994, fig. 177

34 Coarse registration in a machine model of vision, from Roger Watt, *Visual Processing: Computational Psychophysical and Cognitive Research*, (Hove and Hillsdale, NJ.,1988), figs. 1. 14, p. 21 and 2. 7, p. 38, reproduced in Michael Baxandall, 'Fixation and Distraction: The Nail in Braque's *Violin and Pitcher* (1910)', in *Sight and Insight: Essays on Art and Culture in Honour of E. H. Gombrich at 85*, ed. J. Onians, London, 1994, fig. 178

Preface

There has to be a strong reason for someone working within an established humanities discipline to look elsewhere for intellectual support. To make that person turn for help to the sciences the reason has to be particularly powerful. In my case it was associated with my department's change of name fifteen years ago from School of Art History to School of World Art Studies. The recognition that art is a worldwide activity with a forty thousand year history forced me to ask a whole new set of questions, ones beyond the remit of art history, which still betrays its origins as a framework developed for the study of a single tradition. Among the new questions I felt called upon to address were: Why is art so widespread? Why are its manifestations in different places and at different periods so varied? Why too are they often so similar? The largest question of this last type was that relating to the activity's beginnings. What was it that caused such an extraordinary behaviour to emerge independently in such widely separated regions as Australia and Europe?

Existing social and cultural approaches, which had been so helpful when dealing with the successive modifications of a single tradition, had little to offer in the way of help in responding to the new challenge. Instead, I felt compelled to turn to a new area, biology, and particularly neurobiology. After all, whatever the social and cultural differences between the individuals and groups making and using art at different times and in different places, they all share, and have always shared, a common biology. Being members of a single species that left Africa perhaps only sixty thousand years ago, they all had the same genetic make-up, and this meant that their brains were essentially the same, the formation and operation of their neural apparatus being governed by the same principles. Since they were dependent on their brains for everything they did, knowledge of those principles might aid me when trying to answer some or all of my new questions. It was to understand those principles that I turned to neuroscience.

I had, of course, no idea how far the new expertise I was seeking might take me. Initially all I had to go on was the little neuroscience that I had myself used fifteen years earlier in a 1978 article on 'The Origins of Art'. What I couldn't know when I set out on my new enquiry in 1992, was that the 1990s were going to become known as 'the decade of the brain'. During the very period when I was embarking on my exploration neuroscientific research advanced at an unprecedented rate. Within a few years it transformed the understanding of our neural resources, revealing with surprising precision how they support all our activities, from the most basic and visceral to the most elevated and intellectual.

This development was opportune. So too was the chance to spend 1994/5 as a Fellow at the Wissenschaftskolleg in Berlin. That institution offered a particularly felicitous context for my researches for two reasons. One was its multi-disciplinary range, embracing as equal and sympathetic partners, the humanities, the social sciences and the 'hard' sciences. In this environment an openness to other disciplines was not only natural, it was desirable. The other reason why the location was propitious was its association with some of the most ambitious German thinkers. Walking the same streets and breathing the same air as Hegel and Alexander von Humboldt encouraged me to aspire to formulate theories that were more broad and systematic than any I could have conceived of in England.

At first my enquiry was a lonely one. Indeed, feeling alone in my preoccupations I was insecure and that meant that when I presented my ideas in lectures I was liable to become assertive, even aggressive. The result was that I often elicited negative responses, which only increased my problems. Then, in 2001, my teacher, E. H. Gombrich, died and the following year I was invited to talk about his work at a conference in Spain. This invitation revived a vague memory that Gombrich himself had been interested in the biological basis of artistic behaviour and I was moved to explore this interest in a paper entitled 'Gombrich and Biology'. Soon I was reminded of the currency of similar interests in the work of another Gombrich pupil, Michael Baxandall, and it was not long before I recalled that such concerns had surfaced already in the work of the Greek philosopher Aristotle, and of Renaissance Italians, such as Alberti and Leonardo. I began to reread these authors and as I did so my sense of isolation and insecurity fell away. In the space of a few months I came to realise that far from being an eccentric innovator I was only the latest in a long line of individuals who had used biology, and even neurobiology, to explain art.

It was at this point, in autumn 2003, that I had the chance of spending much of a sabbatical semester as a fellow at the Clark Art Institute, and this was again opportune. Michael Ann Holly, the director of the Insitute's Research Program, had once been a pupil of Michael Podro, author of *The Critical Historians of Art*, and she had herself written her Ph.D dissertation on Erwin Panofsky. She was one of the first to show the benefits of writing the intellectual biographies of art historians, and she has subtly encouraged Clark Fellows to see their periods of residence in Williamstown as occasions to develop their own. It felt only appropriate for me to develop mine by sketching the intellectual biographies of those I saw as my predecessors.

This was what I did, sustained at first by the exceptional resources of the Clark's library, and then by that of my own institution, the University of East Anglia, and of the the Warburg Insitute. The book that follows is the product of those researches. By the time I had finished it my view of my own enterprise was transformed. My plan to write a neurohistory of art, I now realised, was new only in the greater range of knowledge of both neuroscience and art that was available to me. As this book's introduction makes clear, I am only the latest of many neuroarthistorians. Nor am I alone in my endeavour today, being one of a growing number of scholars sharing similar concerns. This is why I am now much more confident in the validity of the assumptions underlying my project. Whether or not my personal attempt at neuroarthistory succeeds, the enterprise as such is fully authorised.

Looking forward, then, as I complete this preface, I can see this whole book as itself a preface to my next two. The first of these, already half written, will apply a neuroarthistorical approach to the art of Europe. The second will apply it to the art of the whole world. Both will build on the ideas of the authors discussed here using the latest knowledge. By the time that second book is finished, effectively the last in a neuroarthistorical trilogy, I hope to have fulfilled the mission I set myself in 1992.

As I send this book out into the world I am conscious of many debts. The most important are those to the many friends and colleagues with whom I have discussed this project. These include, most significantly, besides E. H. Gombrich, Michael Baxandall, who was my example long before I realised he was a neuroarthistorian; Hans Belting, my contemporary at the Wissenschaftskolleg, who obligingly published a book entitled *The End of Art History* shortly before I began formulating this new approach to the discipline; the late Richard Wollheim, who offered wise philosophical advice on how I should present my neurally based ideas; Eric Fernie, whose *Art*

History and its Methods is one of my models and whose comments
on an earlier version of this text have saved me much embarrass-
ment; Lauren Golden, my student, whose dissertation 'An Enquiry
Concerning the Imagination in Philosophy, Art History and Evolu-
tionary Theory', anticipates some of the themes presented here;
Semir Zeki, whose discoveries about the visual brain will be funda-
mental to neuroarthistory's future; and, above all, my wife, Elisabeth
de Bièvre, whose theory of the 'urban subconscious',[1] gives her a
claim to be this book's twenty-sixth neural subject, as a neuroarthis-
torian *avant la lettre*. For help with illustrations I owe much to both
Maxine Adcock and Nick Warr of the School of World Art Studies.
Finally, this book would never have been taken on by Yale University
Press, nor acquired its present focus and coherence, without the crit-
ical but ever generous interest of Gillian Malpass, and it would not
have become so perfect in its form without the care and attention
to detail and design of Sarah Faulks.

Norwich, July 2007

Introduction

Neuroarthistory: Present and Past

It is not often that a leading advocate of a fashionable theory announces its fall from authority. It is even rarer for him to welcome its successor. This, though, is what Norman Bryson has recently done. In his introduction to a new book he begins by boldly embracing the neuroscientific approach to art adopted by its author, Warren Neidich. As he says, it offers an entirely fresh 'paradigm for thinking through cultural history and the philosophy of the human subject'.[1]

More decisively, Bryson goes on first to define, and then to analyse, the deficiencies of the preceding paradigms, the group of theories with which he had previously been associated: 'The radicalism of neuroscience consists in its bracketing out the signifier as the force that binds the world together: what makes the apple is not the signifier "apple" . . . but rather the simultaneous firing of axons and neurons within cellular and organic life.'[2] This sweeping statement definitively marginalises Poststructuralist thought, with its focus on words and other symbolic codes. As he says,

> by concentrating on the signifier as the basic unit of description . . . [Poststructuralism] commits itself to an intensely *cognitive* point of view. Feeling, emotion, intuition, sensation – the creatural life of the body and of embodied experience – tend to fall away, their place taken by an essentially *clerical* outlook that centers on the written text. The signifier rules over a set of terms whose functions are primarily textual in scope: the analysis of ordinary language (Wittgenstein); of the circulation of meaning within the literary text (deconstructive criticism); of the disruptions in the symbolic order that indicate the advent of the unconscious fear and desire in the analysand's speech or in the discourse of the work of art (psychoanalysis). While the family of terms that owe their allegiance to the signifier – *text, discourse, code, meaning* – is brilliantly adept at dealing with questions of signification, it encounters a notable limit when the area that it seeks to understand exceeds the sphere of textual meaning.[3]

With these words, their significance hammered home by his italicisation of key concepts, Bryson presents a trenchant critique of ideas fashionable for over two decades. Once the high priest of a semiotics of the image, he now contemptuously relegates three of the main streams of recent thought, Wittgensteinian philosophy, deconstruction and psychoanalytic theory, to the domain of the purely 'clerical'. Concerned only with the 'cognitive', they are incapable of engaging with 'feeling, emotion, intuition, sensation'. Since these faculties are not only essential to our humanity, but above all vital channels for the full experience of meaning, the central concern of semiotics, his verdict on the recent intellectual past is damning indeed. Equally striking in its implications is his vision for the future. What he looks forward to is a study of art rooted in an understanding of something treated as a fiction by many Postmodernists, human nature.

The consequences of his analysis are clear. Bryson's point is not that recent theorists had been wrong to concern themselves with issues such as subjectivity and meaning, issues that had not been faced up to earlier, but that in studying them they had been using inappropriate tools. 'Subjectivity' is an even more real phenomenon than he and others had realised, being formed less by ideologies and discourses than by cerebral and visceral experiences. Experiences are indeed 'mediated', and the exent to which they are mediated by words, images and other forms of discourse can continue to be studied using semiotics, but primarily they are mediated by neurons, so it is on neurons that anyone interested in mediation should really concentrate. Only those of a 'clerical' turn of mind, he suggests, would now continue to credit words and symbolic systems with the primacy they had been accorded for a quarter of a century.

The force that had persuaded Bryson to change his view so dramatically was not Neidich's book as such, but the weight of neuroscience with which it was fortified. During the very decades when many scholars in the humanities became more and more insistent in their denial of the importance of nature for the understanding of human mental activity, scientists had been moving in exactly the opposite direction, revealing more and more about the extent to which such mental activity depended on the properties of the human nervous system. Neuroscience as a whole was revolutionised by the integration of the findings from two parallel lines of research. New, subtle and penetrating experimental procedures allowed a detailed investigation of the brains of frogs, cats and monkeys, and the human brain, which had been protected from such invasive approaches, could now be studied by harnessing ever more effective scanners to ever faster computers. Techniques such as Computed Tomography

1 Head, sagittal section MRI scan

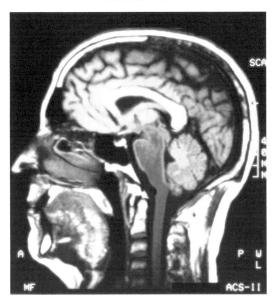

(CT), Positron Emission Tomography (PET) and Magnetic Resonance Imaging (MRI) (fig. 1), allowed an increasingly fine-grained study of the brain in the 1970s and 1980s. By the 1990s functional Magnetic Resonance Imaging (fMRI) (figs 39, 41 and 42) was monitoring neural activity in 'real time'.

These techniques allowed a totally new type of direct access to the extraordinary complexity, flexibility and vitality of our mental resources. They showed how the brain is made up of 100 billion nerve cells, or neurons, how each neuron may receive inputs from other neurons through up to 100,000 fibres called dendrites, and how it typically delivers an output to one or more other neurons through a single axon (fig. 2). They also gave some insight into the myriad chemical modulations that these connections make possible. Most remarkably they made us aware that our mental resources share the same vital properties as all organic life. Not only do neurons develop new connections as part of the normal growth coded for by a creature's DNA, as can be seen in this sequence of views of the developing visual cortex in an infant (fig. 3), but their connectivity continues to change under the influence of experience. As each neuron or network of neurons is more or less frequently stimulated, the dendrites and axons are liable either to grow or to die back, with new connections being built and existing ones abandoned, while, at the same time, the character of the chemical communication between them is equally susceptible to change. The

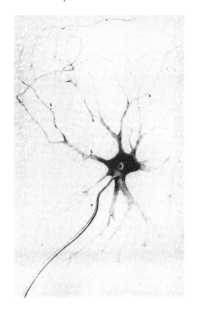

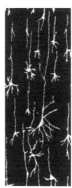
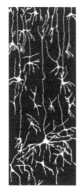
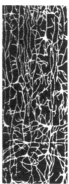

3 (above) Neuronal connections in the human brain: (from left to right) at birth, three months, fifteen months and two years

2 (left) Neuron, drawing by O. Deiters 1865

brain, we learned, is in a state of constant transformation, that is it is endowed with great 'plasticity'. The organ that we rely on for every one of our bodily actions, feelings and thoughts is liable to have its structure affected by all such activities and indeed by all our passive sensory experiences, whether conscious or unconscious. What all this meant was that neuroscience could now provide us with an image of the brain that not only matched the traditional view of the mind, but in many ways surpassed it. The view of the mind offered by neuroscience was not reductionist, as some feared, but more open and dynamic than could have been dreamed even a few years earlier.

Neuroscience also made it not just possible, but necessary, to bring back together things long treated as separate, the mind and the body, the sensory system and the motor system, cognition and the viscera. Soon these discoveries were brought into the mainstream of thought. Two of the first to explore the implications of this new knowledge were the neuroscientists Jean-Pierre Changeux in his *L'homme neuronal* (1983), (published in English as *Neuronal Man: The Biology of The Mind* (1985)) and Colin Blakemore in *The Mind Machine* (1988). Then, in the next decade, Gerald Edelman's *The Remembered Present: A Biological Theory of Consciousness* (1990), Daniel Dennett's *Consciousness Explained* (1991), Francisco Varela, Evan Thompson and Eleanor Rosch's *The Embodied Mind: Cognitive Science and Human Experience* (1991), Antonio Damasio's *Descartes' Error* (1994) and Joseph LeDoux's *The Emotional Brain: The Mysterious Underpinnings*

of *Emotional Life* (1997), and many other books by both neuroscientists and philosophers, greatly broadened the enquiry, so contributing to the formation of the field of 'consciousness studies'. What all these writers agreed on was the necessity of rethinking topics such as consciousness, the mind, memory and feeling in the light of the latest developments in neuroscience. A common concern was the need to take account of the brain's integration with the body and to reintegrate reason with emotion.

At the same time, slowly but inevitably, the accumulation of knowledge, not just about the brain as a whole, but about its different areas, caused disciplines to rupture and new subdisciplines to be born. Already in 1989 Patricia Smith Churchland had published *Neurophilosophy: Toward a Unified Science of the Mind/Brain*, and in the next decade other disciplines, such as neuroethics and neuromusicology, were recognised. One of the strongest was neuroaesthetics, or neuroesthetics, which grew especially rapidly as a result of its ability to capitalise on an exceptionally large body of neuroscientific knowledge relating to vision.

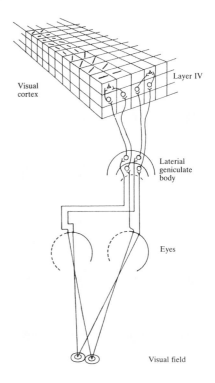

4 Diagram of banks of neurons that respond to lines of different orientation in layer IV of area V1 of the brain with earlier pathway from the eyes, from *The Oxford Companion to the Mind*, 1987, 802

This advantage it owed to two circumstances. First, the part of the brain receiving inputs from the eyes is the largest serving any of the senses, and, second, being relatively isolated at the back of the skull, it is the easiest to study. Some of the landmarks in the neuroscience of the visual system are thus also some of the most important discoveries in neuroscience as a whole. One such was the finding, published by David Hubel and Torsten Wiesel in 1959, that the primary visual cortex of the mammalian brain contains banks of neurons that serve as 'feature detectors', each array reacting only to lines of a particular orientation (fig. 4). Many other discoveries followed. In 1973 Colin Blakemore showed that the responsiveness of such neurons in kittens was drastically affected by their environment. If they were only exposed to vertical lines they would lose the ability to fire when

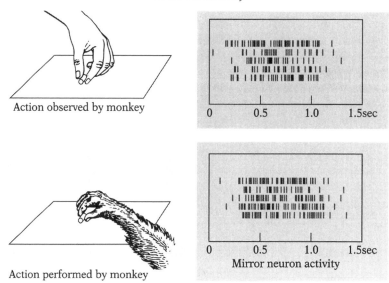

5 Diagram illustrating the operation of 'mirror neurons', showing how a neuron in the ventral premotor cortex of a Macaque monkey fires both when the monkey performs an action and when he sees a human perform the same action, from J. Allman, *Evolving Brains*, 2000, 153

confronted with lines of other orientations while the responsiveness to vertical lines was enhanced. Since this and other experiments demonstrated that such enhancement could be caused both by the proliferation of connections between the neurons concerned and by the retuning of some of these neurons so that they would respond to the lines that were most prevalent, this revelation provided one of the best demonstrations of the brain's neural 'plasticity', that is its ability to restructure itself in response to experience. Soon other groupings of neurons were recognised, and their 'receptive fields', that is the property of the visual environment that caused them to fire, identified. Thus, in the 1980s, Semir Zeki and others showed that the visual cortex could be broken down into separate functional areas with neurons in area V4 for example responding to colour and those in V5 to motion. Yet another remarkable discovery came in the 1990s when Giacomo Rizzolatti and his team at Parma identified 'mirror neurons' in the cortex of macaque monkeys. These were neurons in the premotor cortex that fired when one monkey saw another performing significant hand actions, showing how one primate can learn to imitate and even understand the significance of the actions of another just by watching, without making any movement of his own (fig. 5). Soon it was realised that humans have

even richer neural resources for mirroring, which not only their motor skills, but their social and interpersonal skills depend on.

The significance of this accumulation of knowledge was not lost on those involved. By the later 1990s neuroscientists felt able to take further such earlier lines of investigation as those started by the Gestalt school of psychology in the 1920s and later pursued by scholars such as Rudolf Arnheim, in books such as *Towards a Psychology of Art* (1966). Soon the new discipline, neuroaesthetics was generating its own publications. One was a wide-ranging article by Changeux on 'Art and Neuroscience' in the journal *Leonardo*.[4] In it he used neuroscience to analyse our response to an important painting, Jacques Bellange's *Lamentation over the Dead Christ*, and argued for a broadly based application of all types of knowledge about the specific properties of different areas of the brain, including the recently discovered 'mirror neurons', to the study of art. Another was the major book on art and neuroscience, *Inner Vision* (1999) by Semir Zeki, discussed later in this volume. In the same year a special issue of the *Journal of Consciousness Studies* appeared dedicated to 'Art and the Brain' involving a much wider constituency both of advocates and critics. Among the advocates, Zeki summarised the conclusions of his book and Nicholas Humphreys made a suggestive comparison between autistic and Palaeolithic art, while the most forceful argument was advanced in the lead article by another prominent neuroscientist, V. S. Ramachandran, together with William Hirstein, on 'The Science of Art: A Neurological Theory of Aesthetic Experience'.[5] Since then more and more works on art by people with a medical or neurological background have appeared. Margaret Livingstone's *Vision and Art: The Biology of Seeing* was published in 2002, to be joined a year later by Neidich's *Blow-up: Photography, Cinema and the Brain*, with its introduction by Bryson, and Robert L. Solso's *The Psychology of Art and the Evolution of the Conscious Brain*. There was no doubt in the minds of these neuroscientists that their knowledge could prove helpful to someone trying to understand art.

It has taken longer for art historians to exploit the new knowledge and so give form to a mature neuroarthistory, as distinct from neuroaesthetics. One reason for this was an embarrassment, general in the humanities after the Second World War, about the use of biology to help in the understanding of culture. This is most evident in the work of E. H. Gombrich. He had long been interested in the mechanisms that support perception, but, because of the taint of the bad science of Nazism, for a long time he had reservations about pursuing these concerns biologically. These hesitations only evaporated as memo-

ries of the war receded, and he developed a collaborative relation-
ship with the neuroscientist Richard Gregory, best expressed in the
shared editorship of a volume on *Illusion in Nature and Art* (1973).
By 1979, in *The Sense of Order*, Gombrich was not only able to show
familiarity with the latest advances in neuroscience, as in his refer-
ence to nerve cells in animals that are 'feature detectors', but in its
second edition (1984) he was confident enough to claim that it had
been written 'to establish and test the theory that there exists a
Sense of Order which manifests itself in all styles of design and which
I believe to be rooted in man's biological inheritance'.[6] By 1992 he
was prepared to go even further, telling Didier Eribon in his book-
length interview, 'my approach is always biological'.[7] This, however,
did not mean that he was necessarily in favour of biologists them-
selves writing about art and it is characteristic that one of his last
pieces of writing was a sceptical response to Ramachandran's article
in the *Journal of Consciousness Studies*.[8]

Gombrich's pupil, Michael Baxandall, was less coy about moving
closer to the scientists. Already in *Painting and Experience in
Fifteenth-Century Italy* (1972) his concept of 'the period eye' was
based on the notion that individuals are differentiated by their neural
apparatus. As he says in the first paragraph of the chapter that intro-
duces the idea,

> The brain must interpret the raw data about light and colour that
> it receives from the cones [in the retina] and it does this with innate
> skills and those developed out of experience. . . . each of us has
> had different experiences, and so each of us has slightly different
> knowledge and skills of interpretation. Everyone in fact processes
> the data from the eye with different equipment.[9]

Such was his conviction that the art historian should take seriously
the extent to which the neural equipment of the individual is sus-
ceptible to fundamental reshaping that he even went so far in the
preface as to state that 'the visual skills evolved in the daily life of
society become a *determining* [my italics] part of the painter's
style'.[10] At this stage Baxandall, like everyone else, still knew little in
detail about 'neural equipment', but by the 1990s, as will be seen
later, he had become the first art historian to publish illustrations of
the neural structure of the retina in support of detailed new inter-
pretations of individual works of art.[11]

Meanwhile, I, too, another pupil of Gombrich's, had also begun to
adopt a 'neural' approach to art history. Already in 1977 I had sought
out and had discussions with Colin Blakemore inspired by his 1976
Reith Lectures and, in the editorial of the first issue of the journal *Art*

History (1978), I looked forward to art historians turning to neurologists. In the same issue I also published an article on 'The Origins of Art' making use of some of the latest knowledge of neuroscience. Noting 'the operation of sets of neurons in the cortex of our brains which are specifically programmed to be stimulated by information of a particular character' and drawing attention to even more specialised neurons in the brains of rabbits and frogs, I unknowingly became perhaps the first art historian to talk of 'neurons' and to differentiate between them in terms of what I later came to know as their 'receptive fields'.[12] At that stage, I was only using a knowledge of neurologically based inclinations that are shared across our species, but by the 1990s I had learned about the plasticity of the cortex and this allowed me also to write a series of articles explaining differences in artistic output in place and time in terms of the neurally based visual and motor preferences of individuals and communities. I also began to make pleas for the formulation of a world art history rooted in neuroscience, as, for example, in the article, 'Inside the Brain: Looking for the Foundations of Art History' (2003), and the introduction to the *Atlas of World Art* (2004).[13] It was to advance this project for a new neuroarthistory institutionally that I then started to teach an MA unit on 'Art and the Brain' which I have run for the last three years at the University of East Anglia, now producing its first Ph.D candidates.

Recently too, elsewhere, other art historians have begun to move in the same direction. In Germany, Horst Bredekamp is fostering an interest in art and neuroscience at the Berlin Wissenschaftskolleg, as is Oliver Elbs at Tübingen, while, in the United States, David Freedberg, another Gombrich pupil, is doing the same at the Italian Academy in New York. Freedberg has also started to use neuroscience to further the study of response that he began with *The Power of Images* (1989), working closely with neuroscientists such as Vittorio Gallese.[14] At Chicago Barbara Stafford has also been relating art to neuroscience and has recently produced a book entitled *Echo Objects: The Cognitive Work of Images* (2007). In addition, Renata Holod, Cecelia Klein and Kathy Weil-Garris Brandt are all either supporting work in the area or pursuing it themselves. More significantly, a growing number of graduate students in art history in Europe, North America and elsewhere are also beginning independently to make use of the new neuroscience that they, like everybody else, read about every day in magazines and newspapers. The use of neuroscientific knowledge as an aid to the study of art is now an established practice.

★ ★ ★

However, it is not a new one. It has been slowly developing for thousands of years, and it is the story of that emergence – or rather an important part of it – which is told in the following pages. In its long prehistory neuroarthistory is like neurophilosophy. Just as there were neurophilosophers before neurophilosophy, so there were neuroarthistorians before neuroarthistory. Aristotle and Pliny at the beginning and Baxandall and Zeki at the end may differ in the degree of their knowledge of nature and neuroscience, but they share the belief that such knowledge is potentially useful. The better this knowledge became, the more they took advantage of it. Just as the dramatic coming of age of neuroarthistory in the last twenty-five years has been made possible by a sudden expansion of that knowledge, so its more gentle emergence over the previous twenty-five centuries was the product of an incremental process by which the mysteries of the nervous system were slowly revealed. Had they not benefited from that process, the twenty-five individuals who play the leading roles in this story of the development of neuroarthistory would never have made the contributions they did.

At first millennium by millennium, then century by century and more recently decade by decade, the better our nervous system was known the more its properties could be exploited. Or rather we should say the better our nervous system was *seen*, since to a remarkable degree it was improvements in its visibility that brought improvements in its understanding. The Greeks two thousand five hundred years ago called nerves, *neura*, 'sinews', because to the naked eye they resembled sinews and because like sinews they were attached to muscles. Leonardo in the sixteenth century could see little more. It was only with the development of the microscope in the seventeenth-century Netherlands that the distinctive properties of nerves became far more visible, allowing Antonie van Leeuwenhoek to describe and illustrate them with a new precision (fig. 6). His representation of the way in which they can be bundled together begins to suggest their complexity, although his implication that they were hollow tubes gave an incorrect impression of how they functioned. Van Leeuwenhoek used a single lens and it was only in the early nineteenth century that compound lenses brought the next critical advance. The Frenchman René Dutrochet in 1824 drew nerve cells in slugs and the German Gabriel Valentin in the 1830s published some of the first detailed studies that shifted attention from the peripheral to the central nervous system in humans by describing the nerve cells in the cerebellum. In 1865 O. F. C. Deiters published the first drawing of a cell from the spinal cord, clearly differentiating a single axon from the smaller fibres, or dendrites (fig. 2), but it wasn't

6 Nerves as seen through an optical microscope (single element lens), Antonie van Leeuwenhoek, 1718

until the 1870s, when the Italian Camillo Golgi developed and published a superior form of staining, that the detailed structure of nerve cells in the brain and the intricate nature of the relationship between them became directly visible. The extent to which the visual experience of nerves brought with it comprehension is illustrated by the remarks of the Spaniard Santiago Ramón y Cajal with whom Golgi was to share the Nobel prize in 1906. Looking back on the impact of staining he noted how 'On a perfectly translucid yellow background there appeared scattered black filaments, smooth and narrow or spiny and thick, black bodies, triangular, stellate, fusiform! . . . Everything looked simple, clear, unconfused. Nothing remained but to interpret. One merely had to look and note'[15] (fig. 7). The role of electricity in communication along these filaments had been known for

7 Nerves made visible by staining method discovered by Camillo Golgi, as seen under an optical microscope (multiple element lens), S. Rámon y Cajal, *Histologie du Système nerveux de l'Homme et des Vertébrés*, 1909

8 Neuroadrenaline in a section of a rat's brain stem made visible
by exposure to formalin vapours, as seen through an electron
microscope, from A. Dahlström and K. Fuxe, L. Olson and U.
Ungerstedt, *Acta Physiologica Scandinavica* 62, 1964

some time, but Hermann von Helmholtz used improved measuring
instruments to reveal its speed. Neurotransmitters were only identi-
fied later in the 1940s and they too became visible thanks to colour-
ing techniques with the invention of the electron microscope (fig. 8).
This last instrument, with its capacity to magnify not by a factor of
thousands, like a microscope that operates with light, but by mil-
lions, finally allowed the anatomy of individual nerve cells and the
relations between them to be studied in detail. It was the electron
microscope's ability to provide high resolution images of neural
tissue combined with the scanner's ability to make visible the brain's
structure and functional organisation that allowed the developments
in neuroscience that inaugurated the new age in which we live.
However, the revelations they brought were only the latest in a long
line that have progressively transformed, first, the image of the
human nervous system and, then, ideas of how the properties of that
nervous system might affect both the making of and response to art.

 This is not to say that all the writers discussed in the following
chapters were in direct contact with neuroscientists, still less that
they were familiar with the visual representations of the nervous
system described here. Some certainly were, but many were not. The
point is only that the gradual improvement in the understanding of
the previously mysterious structures of the nervous system continu-
ously fed through into society at large, that the existence of ever
fresher and more detailed images accelerated that process, and that
the inherently greater accessibility of visual images meant that those
who were confronted with them found themselves learning from

them. Anybody who saw an illustration by Van Leeuwenhoek, a Golgi staining or an image from an electron microscope, like anyone who today sees a brain scan, felt to some extent the instant understanding described by Ramón y Cajal.

Nor did they need to be conscious of it. Any more than they needed to have had the artist's nervous system in mind when they were writing. But most of the writers discussed here did have a physical and material view of the mind and when they point out the regularities of human behaviour that interest them they implicitly draw attention to the principles governing the nervous system's operation. It is this that gives them their place in this story of neuroarthistory's formation. The last of our authors, Semir Zeki, claims that artists are often neuroscientists without knowing it. This book makes a similar claim for writers on art.

A significant consequence – or correlate – of these writers' conscious or unconscious responsiveness to the latest neuroscientific knowledge was their heightened sensitivity to their own neural make-up, and one aspect of that self-awareness was the realisation shared by several of them that they were themselves influenced, consciously or unconsciously, by their own daily experiences. This is why the role of those experiences in their mental formation has such prominence here, displacing the textual souces whose importance is more usually emphasised. The particular strength of neuroarthistory is its ability to reconstruct the unconscious intellectual formation of the makers, users and viewers of art, and, inspired by that example, this book stresses in particular the role of visual and non-verbal experience on the intellectual formation of those who wrote about it.

It is not that other types of formation are not neural. They are. It is only that we have not needed neuroscience to have access to them. Art history has over the years built up robust methods for exploring the conscious mental formation not only of those who make and use art but of those who write about it historically. As a result, just as anyone wishing to find out about either the conscious thoughts of the makers and the users of art, or the verbal culture of the communities in which they lived can turn to the vast existing art historical literature, so too anyone who wants to learn what is known about the conscious mental formation of art historians can consult the available literature on that subject. Books such as Michael Podro's *The Critical Historians of Art* (1982), Udo Kultermann's *The History of Art History* (1993) or Eric Fernie's *Art History and its Methods* (1995) all discuss the ideas of the authors on whom they concentrate and explore their intellectual backgrounds. Where the 'neural history' of neuroarthistorians offered here differs from such

accounts is in paying particular attention to the more unconscious formation of their minds, focusing on the uniqueness of their experiences, especially those of the visual kind, and suggesting ways in which the impact these had on the formation of their neural equipment may have had as 'determining' an influence on their ideas, as Baxandall's 'visual skills' had on his artists' styles.

In the same spirit, in order to bring out the importance of such passive environmental exposure for the neural formation of the individuals it discusses, this book talks less about the 'minds' of the authors discussed than about their 'brains'. It does so in order to mitigate the losses associated with traditional approaches to the world of ideas, losses we rarely reflect on. More habitual terms, such as 'mind' and 'intelligence', with their lofty, even godlike, associations, distort our view of the people to whom they are credited in a precisely opposite sense, by overemphasising the active character of their relation to the world. Not only do they credit them with some higher conscious control, they elevate their activities almost to the level of the divine. Besides, the use of a term like mind suggests an organ that is relatively unitary, coherent and static and so predisposes us to be sympathetic to explanations in terms of such unitary, coherent and static influences as 'theories', which have been extracted from unitary, coherent and static books. To talk of someone's mind can give us a sense that we have understood the basis for their achievement when we have only reverently gestured at it. To talk not of a unitary mind, but of an organic living brain with its myriads of neurons, with their myriad upon myriad of connections forming and fading under the influence of the totality of an individual's experiences both conscious and unconscious, ultimately offers a much richer and more flexible framework for accounting for the full range of factors that may affect an individual's behaviour during his or her life. It also potentially offers a more demanding and satisfying framework within which to model the answers to any questions we may ask about them.

This more 'neural' approach to intellectual identity also explains why the people discussed here are treated as 'neural subjects'. Neuroscience not only provides a model of the mind which accommodates all those features captured through the concept of 'subjectivity', it also provides a medium through which they may be investigated. The subjectivity of the individual is not, as some have argued, just a social construct. It is embodied in the brain, and can be analysed at many levels. Throughout an individual's life it manifests itself in his or her actions, thoughts and products, and, since all the experiences a person has during their life are liable to affect the

formation of their neural networks, to the extent that those experiences can be reconstructed, the subjectivity they produce can also be reconstructed hundreds or even thousands of years after the person in question has died. Central to that subjectivity are the biases of perception, behaviour, belief and so forth to which those experiences would have given rise. Awareness of this correlation between experience and subjectivity is helpful in understanding anyone, past or present, but it is particularly valuable when we are dealing with people about whom we know so much as the well-known figures discussed here. This book thus offers some account of the distinctive neural formation of each of its 'neural subjects'.

It also provides another key to their study by suggesting how such a formation may have helped them to surprisingly anticipate modern science. A recurrent feature of the account that follows is the way in which the observations made by our writers look forward to some of the most remarkable of the recent findings about the brain. Their sensitivities were so heightened that they could identify neurally based phenomena that are only now surrendering their secrets to the latest technology.

This book makes no claim that its 'neural subjects' were the only such figures, either within the European literary tradition dealt with here, or outside it. Within the European tradition there were many other people who might have found a place in this account. Those discussed here are to a large extent only representatives of different approaches. For every philosopher, encyclopedist, scientist, aesthetician, political theorist, art critic, psychologist, anthropologist, art theorist, artist or art historian mentioned in the following chapters, there were many others who had similar concerns and who attained similar insights.

Once we step outside the European tradition, the number of individuals and cultures who might have been brought into the discussion increases further. Many other literary traditions can document a comparable range of interests and insights. The ancient Egyptians, for example, have transmitted to us the earliest text describing the physiology and the pathology of the brain. This clearly recognises the behavioural consequences of physical damage to the brain, noting how one type of blow to the head can damage the capacity to speak, while another can cause the eyes to lose focus and impede walking.[16] Other texts from ancient Egypt deal with issues of viewer response which are also neurologically acute, and so do some from ancient Mesopotamia. Writings from later India and China do the same, and are often especially revealing because members of those cultures were more ready to accept the integration of all the body's

physical and mental resources. Earlier Asian authors are often closer to modern neuroscience than any writers in the European tradition.

The oral traditions of non-literate cultures are as rich again. Belief systems such as those classifed by anthropologists as animism or shamanism, and practices such as sympathetic magic and fetishism, successfully exploit responses that Europeans could only struggle to understand before their neuropsychological basis was demonstrated. Any human being is liable, just by experiencing his or her own body and behaviours and by observing those of others, to acquire some understanding of human neural resources. Furthermore, the members of hunter/gatherer communities who felt such a sense of kinship with other species that they could observe the bodies and behaviours of other animals with the same interest that they felt for their own, were more likely to acquire such an understanding than those distanced from the animal world by agricultural practices and urban living.

In many ways the most impaired in their self-awareness were those Europeans who during the last two and a half thousand years were most influenced by Jewish and Greek thought, whatever advantages such influence may have given them in other areas. Subscription to the Greek delusion that the rational brain can be separated from the body restricted their sensitivity to faculties familiar to the rest of humanity, while support for the Jewish belief that they alone were made in God's image denied them the wisdom that might have come from studying other creatures. One way of understanding the story told in this book is as the tale of Europe's laborious recovery of an unconscious knowledge that had hitherto been widely shared elsewhere.

This book is thus not the whole story of neuroarthistory up to now. It doesn't even tell the whole story of the figures discussed. In most cases their interest in biology and neurobiology was only a small aspect of their work, and their main interests lay elsewhere. Even where someone's interest in man's neural resources was predominant, it is not treated comprehensively. Nor is there much discussion of the secondary literature about them. This is partly to honour the spirit of most of the writers, who frequently stress the danger of depending on existing literature, and partly to allow each writer's communication with the reader to be as direct as possible, unmediated by the commentary based on the secondary literature that has become the predominant feature of much recent cultural history. This book is specifically designed to encourage more of the fresh reflective observation to which so many of its 'neural subjects' credit their insights.

It is also designed to encourage an enquiry which is as open as possible. As the variety of the assumptions and interests of the

twenty-five authors discussed here demonstrates, neuroarthistory is not associated with any particular point of view. To judge from the past, it can serve virtually any agenda and be practised within almost any theoretical framework. Neuroarthistory is not a theory, but an approach. Its defining feature is only a readiness to use neuroscientific knowledge to answer any of the questions that an art historian may wish to ask.

One consequence of defining it in this way is the recognition that it will constantly change as the knowledge on which it is based is expanded, reinterpreted and revised. Knowledge in some areas will change less than in others, but there will be no abiding canon. The process by which knowledge is renewed can already be followed day by day, week by week and month by month, as new data is published in scientific journals, often first online. Printed and bound textbooks of neuroscience may seem to freeze the picture for a time, but they too are largely rewritten with each new edition. Handbooks such as *Fundamentals of Human Neuropsychology* by Bryan Kolb and Ian Q. Whishaw, *Principles of Neural Science*, edited by Eric R. Kandel, James H. Schwartz and Thomas M. Jessell, or *Cognitive Neuroscience: The Biology of the Mind*, edited by Michael S. Gazzaniga, Richard B. Ivry and George R. Mangun, which first appeared in the 1980s and 1990s, or the first compendium of knowledge of the visual brain, *The Visual Neurosciences*, edited by Leo M. Chalupa and John S. Werner in two volumes in 2004, may seem to offer the reassurance of bibles but they will only continue to be referred to if they are kept up to date. None of these works can do more than capture what passes for knowledge at one moment and today's knowledge easily degrades into tomorrow's opinion and error. By the time this book is printed even the limited coarse-grained knowledge to which it refers will no longer have the value it did when the text was written. It may be daunting that neuroarthistory is destined to become dependent on another fast-moving field, neuroscience, but the reward for this dependence will be access to ever more refined tools for answering questions that might otherwise forever remain unanswerable. Much more depressing is the future of those current approaches, such as those cited by Bryson, that are destined to relapse into the ever less reassuring citation of ever more temporally remote authorities.

No one knows where neuroarthistory will be in ten, twenty or a hundred years, but it would be surprising if, having come of age, it doesn't soon add a significant dimension to the study of art. There can hardly be a stronger indication that this will happen than the fact that even in the story of its emergence told in this book it looks surprisingly like a dominant tradition.

1

Aristotle

Aristotle (384–322 BC) inaugurates many of the lines of enquiry that were to be pursued in Europe over the next two and half thousand years. In many cases all he does is to start to ask a particular type of question, which is then picked up by ever more curious minds until decades, centuries or, indeed, millennia later a new discipline or theory emerges. This is what happens in the case of neuroarthistory. Aristotle was the first person to suggest that the making of, and the response to, art might have a biological, even a neurobiological basis. Many of his heirs shared that assumption, but it was not until the end of the twentieth century that neuroscience had achieved a level that could allow the development of a true neuroarthistory.

There are, admittedly, grounds for giving the role of founder of the tradition to Aristotle's teacher, Plato. After all, he often alludes to what we now know to be neurally driven inclinations, as when in the *Symposium*, the learned lady, Diotima, describes love: 'All human beings, Socrates . . . have desire, as regards to both body and soul, and when we arrive at maturity our nature longs to beget. But it is unable to beget upon an ugly thing, but only on a beautiful one. For the begetting is through the connection of a man and a woman' (*Symposium* 206c). The same is true of animals: 'Don't you see how all wild animals are similarly affected when they feel such a desire to breed, both quadrupeds and birds?' (*Symposium* 207a). Diotima is certainly talking in terms that anticipate neurobiology when she describes how on arrival at physical maturity we become affected by a powerful visually driven desire. In her stress on the role of beauty in the attraction, she even prefigures the lessons of evolutionary theory. The pursuit of symmetry and regularity in sexual partners, not just among humans, but among many animals, is now well understood to have its origins in the selective advantage of avoiding their opposites, asymmetry and irregularity, which are liable to be signs of ill health and decrepitude. Since those who had an inborn preference for the greater regularity in their partners had a

greater chance of survival, the coding for the neural equipment that underlies such a preference has become part of many animals' genetic material.

Such preferences Plato knew to be inborn. Others, he realised, are acquired during pregnancy and after birth because the *psyche* or 'soul' is an exceptionally soft and sensitive organ. As he says, we are especially responsive to experiences when young: 'For it is then that a creature is best moulded and accepts the impression that one wants to stamp on it' (*Republic* 377b). We must not expose the young to words or images representing the bad actions of the gods. Exposure to the visual is particularly important, because in painting, weaving, architecture, furnishing, as well as in the bodies of animals and plants, there is goodness and badness of form (*euschemosune* and *aschemosune*) and it is very important that young people are exposed to the correct type (*Republic* 401a): 'We must seek out the works of artists who know beauty and goodness of form, because the influence that comes from works of beauty blows into the eye and ear like a breeze and so gives them good guidance' (*Republic* 402). According to Plato, we must also expose young people to music, because this art form, being inherently mathematical, possesses and transmits those qualities best. Somebody with a good education along these lines 'would praise beautiful things and take delight in them and receive them into his *psyche* to foster its growth and become himself beautiful and good' (*Republic* 401e). Plato understands the consequences, though, of course, not the mechanism, of neural plasticity, that is the extraordinary extent to which our neural networks are formed and broken down in response to our experiences. He is also right in noting that plasticity is greater in the young.

Equally acute is his observation that craftsmen who concentrate on one activity get better and better, but only in one field: 'the same men cannot practise at once even the two forms of imitation that seem the most cognate, such as the writing of tragedy and comedy' (*Republic* 395a). This tendency towards specialisation is a necessary consequence of that plasticity, as revealed by recent neuroscientific studies. For example, the little finger on the left hand is so important to a concert violinist that the connections between the neurons that control it develop to such a degree that the area of the brain in which they are located becomes greatly enlarged. To the extent that we each concentrate on particular mental and physical activities, we will necessarily develop neural resources that are appropriate for those and inappropriate for others.

Plato does not know much about the brain, nor is he particularly interested in the *psyche*'s location, but in the *Timaeus* he does place

it within the head: 'First, the gods . . . bound the two divine circles of the soul in a spherical body, that which we now call the head' (*Timaeus* 44d). His preference for this location is certainly influenced by his recognition that the head is the most geometrical part of the body, sharing its spherical configuration with the heavenly bodies.

Plato inherited this view from the Pythagoreans and it was the Pythagorean, Alcmaeon of Croton, who, around 500 BC, had shown that there were additional reasons for giving it that importance.[1] Alcmaeon had great authority as the first person to use anatomy to penetrate the head and to draw attention to the importance of the organs it contained. He explored the eye and crucially identified the optic nerve as a passage between the eye and the brain. He also distinguished perception from understanding, noting that animals have only the first property, humans both. Plato may also have been aware of the more recent work that was to prepare the way for Erasistratus in the early third century. The latter was a medical scientist and anatomist who became the first to use the word *neura*, the Greek word for 'sinews', in its modern sense, for the visible nerve fibres. He was also the first to correctly recognise their division into the motor and the sensory, tracing them back to their convergence in the brain.

Plato's own imagery could be understood as pointing in the same direction, for example, in *Laws* 644e, he talks of our emotions being like *neura* (sinews) or cords that tear us, pulling against each other in the direction of opposite actions. More significant, though, is the difference in the two authors' use of the term. While Erasistratus was on his way to discovering the role of nerves as pathways within a living organism, Plato was still thinking of *neura* in fundamentally mechanical terms, as in his suggestion in the same passage that the gods manipulate us like puppets on strings.

It is Plato's general preference both here and elsewhere for a mechanical form of imagery that ultimately limits his ability to realise the biological basis of the phenomena he is discussing. We have already heard him talking in the *Republic* of the young *psyche* being 'moulded' and 'stamped' and in other passages he refers more precisely to metalworking, for example when talking of the influence of wine he says that, 'the souls of the drinkers get softer, like iron, through being heated, and younger too; this is why they become ductile, just as when they were young in the hands of the man who has the skill to train and mould them' (*Laws* 671b and c). In other places his reference is to the craft of textile processing, as when he describes the effect that he sought to achieve on the souls of his soldiers when he had them educated in music and gymnastics. The

single aim of his efforts was that 'they should be convinced and receive our laws like a sort of dye, so that their belief and faith might be fast-coloured both about the things that are to be feared and all other things, because of their nature [*phusis*] and nurture [*trophe*]' (*Republic* 429d and e). Although the last two terms imply an awareness that the process is in fact biological, he prefers to treat it as what in our terms would be classified as chemical. Plato evidently thinks of human beings not as having a life of their own, but, like the raw material of any manual craft, as subject to external formation.

Plato's choice of imagery certainly helped him to explain his role as an educator, but its origin lies in his daily experience. Living in Athens, a city in which craftsmen had a more prominent role than in any other earlier community, he had so often witnessed the transformation of clay, stone, metal, wood and fibres into high-grade artefacts that this operation became the model for his own. Everywhere around him he saw artisans understanding the inherent 'nature' of their materials and then processing them until they emerged in fixed configurations as socially useful products. Plato's neural networks had so often been exposed to this process that it became 'natural' for him to think of treating human beings in the same way.

Aristotle has a more unqualified claim to be a founder of neuroarthistory. This is because, although he was the most important pupil of Plato, his neural formation could not have been more different. While Plato came from an aristocratic background and lived in Athens until the death of Socrates in 399 BC, Aristotle was the son of a doctor and, although from an Athenian family, brought up in the relative wilds of Macedonia. His experience of humanity, which he first must have acquired through the eyes of his medical father, was much more direct and physical than that of Plato. For him our bodily attributes were primary and he took for granted the fact that we are just part of nature. His approach to the 'soul' was typical. For Plato it had been immaterial and divine. For Aristotle it was instead the 'primary reality of a natural body with the power of having life' (*On the Soul* 412a). The soul was thus an attribute of all living things, whether plants or animals. The only difference between them is in their exploitation of its several faculties, those for nourishment, for appetite, for sensation, for movement in space and for thought. Some living things, like plants, have only the first, and others, like man, have all (*On the Soul* 414a).

As a result, man figures regularly in the *Historia Animalium*, (History of Animals). Of the gregarious animals some are social (*politika*) and others dispersed. Included among the *politika* are man, bees, wasps, ants and cranes (*Historia Animalium* 488a). This com-

parative approach allows Aristotle to use his knowledge of animals to help in the understanding of man. As he says, the inner organs of man are much less well known than those of animals; so when we want to understand an organ, such as the brain, we can refer to those of animals. All animals with blood have a brain, and so do the cephalopods, but 'man has the largest and the most fluid' (*Historia Animalium* 494b), a point he elaborates when he says that it is also the largest in proportion to the size of the body (*On Sense and Sensible Objects* 444a). The brain is 'double' and has a separate part behind, the cerebellum. 'From the eye three passages lead to the brain, the largest and second largest to the cerebellum and the smallest to the brain itself' (*Historia Animalium* 495a), a point again elaborated when he notes that both the sense of smell and the eye have their origin in the brain (*On Sense and Sensible Objects* 438b). This does not mean that he was sure of the brain's importance. In fact, in *On Youth and Old Age* he explicitly states his uncertainty about the relative importance of the brain and the heart (469a).

His ignorance about the brain did not prevent him from developing remarkable new insights into its operations, one of which was his identification of a whole new visual faculty, the imagination (*phantasia*). Aristotle realised that in our mental activity we often seem to be working with images of things we cannot see, as when we remember or think about something. He even went so far as to say: 'it is impossible to think without a mental image [*phantasma*]' (*On Memory and Recollection* 449b). Since these images exist independently of visual experience Aristotle came to the conclusion that we have two ways of seeing: one perceptive (*aisthetikon*), and the other imaginative (*phantastikon*). A crucial feature of the imagination, besides the fact that it operates even when we are not looking at something or have our eyes shut, is that it can be easily wrong (*On the Soul* 428a).

Aristotle was, of course, correct. We now know that because the process of seeing takes place not in the eye but in the brain, we can indeed see something whether or not it is before our eyes. When we do see something in our imagination we are simply working with things we have seen before, either as themselves or in combination with something else. As he notes, this helps us to understand both dreams and daydreams. It also helps us to comprehend how even direct seeing can be distorted, for example, when we are in one emotional state or another, such as cowardice or love, we are deceived in our perceptions:

> so that even from a very faint resemblance the coward thinks that he sees his enemy, and the lover his loved one; and the more he

is excited the lesser the similarity he will be deceived by. In the same way, people in a state of anger or desire are all easily deceived, and the more so the more powerful the emotion; so men who are feverish sometimes think that they see animals on the walls from the slightest resemblance of marks in a pattern. (*On Dreams* 480b)

Aristotle believed that we see incorrectly when we are in such states because during these times our faculty of judgement is suspended. However he does not have an explanation as to why we are deceived in the specific ways referred to, that is why we are most likely to imagine the things we most fear or desire. This is easier for us today. Knowing as we do, on the basis of evolutionary theory, that the main reason why we have highly developed senses in the first place is precisely because they help us to avoid dangerous things and to obtain those that are beneficial, we can easily appreciate how in circumstances in which those responses seem most at issue we are more likely to overinterpret the available data. Being able to infer the presence of an enemy or lover on the basis of incomplete evidence gives us an advantage in the battle for survival because it gives us an early warning of the potential need to take the right action in relation to them. That is why we inherit neural resources that equip us with those abilities.

Aristotle's recognition of the imaginative faculty allowed him to observe other quite different phenomena that are reliant on the more basic mechanics of the human visual system (*On Dreams* 459b). One is the way in which when we look at an object of a particular colour and then look at something else it will at first seem to acquire the same colour and will then change to other colours. We now know that this is because of the way the cones, which are the colour sensors in the retina at the back of the eye, first become excited and then cease reacting. Similarly, the phenomenon of the afterimage left by looking at a bright object such as the sun, which Aristotle also notes, can now be explained by reference to variations in the responsiveness of the rods. Rather different is the phenomenon noted in the same passage of how when we look first at a fast-flowing river and then at something that is still it too will seem to move. This phenomenon, now known as the 'waterfall effect', is due to the neurology not of the retina but of the cortex.[2] Neurons in the principal area of the visual brain concerned with motion, V5, are tuned to react to movements in particular directions and they normally balance each other out, but when the neurons that respond to movement in one direction have been activated for a brief time they cease to respond,

allowing those that respond to movement in the opposite direction to suggest that is what is actually taking place. A similar involvement of the brain also lies behind the phenomenon noted a little later of how a person on board ship may have the impression that it is not he who is moving, but the land past which he sails (*On Dreams* 460b). In this case too the brain is driven by its internal economy. It treats getting information that something is moving through the field of vision in the same way as it processes those things that move across the retina in a more normal situation, in other words when it is stationary. Although Aristotle had no knowledge of the neurobiology of the visual system, he was able to correctly describe and classify some of the more remarkable manifestations to which it gives rise.

Since he could not study the brain, Aristotle's only way to further his understanding of man was to study human behaviour. This he did by using two other faculties: reasoning (*logismos*), which he sees, like the imagination, as being possessed in some degree by other animals (*On the Soul* 415a), and theoretical or speculative thought (*theoretice noesis*), which, requiring the use of words, is only available to humans. One of the best examples of the application of this approach, and one which was to provide a model for two and a half thousand years of thinking, is the so-called *Metaphysics*, a book whose name means only that it comes *meta*, that is 'after', the *Physics*. In it he picks up on his idea that the human animal is characterised by universal inborn tendencies which are associated with generic needs, as discussed in the first sentences:

> All men by nature desire to know. A sign of this is their love of the senses; and they are loved for their own sakes, irrespective of their utility, above all the eyes. For not only when we are intending to do something, but even when we have no such intention, we choose the eyes above all the other senses. And the reason for this is that it is the most helpful in identifying things and brings out many differences. (*Metaphysics* 980a)

The knowledge gained in such a way may not relate to immediate actions, but will certainly be useful in the long run. He then goes on to further characterise the human animal as being particularly distinguished by the ability to learn in different ways, either from memory or from experience, by art (*techne*), that is some sort of acquired systematic knowledge of how to do something, and by reasoning (*logismos*). The cumulative effect of memory is particularly important: 'For many memories of the same thing have the force of a single experience. And experience seems to be similar to both systematic knowledge [*episteme*] and art. For men acquire both knowl-

edge and art through experience' (*Metaphysics* 981a). Aristotle follows Plato in discriminating between inborn and acquired resources, but in his thinking he is closer to modern evolutionary theorists and brain scientists. Like the evolutionary theorist he can relate our species' resources to our biological needs, seeing this as the reason for the emotional energy behind activities that may seem purely rational, such as the pursuit of knowledge and the perception of difference. And like an expert in neural plasticity, he recognises the cumulative value of repeated similar experiences.

In the *Poetics*, his study of drama, Aristotle talks more about our inborn drives: 'The poetic art seems to have been born entirely from two causes, both of them natural [*phusikai*]. First, imitation is an instinct in men from childhood and in this they differ from other creatures, being the most imitative and learning the first lessons by imitation, and everybody enjoying imitation' (*Poetics* 1448b). This last point he goes on to illustrate with the observation that we enjoy looking at images even of things that would distress us if we saw them in reality, such as the lowest animals and dead bodies. The reason for this is because learning is an enjoyable experience for all men, not just philosophers: 'The reason we enjoy this is because as we look we learn and infer what each thing is, such as "this is that". And if we have not already seen the thing concerned the pleasure comes from the workmanship, the colour or some other such cause' (*Poetics* 1448b). Although Aristotle is primarily talking about our response to drama, tragedy in particular, he applies his point equally to painting or sculpture, and indeed his remarks about workmanship and colour relate primarily to those fields. He never explains what he thinks is the basis of these last pleasures, but he is clear that the roots of our overriding interest in the representational arts are our dual instincts for imitation and learning by identifying what we see.

Both of these inclinations are today recognised as biologically driven. Not only is imitativeness a trait long noted in both humans and monkeys, but the discovery of so-called mirror neurons, which cause us unwittingly to prepare to imitate the actions that we see others performing, shows that it has a specific neurological basis. Indeed, later on, when discussing how the dramatist makes his writing most effective in moving the audience, Aristotle points out that the poet should cooperate with the movements of the actor, 'because he agitates others who is himself agitated, and he excites others to anger who is himself most truly enraged' (*Poetics* 1455a). In his claim that we move people most when we are ourselves most moved he draws attention to one of the most powerful consequences of the operation of 'mirror neurons': the transmission of

empathy. When we see someone doing something, the neurons in our own premotor cortex whose firing would enable us to do the same thing are also activated. When a mother smiles at her baby and the baby smiles back it shares the mother's happiness. When a particular movement is associated with the expression of a particular emotion, the emotion can be transmitted too.

Aristotle's understanding of this response may have been only a product of his own observation of interpersonal reactions. It may also be the result of an awareness of viewer response which had been slowly built up during two centuries of Greek exposure to monumental paintings and statues. We have already seen how Plato noted the potentially beneficial or deleterious effect of exposure to representations of good and bad actions and, in a similar spirit, Aristotle himself at the beginning of the *Poetics* illustrated the range of subjects of tragedy and comedy by pointing out that Polygnotus painted people as better than they were, Pauson as worse. During the fourth century both monumental paintings and statues became more and more mobile and by the time Lysippus made his *Apoxyomenos* (or *Man Scraping Himself*), it may have become clear that such statues also were liable to produce a bodily reaction. The athlete transmitted his movement to the statue and the statue passed it on to the viewer. Before the emergence of movement in statues such transmission would have been less likely to take place. Emotion emerges at the same time. Anyone looking at Praxiteles' *Hermes* at Olympia smiling at the infant Dionysus might have felt compelled to smile too, just as someone looking at Aëtion's great painting of the *Battle of Alexander and Darius*, whose composition is probably preserved in the great mosaic from Herculaneum's House of the Faun, might have shared the Persian ruler's evident distress.

Another phenomenon noted by Aristotle which has been the subject of modern scientific reflection and explanation is the pleasure in inferring that 'this is that'. First, the Gestalt psychologists showed by behavioural observation that we have a preference for so-called closed forms, in other words forms that, because they tend to peripheral completion, suggesting the outline of a shape, have a clear identity. Then, more recently, the neurological basis of this behaviour has been clarified. Our neural networks are primed so as to help us recognise particular objects around us. In some cases, we are primed from birth, as with the human face, in most instances, however the priming is the product of experience. In all cases, when such recognition occurs after a searching process within the brain, which has something in common with what Aristotle calls 'inference', our neurochemistry causes us to experience something akin to pleasure.

Remarkably, Aristotle's statement that these drives help us to 'learn' even suggests that he understands why they came into being. Since those members of the species whose neural networks encouraged them either to imitate or to search for and recognise forms would have had a greater chance of survival, those predispositions would have been constantly selected for by evolution and so would have been likely to become stronger and stronger. Not only does Aristotle understand something of the biological basis of artistic activity, but, by his appreciation of the adaptive function of the inclinations involved, he looks forward to the identification of the role of genetic selection in the shaping of this area of our neural make-up.

In his study of human behaviours, from the most simple to the most complex, Aristotle's biological interests bring him close to a modern scientific point of view. However, when he applies a biological model to the history of an art form, such as drama, as he does in the *Poetics*, it has as many disadvantages as advantages. The idea that the poetic art has a 'birth' from two 'natural' causes makes sense and follows on from Aristotle's fresh and objective way of thinking. Since man is defined as a natural being, it is only appropriate that human behaviours should be treated as having natural origins. Dangers, though, emerge when he explains the origin of the division into tragedy and comedy in terms which Plato would have approved of. Since the one treats lofty subjects and the other low ones, his argument is that the more respectable poets naturally developed the former, cheaper poets the latter. The notion that there is a simple correlation between the character of a writer or artist and his or her products was to constrain open investigation of such topics until the nineteenth century. There were similarly negative consequences to his presentation of the notion that tragedy 'grew' until it achieved its 'nature', when the development 'stopped'. The idea that, because humans are natural, each of the artefact types that they produce also has a 'nature' again makes the study of their history excessively predictable. If a poetic art is thought of as having an ontogeny, as does a species or an individual living thing, its study becomes above all a question of description. If it is also thought of as like a life form, its history has to be like the history of a life form, and that is how Aristotle presents the different forms of drama. What his account fails to acknowledge is that while the growth of a life form is principally governed by its internal properties, or, as we would now say, by the coding of its DNA, changes in the character of an 'art form' are much more the product of its exposure to miscellaneous external factors.

The potentially harmful effects of Aristotle's application of bio-
logical metaphors to the visual arts is already apparent in the first
accounts of the history of art written by Xenocrates, an early third-
century Athenian, whose approach, insofar as we can reconstruct it
on the basis of fragmentary evidence, suggests a direct influence
from Aristotle's school. For Xenocrates the arts of painting and sculp-
ture both developed through a series of similar stages until each
achieved full development in the works of a master, painting with
Apelles, and sculpture with Lysippus. Xenocrates did not talk of the
art 'declining' or 'dying', but those stages were implicit in the bio-
logical model and they were often taken up by those who continued
his histories. Pliny the Elder, the subject of the next chapter, proba-
bly quoting an earlier source, talks of the art of sculpture, 'stopping'
in the second century BC and goes on to claim that it later 'came to
life again' (*Natural History* xxxiv, 19.52). This gave the metaphor a
new authority and when the inhabitants of the Italian peninsula
started again to write about the history of art in the fifteenth and six-
teenth centuries, it was easy for them to claim that painting and
scupture had, like other cultural activities, again 'come alive', in what
we now call a renaissance or rebirth. Indeed, such was the attrac-
tiveness of the idea of treating an art as a life form, that it subse-
quently became established as the model for most of diachronic art
history, with every style being treated almost as something organic,
developing through 'early', 'middle' and 'late' phases, which had
some of the overtones of the sequence: youth, maturity and old age.

Aristotle illustrates both the advantages and the dangers of taking
a biological approach to art. He is clearly mistaken in seeing art
forms as developing like life forms and he also exposes the more
general risks of treating cultural products as if they were as alive as
their makers. This does not mean, however, that all attempts to see
analogies between biological and cultural processes are mis-
conceived. Many would see merit in Richard Dawkins's concept of
memes, or culturally transmitted behaviours, as equivalents of
genes. But, if the analogy works, it is only because it illumines some
aspect of the process of cultural transmission. It is not because the
process is itself biological.

The same reservation does not apply to the process of making and
responding to art. Because these processes necessarily depend to
some extent on the properties of our biological make-up, it is clearly
desirable to see whether an understanding of that make-up can help
us to comprehend them. Indeed, to fail to do so would be to deny
oneself an appropriate avenue of enquiry, as Aristotle's work illus-
trates. Aristotle had limited access to biological knowledge, but he

did try to treat human beings as biological specimens and look for regularities in their behaviour which might constitute something like scientific principles. The merits of his scientific approach to artistic behaviour have been recognised for nearly two and a half thousand years. We can now confirm them further by noting the extent to which they anticipate the views of modern neuroscientists. This does not make him right, any more than it does the neuroscientists. All science is constantly subject to testing, leading often to refinement and sometimes to refutation. But what the convergence does suggest is that a scientific – even a neuroscientific – approach to human behaviours, even the most complex, may be a productive one.

What was it that led Aristotle to adopt such an approach? The inclination to adopt it must have its roots in his distinctive upbringing as the son of an Athenian doctor at the court of the king of Macedon, and the rigour and clarity with which he applies it must be a result of his studies with Plato, but what ultimately fuelled his research and allowed him his insights was the exceptional variety and directness of his experiences. By living with his medical practitioner father he was used to treating the body not as a cultural but as a physical entity. By living in a variety of environments, including Macedonia, Athens, Asia Minor and the Aegean island of Lesbos, he was not only confronted with the many different ways in which that physical entity reacted to a series of different ecologies, he was also in a good position to identify the underlying similarities and dissimilarities of behaviour that these ecologies produced. Moreover, since he often, and especially in Macedonia, had much closer contact with an even greater variety of wildlife, both flora and fauna, than the typical urban Athenian, it was easier for him to see man as just another life form, one with its own nature. This is why he found it so easy to talk not of what is appropriate to a Greek or an Athenian, but of what is 'natural' to man as an animal. Aristotle realised that it is inherent in this 'nature' that our mental apparatus is shaped by our experiences. Today we can see that Aristotle's neural apparatus was shaped by his.

2

Pliny the Elder

There were many in Greece who, following Aristotle, reflected on the relation between art and nature, but it was in Rome that this connection was first explicitly united in the *Natural History* of Gaius Plinius Secundus, known as Pliny the Elder (23/4–79) to distinguish him from his nephew and adopted son, Pliny the Younger. All art historians are aware of the importance of the *Natural History* as a source to be mined for knowledge of Greek texts. Few realise that the multi-volume work and its title have enormous importance in themselves.[1]

Dedicated to the emperor Vespasian (69–79), and claiming to be about *'rerum natura, hoc est vita'*, (the nature of things, that is life) (*Natural History*, preface 13), it presents what is, in many ways, an epitome of the extraordinary natural resources under the emperor's control. Pliny well knew the particular importance of such control for the man who was first his friend before becoming his superior. Vespasian came to power during the turmoil that followed the death of Nero, the last of the Julio-Claudian emperors, the direct heirs of Augustus. Since Nero had conspicuously exploited those resources for his private pleasure in buildings like the Golden House, one of the ways the new emperor could establish his authority and win support was by distancing himself from his predecessor and placing them instead at the disposal of the whole population. The Colosseum, erected next to Nero's Colossus, was a prominent expression of this policy, a vast amphitheatre built out of minerals where thousands could witness displays of the destruction of the empire's human and animal wealth. Pliny's *Natural History*, a written compendium of these and other resources, was another.

Pliny was familiar at first hand with the benefits of such control. As an exceptionally wealthy man from Como, a town on a great lake situated where the Alps meet the fertile plain of Lombardy, he himself had power over an environment unusually rich in resources. He had also vicariously enjoyed a similar power as the emperor's soldier and administrator in lands ranging from modern Germany and the

Netherlands to southern France and Africa, before becoming admiral of the fleet based at Misenum near Naples, where he was responsible for the entire western half of the Mediterranean. Proof of his interest both in nature and in the public service is provided by the manner of his death. When Vesuvius erupted in 79, with catastrophic consequences for Pompeii, Pliny set sail, hoping to investigate the event and to rescue its victims, but died of asphyxia.

Pliny also knew the value of books and these too he exploited intensively. Able to pay someone to read to him at all times of day, whatever he was doing – except when bathing – he scoured his library as others now surf the internet, taking notes himself and having extracts copied in shorthand. It was these that formed the basis for his thirty-six volume encyclopedia. In a digest of observations extracted from 2000 volumes, he moved from the heavens, to earth, to animals, to plants, to minerals, noting in each case the way in which these natural materials have been adapted by man for his use. The treatment of painting and sculpture in the final books on minerals is thus no different from the earlier discussion of architecture under geography, or linen – and things made from linen, such as the sails of boats – under plants.

Pliny writes clearly about human nature. He first contrasts the 'shells, bark, spines, hides etc' with which other living things are equipped with man's nakedness, so setting the stage for man's appropriation of these resources from his environment for himself (*Nat. Hist.* vii, 1.2). He then goes on to point out that while all other creatures appear 'to feel their nature, some claiming speed, others swift flight and others swimming, man knows nothing except by learning, whether speaking, walking or eating, indeed, doing nothing by nature except crying' (*Nat. Hist.* vii, 1.4). Pliny has no sense of the mechanisms underlying the phenomena that he, or his sources, noted, but the distinctions he makes relate to the observations of modern science. Ethologists, for example, have noted the pleasure different animals appear to take in their particular skills, such as flying or swimming, and students of human behaviour make a clear discrimination between those that are inborn and those that are learned. Modern psychologists would certainly think that he was too reductive in claiming that only crying was unlearned, presumably because it is often the first thing a baby does when it is born, but they would agree on the fundamental importance of later learning, as neural connections are formed after birth as a result of exposure to the natural and social environment. Some of his ideas are absurd, such as the notion that 'many fortuitous experiences, such as memories of things seen or heard and images absorbed at the time of

conception' could influence somebody's appearance (*Nat. Hist.* vii, 12.54). Still, the underlying idea that this happens 'because [in man] the speed of thought, the rapidity of the spirit and the variety of the mind impress on us multiformed marks, while in other animals the spirit is immobile and each is identical to the others of its kind' can be seen to agree to some extent with neuroscience (*Nat. Hist.* vii, 12.54). In contrast with other creatures, only fifty per cent of our brain is formed at birth, and its extraordinary continuing neural 'plasticity' does indeed make us much more liable to be affected by all sorts of experiences than other animals. As a result, we are indeed likely to be more individualised.

Pliny does not discuss the brain as such, but it is there that the memory had been located since Aristotle and his account of the way memory can be damaged in different ways also anticipates the recent observations of neuroscientists and psychologists:

> No other faculty is equally fragile. Its vulnerability to the experience of – and even the fear – of disease or injury, can affect it sometimes partially, sometimes totally. Someone hit by a stone forgot only how to read, nothing else. A person who fell from a high roof forgot – [today we would say lost the ability to recognize] – his mother, relatives and friends, and another, when ill, forgot his servants and Messala Corvinus even forgot his own name. (*Nat. Hist.* vii, 24.90)

Each of these examples, which anticipate those discussed by Oliver Sacks in *The Man who Mistook his Wife for a Hat*, could today be related to a particular type of physical or psychological injury or trauma to a particular part of the brain. Loss of the ability to identify faces, for instance, is often associated with damage to an area in the right temporal lobe known as the fusiform face area. Pliny describes many plasticities of the human mind and human behaviour which are now much better understood.

His interest in human plasticity is closely related to his interest in the plasticity of all of nature. After all, it is this plasticity that makes nature so useful to man. The chapters on sculpture and painting are thus only accounts of other forms of plasticity, the plasticity of stone, ores, mineral and vegetable pigments and so on. He even draws attention to the plasticity of his own magnum opus as a work put together out of the raw materials of other texts, noting that it should be thought of in the same way as a work of art that was signed not 'so-and-so made it' but 'so-and-so *was* making it' (*Nat. Hist.* preface, 26). Writing is less an action than a process. Behind the barrage of facts, the sense that he is concerned with transformation, and espe-

cially the transformability of human nature and nature as a whole is a recurrent theme.

Pliny's inclination to discuss man and nature in this way grew out of his own unconscious experiences, ones that were largely new for him and his contemporaries. The Roman conquest and administration of a large area stretching from Asia to Britain and from Africa to the Danube basin had placed at their disposal an exceptional range of resources, human and animal, organic and mineral, over which they had an unprecedented degree of control. The Colosseum, like Nero's Golden House, and the Baths of Titus, constructed by Vespasian's son and immediate successor, were among the fullest expressions of that control in the fields of all the visual arts. Most visibly, intractable substances, such as stone and water, were made to obey the emperor's whim and behest. People of his generation had witnessed far more transformations of all types of materials than anyone before them and Pliny himself had come to see the transformation of material as the key to the significance of the Roman Empire. In the *Natural History* he explained that significance to his ruler. It was entirely appropriate that the last books should discuss the historical development of art as the ultimate illustration of both the plasticity of man's mind and the plasticity of the natural world in his hands.

The impact of these experiences on Pliny the Elder's neural apparatus is apparent throughout his life. We have seen how he talked of his book as a work in progress and throughout his life he was persistently fascinated by the combination of action and motion. His first book was *On Throwing the Javelin from Horseback*, and he discouraged his nephew from walking so that he could continue to work while being carried in a litter. Pliny's experience had much in common with that of an inhabitant of a wealthy country in the twenty-first century, and so it is not surprising that he saw his *Natural History*, which was created by a process that had something in common with downloading from the internet, as a work not complete but constantly in progress. He was also fascinated by the notion that things which began their lives as static could acquire the property of motion. We have already noted his account of how flax seeds could become swift sails and even more striking is his description of the way great oak trees torn up by the wind from the banks of the Netherland's Zuyder Zee could come to resemble sailing vessels. Driven before the breeze, their roots weighed down by a mass of soil below the water and their branches like masts high above, they were the first fleet with which the Roman ships had to do battle before they engaged the real enemy (*Nat. Hist.* xvi, I.2). Trees

became ships, just as marble became statues. Pliny was surrounded by so much 'morphing' that it became for him a normal condition. His sense that this was so was as much the product of his neural exposure to such phenomena as modern youth's preference for video art over paintings and sculpture is a product of their habitual exposure to moving images on screens. In both Roman and modern culture it is the experience of continuous change that causes the establishment of new and distinctive neurally based preferences and sensibilities.

3

Apollonius of Tyana

Pliny never explicitly discussed the transforming powers of the artist, even less those of the viewer, but these ideas were studied by a remarkable contemporary, the neo-Pythagorean, Apollonius of Tyana (first century AD). Although there is little immediately contemporary evidence for his thought or activities, a *Life of Apollonius of Tyana* was composed 150 years later by the rhetorician Flavius Philostratus. This contains much information that is questionable, but it derives some authority from its dependence on the writings, now lost, of a disciple, Damis, who came from Nineveh in Mesopotamia. Like Pliny, a friend of the Emperor Vespasian and his sons, Apollonius was born in Tyana in Asia Minor and apparently travelled widely, even as far as India, where his presence seems to be independently noted in early texts.

Among the many topics addressed by Apollonius in Philostratus' text is the phenomenon of people seeing animals in clouds. As he says, these are not placed there by the gods, 'rather these shapes are without meaning and carried through the heavens without any divine intervention and it is we who having an inborn mimetic faculty turn them into forms and make them . . . The mimetic art has two sides, one consists of imitation using the hand and the mind, that is painting, the other consists of making images with the mind alone' (*Life of Apollonius of Tyana*, 2.22).[1] Apollonius here shows that he recognises our neurally based tendency to look for form in the formless and to see images where none exists and he goes on to show that this ability also affects our response to paintings.

One example he gives is the way in which we have no problem in getting a powerful response from paintings in only one colour. In such works we readily see resemblances: 'we see form and expression, modesty and boldness, and this even though they are entirely lacking in colour and although no blood is represented and no colour in hair or beard.' Most strikingly, he asserts that the mere outline of an Indian face with its flattish nose, straight locks and

prominent chin is enough to turn the silhouette black: 'Whence I would say that those who look at works of painting also need a mimetic faculty. For no one would appreciate a painting of a horse or bull unless they formed a mental image of the animal represented' (*Life*, 2.22). Apollonius obviously has no knowledge of the neural mechanisms underlying such a complex ability, nor is he interested in drawing further conclusions from his observations, but he strikingly anticipates both modern neuroscience and modern perceptual psychology. Today we understand much better the viewer's perspective. We know that seeing involves memory. By looking at a shape or object we activate neural networks which become progressively reinforced the more we repeat the activity.[2] Often such reinforcement then strengthens our inclination to look for such an object even when we are only presented with a random configuration, such as a cloud. Similarly, such is the brain's search for constancies that if a particular shape, such as the face of an Indian, is always associated with a particular colour, our neural networks may lead us to see that colour when we see that shape, whether or not it is in fact there. Without any knowledge of neural networks, Apollonius has gone some way towards an analysis of the impact of their properties on our visual experience. An important conclusion from his analysis is that the purely mental 'mimetic' operation involved in seeing something in a cloud is similar to that involved in making a painting on a wall or panel. In both cases the existence of something in the visual field depends on the prior existence of its mental image in the mind.

Apollonius' notion of artistic transformation resonates with that of Pliny, and, although in each case a different organ is involved, in Pliny's case the hand and in Apollonius' the mind, both may have their origin in the same first-century experiences. Another aspect of Apollonius' thought resonates with that of another contemporary, Quintilian (*c*.35–*c*.100), the first teacher of rhetoric officially appointed by the Emperor Vespasian and author of a treatise on the same subject, the *Institutio Oratoria*, which was to become a standard textbook. Quintilian too reflects on mental imagery (*phantasiae*), noting, in a similar spirit to Aristotle when writing about acting, that a speaker will be more effective in using his gestures and words to persuade his audience if he can himself imagine the scene he is describing, and thus acknowledging the way in which the imagination, the emotions and the body are all linked. Modern neuroscience confirms such connections.

Apollonius' interest in transformation has something in common with that of Pliny, with whom, as a contemporary in the Early Roman

Empire, he would have shared the experience of a world reshaped from raw materials. But the extent of Apollonius' new appreciation of the transforming power of the mind almost certainly stems from experiences that were unique to him alone. Most important among these were his travels. Apollonius appears to have journeyed much farther than most of his contemporaries, including spending some time in India. There he would have seen many things that were unfamiliar to him and would have become conscious that he saw that world differently from those who had always lived there. Effectively, the things he looked for were different from those looked for by the indigenous population. He would also have come across thinkers, for example those who followed the Buddha, whose ideas on the nature of perception, knowledge and so forth were quite different from those of the Greeks, placing a greater emphasis on the many dimensions of consciousness. The correlation of these new ideas with his recent experiences would have encouraged him to come to his important innovative conclusions on the role of images in the mind.

4

al-Haytham

Arabic views on vision were profoundly influenced by those contained in Greek texts, but they moved beyond them. The most important treatment of the topic is the *Kitab al-Manazir* (Book of Optics), composed in the second quarter of the eleventh century by al-Hasan ibn al-Haytham (965–1040), known in Europe as Alhazen. Little is known about his life, but he was certainly born in Iraq, may have visited Syria and Spain, and spent much of his life in Egypt.[1] He wrote on many subjects, but the *Book of Optics* is the work for which he has always, and deservedly, been most famous.

Based ultimately on the Greek writings of the second-century Ptolemy for its mathematical optics and on those of the third-century Galen for its physiology, it is revolutionary, as al-Haytham himself says in the beginning of the first book, in blending two separate fields, 'the natural and mathematical sciences'. This combination is made visible in a surviving manuscript where a geometrical diagram represents the schematic anatomy of the eye, optic nerve and brain (fig. 9).[2] Not only is this integration of knowledge from two previously separate fields new in itself, it allows him to develop the first elaborate account of the mental activity associated with seeing. Disposing of two of the most common ancient theories of vision, that the eye either emitted a ray to the object or that the object emitted little images of itself to the eye, al-Haytham demonstrated by analysis that vision depends in fact on light being emitted from an object, entering the eye, being passed to an organ that he calls 'the sentient' and then being interpreted by the brain through a process variously described, following Aristotle, as involving judgement and inference. This account of the role of the brain in interpreting what it receives from the eyes via the optic nerve is the first coherent attempt to develop a psychology of perception.

Fundamental to this is the distinction between two types of attention, the glance and contemplation: 'sight's perception of visible objects occurs in two ways: through glancing and through contem-

9 al-Haytham, drawing of eyes, brain and connecting nerves

plation. Glancing perception is non-ascertained perception, but contemplative perception is the means by which the forms of visible objects is ascertained.'[3] This higher level of perception can only be attained by the eye moving around the object, so building up a full knowledge of it. Al-Haytham insists that it is important that the object is opposite the middle of the eye because the 'part opposite the middle of the eye' appears 'clearer than the other parts'.[4] Although he had no knowledge of the role of the retina in vision, and wrongly believed that it was the glacial humour in front that was the recipient of light, he seems to have become aware of a difference in visual acuity between the centre and periphery of the eye, which we now know is caused by the greater concentration of light receptors in the retina's central area, the fovea. He goes on to insist that the more we look at an object the more it will be imprinted on our imagination,[5] and here too, without knowing why, he also anticipates the most up-to-date scientific discoveries about the role of repeated stimulation in promoting the formation of the neural connections necessary for effective perception of any object or person.

Even more importantly, al-Haytham reveals a much clearer view of the role of the brain in perception than any of his predecessors. Not only does he note that all perception involves matching a form per-

ceived with forms already built up and then stored in the imagina-
tion, he also realises how, if the object perceived has never been
seen before, the faculty of judgement 'will look for a similar form in
the imagination' and if it doesn't find one 'it may err by likening the
object to another, different from it, if the object has a property that
exists in the other'.[6] Just as not having 'an ascertained form' in the
imagination makes perception less reliable, so having one makes it
more secure, even to the extent of making it possible to identify an
object by one part or property alone, as when one recognises an
individual simply 'by the snubness of the nose . . . a blueness in
the eyes, or the joining of the eyebrows or the wrinkles on the
forehead'.[7] Al-Haytham also realises that we recognise types quicker
than we recognise individuals and that the less an object is differ-
entiated the more difficult it is to identify. As he says, we quickly
recognise a rose, because of its obvious uniqueness, but identifying
sweet basil, because it is just another green plant, requires the
recognition of a whole array of properties which takes more time. He
also points out that once we have an ascertained form for some-
thing, when we see it again, much later, even if it has changed to
some extent, as may happen with an ageing person or a ripening
fruit, because we match it to the existing ascertained form, we are
less likely to notice the modification to its appearance, until we con-
template it for long enough to modify the original mental form.[8] It
is now well known that we have particular areas in the temporal lobe
of the cortex where we build up specialised neural resources for
dealing with such separate categories as faces, objects and places,[9]
and recent experiments have confirmed the brain's readiness to cling
to existing knowledge, as when participants in psychological exper-
iments fail to notice when a new person is introduced to a familiar
scene. No one before had so acutely described these propensities
of the brain, nor generalised about them with such precision.

Al-Haytham understands that the more visual attention we give
something and the more repeatedly we look at it the more easily we
recognise it, a phenomenon we now know to be due to the impor-
tance of such exposure for stimulating the formation of the neces-
sary connections between the neurons involved in its perception. He
also understands that because the brain is constantly trying to match
what it sees to forms it has already ascertained, when it is unable to
do so it may make a mistake, seeing something which is not there.

These observations relate the degree of correctness in perception
to experience. Others acknowledge more fundamental properties of
the visual system, such as those defined by Gestalt theorists. One of
these is his remark that a circle is likely to be seen before a polygon

inscribed within it and that any irregularity in the polygon is likely to be noticed later still. In this series of configurations, from the circle to the polygon to the irregular polygon, there is a consistent decline in the 'completeability' that helps a form to emerge from the confusion of our environment. This is why our perceptual system encourages us to look for such 'Gestalts' or 'forms', and why the perception of different objects can involve delays of several milliseconds.

Many of al-Haytham's most sophisticated reflections on vision relate to the problem of seeing forms in a confused environment and his particular interest in the phenomenon of the mirage suggests that his analytical skills are the product of his exposure to a distinctive set of surroundings. He may himself have spent most of his time in cities, but as he travelled from one to another, for example from Basra to Cairo, he was liable to pass through the desert, which is where many of the traders and others he met would have spent their time, an environment notorious for its visual and mental deceptiveness. Not only do people in such undifferentiated and ecologically poor surroundings frequently search for animals or fruit to eat only to be deluded, but their heads are full of things that they miss there, friends and flowers, girls and fountains, as much early Arabic poetry illustrates. In Greece, the habit of looking at an object-rich environment through clear air gave people a feeling that seeing was a relatively unproblematic experience. In the deserts of the Arab world, on the other hand, where objects were frequently absent and those that were present were liable to be concealed by heat haze or sandstorm, vision was much more uncertain. In such conditions the imagination became much more active and visual experience often needed to be confirmed by relating it to visual memory. Al-Haytham's neural habituation to that particular environment may be the ultimate source of some of his most critical contributions to perceptual psychology.

Alberti

By the thirteenth century, al-Haytham's *Optics* had been translated into Latin and was widely used in Europe by figures such as Roger Bacon, John Pecham and Witelo. They, however, being more closely dependent on the Greek tradition, were less interested in the psychology of perception and more in its mathematics. This situation only changed after the fourteenth century, when it was translated again, this time into Italian, the language of daily life in the peninsula. It was now accessible to artists, for example the fifteenth-century Florentine sculptor Lorenzo Ghiberti, who quoted some excerpts. But someone who may have been more substantially influenced directly or indirectly by al-Haytham was Leon Battista Alberti (1404–1472).

Alberti was a Florentine humanist, whose reflections on the arts of sculpture, painting and architecture were to lay the foundations for modern European theories in all three areas. His interest in psychology was probably stimulated by a feature of his particular personal experience that he shared with many of this book's 'neural subjects', intense exposure to a variety of different environments. While the experience of most fifteenth-century Italians was limited to the town of their birth and its surrounding countryside, Alberti seldom stayed in one place for long. Born in Genoa, he was taken at the age of four to Venice, and went on to study first in Padua and then in Bologna before becoming a secretary in the papal curia at Rome and embarking on a peripatetic career that took him to, among other places, Ferrara, Florence, Mantua and Rimini. In each of these cities he became involved in advising and designing buildings for demanding princes, ecclesiastics and merchants, each of whom had very different interests and visual preferences. He could take none of their expectations for granted. Nor did he inherit any clear ones from his parents, since he was the illegitimate son of a member of a wealthy Florentine banking family and a Genoese woman, who was soon supplanted in the role of mother by his

father's new Venetian wife. Every contact Alberti made will have raised new questions for him about what went on in the human mind, a subject that was necessarily central to his concerns, since, having been definitively denied an inheritance, it was only by his own personal mental resources that his survival and well-being could be assured. Therefore it is hardly surprising if he shared with al-Haytham an interest as much in the psychology of perception as its geometry.

One of the best illustrations of the freshness of his thinking on the subject is his account of the origins of sculpture at the beginning of the *De Statua*, written probably in the 1440s. There he describes how people,

> probably occasionally observed in a tree-trunk or clod of earth and other inanimate objects certain outlines in which, with slight alter-ations, something very similar to the real faces of Nature was rep-resented. They began, therefore, by diligently observing and studying such things, to try to see whether they could not add, take away, or otherwise supply whatever seemed lacking to effect and complete the true likeness. So by correcting and refining the lines and surfaces as the particular object required, they achieved their intention and at the same time experienced pleasure in doing so.[1]

In this passage he may be only drawing on his own experience, but he may have had his consciousness of that experience first raised by al-Haytham's recognition that the brain can only see forms that it has already 'ascertained'. Whether it is the observation of the Arab writer, or, even the brief suggestions of Aristotle about seeing animals in marks on walls or of Flavius Philostratus about seeing images in clouds, that is the source of the idea, Alberti extrapolates enough from these writings to reconstruct the mental activity, or rather the neural events, that led to the making of the first sculp-tures. Whatever Alberti's inspiration, his explanation gains support from the fact that for over a century it has been repeatedly noticed that much of the earliest Palaeolithic art was indeed suggested by markings and reliefs on the walls of caves.

What makes it appropriate to talk of neural events is Alberti's com-plete disregard of any social framing or consideration of function. The making of the sculpture begins with a chance recognition of a resemblance and leads only to the maker feeling pleasure. Alberti does not identify the source of this pleasure. He may only be recall-ing what Aristotle had said about the pleasure of looking at imita-tions. But the particular emphasis that he gives to pleasure makes it

likely that he is also remembering his own activity as an 'amateur' sculptor, and the pleasure he got as the clay he was working – perhaps with no particular goal – took on a greater and greater resemblance to something in his environment. A similar self-awareness must also lie behind his recommendation that when you look at sculptures in order to improve your paintings you should 'dim your vision by half-closing your eye lashes, so that the variations in the lighting come over as half-tones, almost as if they were anatomised'.[2] The passage is hardly transparent, but it appears to suggest that half closing the eye reduces the strength of contrast and so allows a more subtle analysis of shading. It is certainly likely that such a situation, much as with the softer north light of a studio, would help the painter's neural resources to generate better calibrated data. Here Alberti is concerned with the way in which the artist can improve his performance by taking artificial control of the process of vision. Earlier he had drawn attention to a very different way of improving performance. In order to illustrate the benefits of increasing naturalism he notes how 'We can see how desirable this is in painting when the figure of some well-known person is present in a "historia", for although others executed with greater skill may be conspicuous, the face that is known draws the eyes of all spectators.'[3] What interests him here is not the way that vision changes as environmental conditions change, but the way in which a predictable normal response – in this case to a more or less effective piece of painting – can be overridden when we draw on neural networks whose efficiency has been abnormally heightened by repeated exposure to a particular phenomenon, in this case a friend or celebrity. Familiar faces do indeed jump out at us for this reason. Alberti was remarkably alert to the extent that his brain's response to features in the visual field could be affected at one moment by present viewing conditions and at another by past experiences.

There are many other examples of Alberti using his sensitivity to the workings of our brains, or rather our *animus* (disposition) or *ingenium* (talent) as he calls it, to explain some aspect of artistic activity. Some were already recognised in antiquity, but never so clearly formulated. One such is the notion behind his claim that a painted scene 'will move spectators when the men in the picture outwardly demonstrate their own feelings as clearly as possible. Nature provides – and there is nothing to be found so rapacious of her like than she – that we mourn with the mourners, laugh with those who laugh, and grieve with the grief-stricken.'[4] Alberti could never have known that the neural basis of such tendencies would progressively become better understood until it was discovered that 'mirror neurons' in the

premotor cortex can cause many primates to automatically follow the actions of other members of the same species and that a neurally based empathy causes a similar sharing of emotions. All he was doing was, once again, using his own reflections to extrapolate from common knowledge.

Sometimes that common knowledge sounds more like an old wives' tale, as in the case of the passage in the *De re aedificatoria* where, recalling Pliny the Elder, he recommends that in the areas of the house where children are conceived 'it is desirable to hang portraits of men of dignity and handsome appearance, for they say that this may have a great influence on the fertility of the mother and the appearance of future offspring.'[5] There is here, of course, an element of magic, but underlying it is the idea that people who look at beautiful faces take on their expression, which is exactly what 'mirror neurons' and their relatives lead us to do. Alberti also appears to be aware of another neurally based consequence of a woman looking at a good-looking man. A woman in love, even with an image, is indeed, for hormonal reasons, more likely to conceive.

Another case where Alberti appears to have recognised a biological tendency that is neurally embodied is when he discusses the design of buildings. There he repeatedly insists that buildings designed with symmetry about a vertical axis are more attractive to look at than those that are not, and he explains the preference in terms of the importance of symmetry in the human body. Indeed, in his claim that the symmetry of openings and vertical members on façades gives them the visual properties of the human face and body, he hints at the reasons as to why such preferences have been selected for by evolution. The same could be said of his observation in the *De pictura* that when people are represented in paintings their limbs should be regular.[6] Although Alberti would probably, following Plato, have related this preference to a taste for regularity associated with rationality, we now know, as noted earlier when discussing Plato, that there is a specific inborn preference for regularity in the body's members which is almost certainly again the result of the pressures of evolution, a lack of symmetry and regularity being often a sign of weakness or ill health. Alberti correctly identifies the preference, without knowing that it is biologically determined.

Alberti's distinctive awareness of the role of nature has several sources. The most important is certainly the fact that he is the first person with an elaborate intellectual formation to have attempted to write about art in the same way that people had long written about rhetoric and poetry, not to mention philosophy. He was familiar with the types of methods and explanations current among prac-

titioners in these other fields and he knew that he should try and find analogous principles in his own. He was also living in a social environment in which there was enormous competition between artists to satisfy demanding clients and particularly to give their works the aesthetic and expressive powers credited to ancient art by Greek and Roman writers. In the middle of the fifteenth century there was certainly a climate encouraging an exceptional reflection on artistic activity on the part of its practitioners, especially in the Florentine circles in which Alberti was most at home. Besides, as already noted, Alberti's unusually varied and intimate experiences of such different environments as Venice, Padua, Bologna, Ferrara, Rimini, Florence, Mantua and Rome would have forced him, much as a similarly varied experience had forced Aristotle, to come up with observations that were not based on a particular local practice but would hold true generally.

The third circumstance favouring his intensive reflection on the nature of art was his illegitimacy. For one thing, his lack of an inheritance placed him in a situation in which he had to be much more competitive than his legitimate peers. For another, as an Alberti not by 'law', but by 'nature', he had every reason to downplay the value of convention and give a new prominence to lived experience. It was his readiness to allow such direct experience to take precedence over existing book knowledge that above all gave the writing of this well-read humanist its edge.

6

Leonardo

Illegitimate birth probably had a similarly profound and creative effect on Leonardo da Vinci (1452–1519). As a so-called natural child, that is a child by nature not by law, who was also a professional artist, he was in an even better position to reflect frequently and intensely on the nature of vision and of our relation to the world. And, as in the case of Alberti, his frequent change of working environment, from Florence to Milan, Venice to Florence, and eventually from Italy to France, where he spent the last years of his life, would have only added urgency to such reflection.

Besides, the fact that his father was himself a man of the law, dependent on an expertise founded in texts, would have made his illegitimacy especially poignant. It could well have fuelled his passionate resistance to authority and especially to authority represented by books. It is thus probably in this sense that we should understand the bitterness of his attack on those who borrow their ideas from other writers rather than deriving them from their own experience:

> People who are little reliant on nature are dressed in borrowed clothes, without which I would rank them with the herds of beasts. Anyone who argues on the basis of authority does not exploit his insight but his memory. Good writing is born out of a good natural understanding . . . you should praise natural understanding without bookish learning rather than bookish learning without understanding.[1]

Leonardo was not, of course, himself immune to the influence of books, as can be seen in his diagrams outlining the way in which the eye relates to the brain (fig. 10). Although the section through the skull and its immediately interior layers, which he aptly compares to those of an onion, reflects experience gained using dissection, the representation of the brain itself depends closely on an Aristotelian tradition. Nerves are thus seen going from the eye and the ear to the anterior 'ventricle' housing the *sensus communis*, the part of the

10 Leonardo da
Vinci, head in
section, showing
outer layers
compared to an
onion and
diagram of
interior
ventricles of the
brain, c. 1490

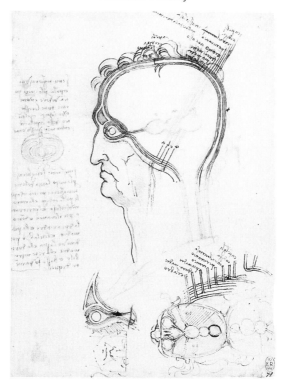

brain that receives the inputs from the separate senses and inte-
grates them into a single representation, and the imaginative facul-
ties. Behind this is the middle ventricle with the intellectual faculties
and behind that the posterior ventricle where the outputs of the first
two are stored in the memory. Elsewhere Leonardo introduced an
imprensiva, or 'receptor of impressions', dealing separately with
visual information, between the eye and the *sensus communis*, but
this view was not based on anatomical investigations any more than
the previous one.[2] Even when, around 1509, he made further re-
searches, taking wax casts from the voids in an ox brain, he was not
able to resolve his uncertainties. He didn't know, as we do now, that
the neural pathways from the different senses, such as touch and
sight, do indeed feed into each other and that such feedback is
essential for our perception of objects, but his alertness to his own
experiences may have brought him closer than others to such a real-
isation. This concern with sensory experience as a source of knowl-
edge drove many of the enquiries that helped him to produce
paintings that were more natural than those of any of his predeces-
sors or contemporaries.

One of these enquiries was into man's biological nature using anatomy, a technique that he applied to the most delicate subjects, including the nerves, as he reveals in a note to himself when planning an investigation of facial expression and its dependence on the brain: 'Represent all the causes of motion which the skin, flesh and muscles of the face possess, and see if these muscles receive their motion from nerves which come from the brain or not. And do this first for the horse which has large muscles and clearly evident parts.'[3] Here his preoccupation is with the motor system linking the body and the brain, but dissection may also have been used to explore the connection between the brain and the senses, as in the passage where he notes in relation to the operation of the eye, 'here we must have regard to the proportion of the mass of that portion of the brain which is given up to the sense of sight and to nothing else.'[4] It is difficult to know how far Leonardo could have really evaluated the size of the visual brain, but he may well have anticipated the computations of the modern neuroscientist, estimating correctly that it is indeed larger than the parts dealing with the other senses. Certainly, the issue raised here had been an important one ever since Aristotle noted the general importance of the eye for learning, and Leonardo's observations may well have fortified him in reasserting such claims, as in his remarks that 'the eye is called the window of the soul' and 'the eye is the highest sense and prince of the others'.[5] Only in the twentieth century has the extent of the validity of such claims become clear.

One property of sight that is now well recognised is its importance to our survival and this is something of which Leonardo was well aware:

> Animals receive worse injury by the loss of vision rather than hearing, for many reasons: firstly, by means of sight, they find food with which to nourish themselves, as is necessary for all animals; secondly, through sight they can appreciate the beauty of all created things, more especially those that arouse love.[6]

What is remarkable about this observation that the eye is the most essential sense for satisfying the two most essential needs – obtaining food and procreation – is that it precisely identifies the reason not only why vision was selected for by evolution but also why it is associated with neural networks that endow us with highly specific preferences in those areas. An important corollary of his argument is the association between the sense of beauty and sexual desire and this is elaborated on in another passage:

human beauty will stimulate love in you, and will make your senses envious, as if they wished to emulate the eye – as if the mouth would wish to suck it into the body, as if the ear would seek its pleasure in being able to hear visual beauty, as if the sense of touch would wish it to be infused through the pores, and as if the nose would wish to inhale it with the air it continually exhales.[7]

With his suggestion that the eye makes the other senses envious, Leonardo persuasively communicates the extent to which vision can sometimes trigger neurochemical changes that engage all the other senses. The references to the mouth sucking beauty, to the ear seeming to be hearing visual beauty, to skin wanting to absorb beauty through the pores and to the nose seeking to inhale it with the air, together capture the way in which the sight of a beloved can lead to the total engagement of the lover's whole body. Leonardo had observed this response in others and presumably experienced it in himself, and it was this sensibility to the influence of beauty on the viewer's body that enabled him to create a woman with the extraordinary appeal of the *Mona Lisa*.

Leonardo did not restrict his enquiry to the eye's physiology and to its role in the life processes essential for ensuring our survival. He also, like Alberti, reflected on the psychology of perception. Typical is his suggestion that

if you look at any walls soiled with a variety of stains, or stones with variegated patterns, when you have to invent some location, you will therein be able to see a resemblance to various land-scapes graced with mountains, rivers, rocks, trees, plains, great valleys and hills in many combinations. Or again you will be able to see various battles and figures darting about, strange looking faces and costumes, and endless number of things which you can distil into finely rendered forms.[8]

Leonardo is here noting the same mental inclination to see the things when they are not there that had been referred to by Aristotle and Flavius Philostratus, but he now, for the first time, seeks to exploit it for the artist's benefit. He also shows a scientific interest in generalising the inclination by continuing, 'And what happens with regard to such walls and variegated stones is just as with the sound of bells, in whose peal you will find any name or word you care to imagine.'[9] By noting that the same trend is prevalent in both the visual and aural fields he comes closer to a general hypothesis about the nature of human sensory responses. This observation may well have been facilitated by his recognition of the function of the *sensus*

communis as a region of the brain where the senses were integrated. Certainly Leonardo's tendency to generalise from sight to hearing, like his readiness to generalise from horse to man, reveals a desire to establish general biological principles when dealing with both sensory and motor systems.

Leonardo's recognition of the way in which we project images onto stained walls was almost certainly intensified by his response to his own drawings, which frequently look very different from those of his predecessors, often ending up as apparently chaotic accumulations of lines. One reason for making this new type of drawing was his conscious desire to imitate poets, as he elsewhere points out to the reader:

> Have you never reflected on the poets who in composing their verses are unrelenting in their pursuit of fine literature and think nothing of erasing some of their verses in order to improve upon them? Therefore, painter, decide broadly upon the position of your figures and attend first to the movements appropriate to the mental attitudes of the creatures in the narrative rather than to the beauty and quality of their limbs. You should understand that if such a rough composition turns out to be right for your intention, it will all the more satisfy in subsequently being adorned with the perfection suitable to its parts. I have in the past seen clouds and wall stains which have inspired me to beautiful inventions of many things. These stains, while wholly in themselves deprived of perfection in any part, did not lack perfection in regard to their movements or other actions.[10]

Leonardo's ambition to rival poets led him to take over from them the idea of trying out a number of solutions to a problem. Just as they constantly improved their verses by crossing out some words and adding new ones, so he is ready to superimpose one drawing on another, until he has created a confused and multi-layered collection of images. As he searched in the tangled mass of lines for the best pose for an arm or a leg, he would have come to realise how one can find an image in what appears at first sight to be only a messy patch of ink. Sensing the resemblance of such drawings to stains on walls, he may have seen how even in such random configurations it was possible to find ideas for compositions.

Again and again Leonardo must have been surprised at the directions in which this personal approach took him. He is, thus, likely to have begun his use of dissection principally to understand more clearly the body that was concealed beneath the skin, but once he had begun to penetrate the cadaver, and especially after he had

begun anatomising the head, he would have come across phenom-
ena that would have taken him beyond the body to the mind. Others
might then have stopped, but Leonardo went on, reflecting, as we
have seen, on the consequences of the senses of seeing and hearing
meeting in the *sensus communis*. This relationship was of particular
importance to Leonardo, since he was interested both in the visual
arts and in music. This parallelism in his interest in the aural and visual
arts made it easier for him to observe correspondences between
them, for example, the similarity between the way a painter records
the distances of objects along perspective lines and the way a musi-
cian uses intervals to compose a series of notes.[11] Leonardo's expe-
riences as an anatomist/artist and a musician/painter were exceptional
and, because they gave him a unique neural history, they allowed
him access to privileged perceptions.

His greatest insights, however, seem to come not from such spe-
cific convergences but from a heightened sensitivity to his own inner
life. One of the best examples of this is his reflection that follows
from his aperçu that artists often make the figures in their paintings
resemble themselves,

> which is a thing I have often wondered at, for I have known some
> who, in all their figures seem to have portrayed themselves from
> the life, and in them one may recognise the attitudes and manners
> of their maker. If he is quick of speech and movement his figures
> are similar in their quickness, and if the master is devout his figures
> are the same, with their necks bent, and if the master is a good-
> for-nothing his figures seem laziness itself portrayed from the life.
> And if he is mad his narrative will show irrational figures, not
> attending to what they are doing, who rather look about them-
> selves, some this way and some that, as if in a dream. And thus
> each peculiarity in a painting has its prototype in the painter's own
> peculiarity.[12]

The observation is acute, but it is his further comment on the phe-
nomenon that is most remarkable:

> I have often pondered the cause of this defect and it seems to me
> that we may conclude that the very soul which rules and governs
> each body directs our judgement. . . . Therefore it has completed
> the whole figure of a man in a way that it has judged looks good,
> be it long, short or snubnosed. And in this way its height and
> shape are determined, and this judgement is powerful enough to
> move the arm of the painter and makes him repeat himself.[13]

The language that Leonardo uses, and especially the use of the concept of judgement, goes back, as so often, to Aristotle. What is new, however, is the way that such 'judgement' seems to take control of the artist's body movements.

This particular perception must have come from his own experience. Leonardo must often have felt that there were forces of which he was only vaguely conscious that were moving his hand, and he attributes to others the same sensation. He did not know that this phenomenon is inherent in our nature. As infants our neural networks unconsciously make us imitate our parents' movements, facial expressions and speech, and when we are adults they make us encourage such imitation in our own young, repeating words and actions to them until they take them over. Many mechanisms underlie these operations, including the 'mirror neurons' in the premotor cortex. Leonardo is certainly overstating the effect of these mechanisms on artists, but, as with his recognition of a parallel tendency for people to fall in love with and marry individuals who resemble themselves, he is correct in his identification of forces capable of influencing the movements of the painter's arm.

It must be doubtful whether he would have come to these astute perceptions if his 'natural' birth had not led him to pay less attention to what he could learn from books and more to what he could learn from his own inner being. It was probably this particular aspect of his 'neural' history that gave him his unique awareness of behavioural traits which we now know to be neurally constituted.

Hogarth

William Hogarth (1697–1764), an engraver turned painter, had other reasons to reflect on human visual responses. Growing up in England in the early eighteenth century he would have shared with many the new sense of self-awareness stimulated by John Locke's *Essay Concerning Human Understanding* (1690). Locke had been a medical researcher who saw the brain as 'the presence room of the mind' to which the 'nerves' conducted sense impressions (*Essay*, 2.3,1). There they left marks as on a 'white paper' (*Essay*, 2.1,2), although, depending on the 'temper of the brain', it might in one case retain them as if they were in marble, in another as if they were in freestone and in another as if they were in sand (*Essay*, 2.10,5). Locke's view of the mind affected the thinking of many of Hogarth's contemporaries, but to Hogarth it must have had a special resonance. Trained first in the art of engraving, that is in making lines on blank metal plates so that they could be printed on paper, Locke's image will have seemed to Hogarth particularly compelling, and as he shows in his account of how he trained his memory by repeating in his 'mind the parts of which objects are composed', he certainly found it easier than most to think of his brain as a blank sheet continuously receiving impressions from the senses.

This sensitivity to the things he was impressing on his mind probably lies behind his greatest contribution to art theory. As an engraver Hogarth would have been habituated to nothing more than the curved line made by his burin on a silver or copper plate, and it is such a line that stands out on his self-portrait print of 1749 (fig. 11). It is there identified as 'the line of beauty' and in his book *The Analysis of Beauty* (1753) he explained its meaning. This line for him is the essence of the beautiful. The serpentine form had been praised by Michelangelo, but the English artist gives it absolute pre-eminence. With its double curve in three dimensions he finds it in forms as diverse as shells and women, plants and animals, as shown in plate 1 (fig. 12). In all these it contrasts with the straight lines and the

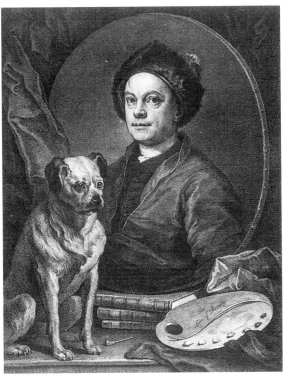

11 (left) William Hogarth, *Self-Portrait*, engraving, 1749

12 (below) William Hogarth, *The Analysis of Beauty*, 1753, plate 1

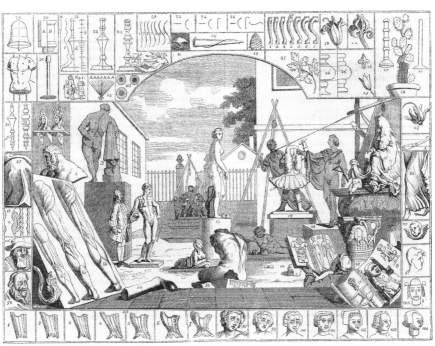

13 Pineapple, from William Hogarth, *The Analysis of Beauty*, 1753, plate 1.10

angular configurations, which lay at the core of the aesthetic ideal promoted by Hogarth's contemporary Lord Burlington and his architect, William Kent. Hogarth's preference for the organic as opposed to the geometrical is well illustrated by his praise for the pineapple, 'which nature has particularly distinguish'd by bestowing ornaments of rich mosaic upon it, composed of contrasted serpentine lines'[1], shown at plate 1.10 (fig. 13). Such was the appeal of the serpentine line to Hogarth that he states that it was only 'a religious motive' that led Sir Christopher Wren to restrict the pineapple to the sides of the front of St Paul's, preferring to place the more regular globe and cross upon the dome.[2] Hogarth's attack on contemporary orthodoxy is striking, and not just because he happens to anticipate the aesthetic preferences embedded in Norman Foster's 'gherkin' skyscraper which now stands behind Wren's cathedral. More relevant to the present enquiry is the justification he offers for his preference. The basis for his praise for the serpentine line is the response it evokes in the eye.

This could be taken to be a very simple explanation, but as we read the text we discover that Hogarth's notion of vision includes everything from the mechanics of the eye itself to the input of the mind behind it. As he says, for example, in chapter one, our sense of an object's functional fitness has a direct effect on our visual pleasure in it:

> This is so evident, that even the sense of seeing, the great inlet of beauty, is itself so strongly bias'd by it, that if the mind, on account of this kind of value in a form, esteem it beautiful, tho' on all other considerations it be not so; the eye grows insensible of its want of beauty, and even begins to be pleas'd, especially after it has been a considerable time acquainted with it.[3]

His observation that visual pleasure in an object or animal can be influenced by non-visual factors, such as the viewer's sense of its fitness, demonstrates a recognition of the importance of the extensive connections within the mental apparatus that supports sight, while his further idea that such pleasure increases with time shows that he realised that those connections become successively more established. The acuteness of his remarks is borne out by their correspondence with modern knowledge of neural plasticity.

This does not mean that he is always right. In chapter three, for example, he uses the observations in chapter one to refute one of the most established criteria of beauty in the classical tradition represented by writers such as Alberti, one that has been confirmed by modern psychologists of perception, that of uniformity: 'It may be imagined that the greatest part of the effects of beauty results from the symmetry of parts in the object, which is beautiful: but, I am very well persuaded, this prevailing notion will soon appear to have little or no foundation.'[4] He goes on to argue that the only reason why we like uniformity is because something possessing that attribute seems better equipped 'to stand, to move, to sink, to swim, to fly etc. without losing its balance. . . . Whence it is clear, the pleasure does not arise from seeing the exact resemblance, which one side bears the other, but from the knowledge that they do so on account of fitness, with design, and for use.'[5] Given that we now know that the preference for axial symmetry is universal and inborn, not only in humans, but in many other animals, Hogarth was certainly wrong to deny its existence. However, his rational explanation for the preference has, as if in compensation, led him to the reason for this omnipresence. The notion of better functionality associated with the uniform is indeed the reason for this property becoming inborn. Biologists recognise that those who have a preference for symmetry have a selective advantage when choosing a mate and this is why such a neurally embedded preference is transmitted by our genetic material. The precision of Hogarth's argument, even when incorrect, illustrates the extent to which he is engaged in a process of genuine scientific analysis, and there is a scientific tone to his assertion that 'this prevailing notion will soon appear to have little or no foundation'. Working in a climate profoundly influenced by the writings of Descartes and Locke, Hogarth saw knowledge as constantly improving under the influence of ever sharper enquiry.

Another example of Hogarth feeling his way towards phenomena which are only now becoming understood is provided by his further suggestion that we like symmetry because we have by nature a love of mimicry. This basic claim, which is, as we have seen, at least as old as Aristotle as an explanation for our love of representational art, is here put to a new use. For Hogarth it also explains why 'we are delighted with the exactness of counterparts'.[6] Our pleasure in things which are symmetrical about an axis is, for him, partly rooted in the correspondence of the two halves, the one imitating the other. Although Hogarth is incorrect in his explanation, he is on to one of the most remarkable human preferences, now often considered under the term 'grouping', which is the tendency of the brain to look

for and group together forms that have some correspondence.[7] He is wrong in connecting our interest in 'counterparts' with our fondness for mimicry, but right in seeing it as innate.

Throughout his analysis of beauty Hogarth repeatedly refers from the human to the animal and from the world of art to that of nature, and he does this nowhere more compellingly than in his most elaborate celebration of the line of beauty in chapter five on 'intricacy'. Not only is our fondness for the double curving line founded in our human pleasure in pursuit, as in hunting, shooting and fishing, but the universality of that pleasure is confirmed by the generalisation that it is essential to the survival of all animals: 'This love of pursuit, merely as pursuit, is implanted in our natures, and designed, no doubt, for necessary and useful purposes. Animals have it evidently by instinct. The hound dislikes the game he so eagerly pursues, and even cats will risk the losing of their prey to chase it over again.'[8] Modern ethologists would agree with Hogarth in his identification of a trait that is so essential for the survival of all carnivorous mammals that it has been so consistently selected for by evolution as to be stronger than is strictly necessary.

The instinct of carnivores for pursuit is so forceful that it will manifest itself even when food is not the goal, and the same applies to humans:

> The eye hath this sort of enjoyment in winding walks, and serpentine rivers, and all sorts of objects, whose forms . . . are principally of what, I call, the **waving** and **serpentine** lines. Intricacy in form, therefore, I shall define to be that peculiarity in the lines, which compose it, that **leads the eye a wanton kind of chace**, and from the pleasure that gives the mind, intitles it to the name of beautiful.[9]

The idea that pursuit is important for humans had already been developed by Locke in his *Essay Concerning Human Understanding*, where, in the opening passage of the preface, he says of the understanding that it 'searches after truth as a sort of hawking and hunting, wherein the very pursuit makes a great part of the pleasure'.[10] This idea had also been followed up by Joseph Addison.[11] But Hogarth makes far more of it, relating the hunt of the mind to the hunt of the body and both to the hunt of animals. In doing so he takes the metaphor back to its roots in physical experience, noting how the pursuit of the eye originates in a pursuit by the whole body, which is why he talks first of real life hunting and takes a winding path as his first example of a serpentine object.

His acknowledgement that the roots of aesthetic experience lie not in some abstract visual preference of a calm mind but in the

visual inclinations associated with intense and vital movement is revolutionary. It demonstrates an unprecedented awareness that the principal function of the senses is not just to provide us with knowledge and facilitate judgement but to enable us to survive by helping us in such activities as finding food. He even implies that there is a similar relation between the taste for pursuit and the selection of a sexual partner, as when he uses his youthful memories to explain his pleasure in the way a ribbon can twist round a stick. He there illustrates the close connection between the sensory and the motor by recalling other enjoyments:

> But the pleasure it [the ribbon] gives the eye is still more lively when *in motion*. I never can forget my frequent strong attention to it, when I was very young, and that its beguiling movement gave me the same kind of sensation then, which I since have felt at seeing a country dance; though perhaps the latter might be somewhat more engaging; particularly when my eye eagerly pursued some favourite dancer, through all the windings of the figure, who then was bewitching to the sight, as the imaginary ray, we were speaking of, was dancing with her all the time.[12]

The extent to which the movement of something that is of particular importance to an individual viewer engages the eye and through the eye the body had never been recognised so clearly before. Today the phenomenon is clearly understood by neuropsychologists, who are well aware that the primary reason we have eyes, and indeed brains, is to help us to move in ways that are conducive to our survival.

Two other phenomena noted by Hogarth that have been studied in greater detail by modern scientists are the progressive decline in the acuity of vision away from the focus of visual attention and the extent to which that focus, by moving rapidly, can mitigate that experience. This is most evident when we look at a line of letters (fig. 14). As Hogarth says,

> Now as we read, a ray may be supposed to be drawn from the centre of the eye to that letter it looks at first, and to move successively with it from letter to letter, the whole length of the line: but if the eye stops at any particular letter, A, to observe it more than the rest, these other letters will grow more and more imperfect to the sight: the farther they are situated on either side of A, as is express'd in the figure.[13]

Hogarth's awareness of the consequences of the decline in the density of the retina's receptor cells away from the central fovea is

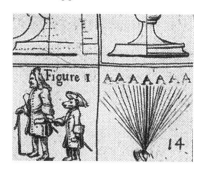

14 Eye and line of letters, from William Hogarth, *The Analysis of Beauty*, 1753, plate 1.14

remarkable and so is his consciousness of the fovea's movement, which he refers to as a movement of the eye's 'imaginary ray'. The eye's alternation between rest and movement had been already noted by al-Haytham, but no one before Hogarth had given such a lucid description of the saccadic – so-called after a French word for the flicking motion of a ship's sail – movements of the eye's fovea that are today known to be essential for our acquisition of knowledge about the world. As he says in the continuation of the previous quotation,

when we endeavour to see all the letters in a line equally perfect at one view, as it were, this imaginary ray must course it to and fro with great celerity. Thus though the eye, strictly speaking, can only pay due attention to those letters in succession, yet the amazing ease and swiftness, with which it performs this task, enables us to see considerable spaces with sufficient satisfaction at one sudden view.[14]

Hogarth's astonishment that, although the eye can only focus on one letter at a time, it still gives us the sense that we 'see considerable spaces with sufficient satisfaction' has only recently been resolved with a realisation that the brain, far from 'photographing' what it sees through the eye, must instead use fragmentary information collected by a fast-moving fovea to build up a picture that we see as stable.

There is a similar freshness of observation in chapter thirteen on 'composition'. Hogarth is there at pains to differentiate between the eye and the mind:

Experience teaches us that the eye may be subdued and forced into forming and disposing of objects even quite contrary to what it would naturally see them, by the prejudgment of the mind from the better authority of feeling, or some other persuasive motive. But surely this extraordinary perversion of the sight would not have been suffer'd, did it not tend to great and necessary purposes, in rectifying some deficiencies which it would otherwise be subject to (tho' we must own at the same time, that the mind itself may be so imposed upon as to make the eye see falsely as well as truly) for example, were it not for this controul over the sight, it is well known that we should not only see things double, but upside down, as they

are painted upon the retina, and as each eye has a distinct sight. And then as to distances; a fly upon a pane of glass is sometimes imagined a crow, or larger bird far off, till some circumstance hath rectified the mistake, and convinced us of its real size and place.[15]

The mind readily overrules the eye if it receives more reliable information about an object from touch, and the proof of the mind's power to 'control' the eye is the fact that, although the image of the world on our retina is inverted, we see everything upright. This discovery as a result of experiments with convex and concave lenses of the inverted retinal image a century earlier had done much to draw the attention of thinkers such as Descartes and Locke to the complexity of the mind, encouraging their different theories of inborn and acquired understanding.

Hogarth followed Locke in his emphasis on the importance of cumulative sensual experience for the building up of knowledge, as he demonstrates in a subsequent passage. Here he insists we can only build up a 'perception of the immense space surrounding us' by receiving cumulative information about light and shade from different points, 'which are remembered and learnt by degrees, and when learnt, are recurred to upon all occasions'.[16] He is too literal minded about the accumulation of information, but what he says about our understanding of objects being built up by experience, and once built up stored in the memory is basically right. Until we have seen and handled a ball we may not know its shape. Once we have learnt what pattern of tones are associated with its appearance and have stored that pattern in our memory, we instantly recognise it when we see it again.

Elsewhere, in a manuscript addition to the text, Hogarth uses the notion of the mind's malleability to explain the formation of visual taste:

> the most remarkable instance, that is given in support of this [struck through: vulgar error] is, that the Nigro who finds great beauty in the black Females of his own country, may find as much deformity in the european Beauty as we see in theirs, by the almost inumerable Instances, that might be given, of the Power of habit and custom. It is easy to conceive, how one brought up from infancy in a coal pit may find such pleasure and amusement there, as to disrelish, daylight, and open air.[17]

Although his main intention in this parody of Plato's myth of the cave is to mock his critics, he incidentally confirms his view of the extent to which the mind's inclinations are formed by experience. He may not have been bothered that by this relativising observation he was

undermining his own overriding claim that the line of beauty constitutes an absolute standard rooted in a universal human nature.

Probably he would have been happy to agree with modern psychologists and neuroscientists, who have shown that we possess both inborn, and so absolute, as well as acquired, and so relative, standards. Certainly his point in relation to members of a black community and people who work in a coal pit is different from that in relation to the line. It is easy to explain, using modern neuroscience, how the preference for a relatively incidental quality, such as the colour of a face or substance, is more likely to be the product of habituation than the preference for a more inherent attribute, a type of line which is present in a wide range of plant and animal forms as well as in man-made objects. Indeed it is interesting that repeated experiments have shown that, exactly as he claims, all humans do indeed generally prefer curved lines to angular ones.

Since this preference is apparently inborn, no experiment can lead us to its source. Evolutionary theory, however, does suggest an explanation that, although not the same as Hogarth's, does relate to it. If we prefer curved lines to angular ones it may well be because curved lines are typical of things in the natural world such as growing plants and animals, including fellow humans, which are all important for our survival, while angular lines are found more typically in the mineral world with which our relationship is quite different. Besides, when angular lines do occur in the 'organic' world, they are frequently the attributes of dangerous and threatening objects, such as thorns and teeth. Hogarth may have been wrong in thinking that the preference for the serpentine line derived from an instinct for the chase, but he was right to expect such a fundamental inclination to be rooted in a basic human need.

A recognition of the beauty of the serpentine line may be universal in some sense, but why should Hogarth have been the first person to identify it? An appropriate way to answer this question is to engage with it in the light of modern knowledge of neural plasticity. If we thus ask what particular experience might have predisposed him to his observation, one answer comes readily to mind. Hogarth, as noted at the beginning, was trained first in silver and copper engraving, an art in which the use of the line, and especially the curving line, on a three-dimensional surface was the core skill; so the strengthening of the neural networks on which that skill depended would have rapidly increased his sensitivity to such forms. The fact that contemporary taste also gave prominence to such configurations as shells and ribbons in which such forms were defining attributes would have heightened them further. So too would his adoption

of a mnemonic system consisting of a short-hand drawing style in order to accelerate his progress when he decided to become a painter. As he tells us, this system involved first retaining 'in my mind lineally such objects as fitted my purpose best'[18] and then making diagrams such as that shown on plate 2, fig. 71 (fig. 15). His concentration on the line, and especially the curved line, increased at each step in his personal development until it became the thing he looked for – and found – everywhere.

Locke's view of the mind as shaped by all the things to which it is exposed had led to Jonathan Richardson's idea earlier in the century that visual taste is something formed above all by experience and this set the scene for someone like Hogarth to be more sensitive to the convergences of features in his environment than his predecessors. There were many elements in that environment

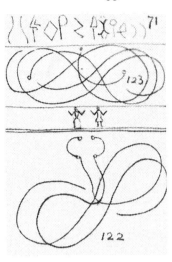

15 Mnemonic drawings (71) and tracks of dancers (122 and 123), from William Hogarth, *The Analysis of Beauty*, 1753, plates 2.71 and 2.123

which strengthened those convergences. One was the rapidly growing popularity of hunting on horseback as a pastime, a trend which gave a new relevance to Addison's emphasis on the drive to 'chace'. Another was the similar growth in the popularity of dancing, especially native English country dancing, which was seen as a healthy alternative to continental varieties and which frequently involved a so called hay, 'a cypher of S's, or a number of serpentine lines interlacing'.[19] The pattern such lines make on the floor, best seen, as he says, in the theatre, is illustrated at plate 2, fig. 123, just below his linear mnemonics (fig. 15). For Hogarth, who, following Locke, Richardson and others, saw 'experience' as the way to learn, all these pleasures had a single origin in the line of beauty. Others such as Laurence Sterne, in *Tristram Shandy*, or Lancelot 'Capability' Brown, in his gardening, having shared many of the same experiences, came to share his view, but it was in the brain of Hogarth, the engraver, trained as a master of the complex curving line, that it acquired such prominence that he could build around it a whole theory.

8

Burke

An inclination to identify universal human tendencies is manifest even more clearly in Edmund Burke's *A Philosophical Enquiry into the Origin of Our Ideas of the Sublime and Beautiful*, which appeared in 1756, only three years after *The Analysis of Beauty*. Edmund Burke (1729–1797) was the son of a Dublin lawyer. Although originally expected to follow his father's profession, he eventually made his career in politics. Long before that, Burke's early work had an equally profound impact on contemporary aesthetics.

The *Philosophical Enquiry* appeared in the same year as his anonymously published *A Vindication of Natural Society*, and an emphasis on nature is apparent in both works. In the case of the discussion of 'the sublime and the beautiful', Burke emphasises their roots in universally shared preferences: 'On a superficial view, we may seem to differ very widely from each other in our reasonings, and no less in our pleasures: but notwithstanding this difference, which I think to be rather apparent than real, it is probable that the standard both of reason and Taste is the same in all human creatures.'[1] The reference to humans as 'creatures' only reinforces the claim that taste is more biological than cultural.

This is why he is able to play down the importance of reason in favour of some more direct reaction. This is well indicated in his discussion of sympathy, where he rejects all claims that it is based on a rational calculation:

> I am afraid it is a practice much too common in inquiries of this nature, to attribute the cause of feelings, which merely arise from the mechanical structure of our bodies; or from the natural frame and constitution of our minds, to certain conclusions of the reasoning faculty on the objects presented to us; for I should imagine, that the influence of reason in producing our passions is nothing near so extensive as it is commonly believed.[2]

Burke thinks that 'it is by this principle [sympathy] chiefly that poetry, painting and other affecting arts, transfuse their passions from one breast to another'[3] and this claim that the response derives not from reason but from 'the natural frame and constitution of our minds' comes close to suggesting that it is, in modern terms, neurally based. When he says explicitly that 'sympathy must be considered as a sort of substitution, by which we are put in the place of another man, and affected in many ways as he is affected' he even sounds like a modern scientist describing an experiment showing how watching someone else suffering physically can activate the pain centre in the insula of our brain. He would certainly have been delighted to learn of the neural basis of empathy.[4]

He would not have had the same reaction to the recent finding that we have a neurally based preference for configurations that share features such as symmetry about a vertical axis with the human form. Echoing Hogarth's mockery of the idea that we have a natural aesthetic preference for the symmetrical, Burke reserves his greatest ridicule for the idea 'echoed backward and forward from one writer to another a thousand times, that the proportions of building have been taken from the human body'.[5] He continues by saying, 'Nothing could be more unaccountably whimsical, than for an architect to model his performance by the human figure, since no two things have less resemblance or analogy, than a man, and an house or temple.'[6] Burke backs up his argument by the observation that it is a real strain for a man to adopt the symmetrical pose recommended as a model by the architects and celebrates the fact that gardeners have already liberated themselves from such geometries.

One aspect of Burke's theory of universal response is his observation that in some way the sense of sight operates more directly and its judgements are more universal than the other senses:

> The principle of pleasure derived from sight is the same in all. Light is more pleasing than darkness. Summer . . . is more agreeable than winter. . . . I never remember that any thing beautiful whether a man, a beast, a bird, or a plant, was ever shewn, though it were to a hundred people, that they did not all immediately agree that it was beautiful. . . . I believe that no man thinks a goose more beautiful than a swan, or imagines that what they call a Friezland hen excels a peacock. It must be observed too, that the pleasures of sight are not so complicated, and confused, and altered by unnatural habits and associations, as the pleasures of

Taste are; because the pleasures of the sight . . . are not so often altered by considerations which are independent of the sight itself.[7]

Again in part three Burke admits that there is such a thing as an idea of beauty that derives from custom, a result of social construction, but argues that the proof that our preferences are inborn is apparent from our reaction to animals we have never seen before: 'and if one of a new species were presented, we should by no means wait until custom had settled an idea of proportion before we decided concerning its beauty or ugliness.'[8] Burke is too extreme in denying the extent to which our tastes can be reconfigured by our experiences but his assertion that many of our visual preferences are inborn has only been confirmed by recent observations. He could not have known that this is because many of our visual preferences are so adaptive that the neural networks which embody them are coded for by our genetic make-up and as a result of this, unlike other aspects of taste, they are not easily susceptible to change.

Related to his disregard of reason and his doubts surrounding the influence of custom is his refutation of the importance of language. He tells his readers several times that his study is not of words but of the phenomena they describe. What he means by this is clearly conveyed in his discussion of terror at the beginning of part two:

Several languages . . . use the same word to signify indifferently the modes of astonishment or admiration and those of terror. Thambos is in Greek either fear or wonder . . . The Romans used the verb stupeo a term which strongly marks the state of aston- ishment . . . and do not the French etonnement and the English astonishment and amazement point out the kindred emotions which attend fear and wonder? They who have a more general knowledge of languages could produce, I make no doubt, many other and equally striking examples.[9]

All that language does is provide evidence of a physical phenome- non, and in this case it demonstrates that it is universal. What con- cerns him is the phenomenon itself and its universality.

9

Montesquieu

During the eighteenth century travel and reading greatly extended the Europeans' knowledge of the rest of the world. This resulted in an increase in the number of cultural and artistic traditions that were regularly taken into consideration and this led in turn to a new level of reflection on the way their formation might have been affected by the places in which they grew up. The most ambitious treatment of this general issue was by Charles Louis de Secondat, baron de Montesquieu (1689–1755) in his *De l'esprit des lois* (On the spirit of the laws) (1748), which covers not only the nations of Europe, but those of the Americas, India, Tartary, China and Japan. The principal argument of this widely read work, which, exceptionally for a book on such a subject, featured a geographical map of the world (fig. 16), is that laws vary according to the differences in the characters of the populations and the societies in which they live. Montesquieu

16 Charles Louis de Montesquieu, map of the world, from *De l'esprit des lois*, 1748

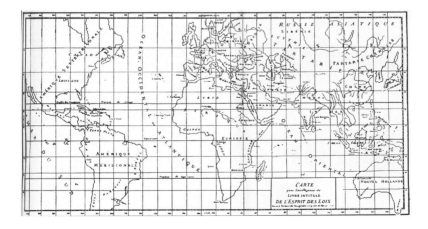

was well equipped to study such differences. Brought up as a member of a wealthy landowning family in the area around Bordeaux and having inherited a title and political position from an uncle, he had travelled widely in Europe. Most influential on him had probably been the many months he spent in England, where both political constitution and customs contrasted strikingly with those of his native France on the other side of the Channel.

Some of the reasons for the cultural differences noted by Montesquieu are ones that would today be called socio-economic, but two of the most important are 'the nature of the climate' (Books 14, 15, 16 and 17) and 'the nature of the terrain' (Book 18). In the case of climate one of the reasons for the difference lies in the nature of the nerves, the physiological refinement of which had been revealed thanks to the discovery of the microscope a century earlier:

> The nerves, which end in the tissue of our skin, are made of a sheaf of nerves. Ordinarily, it is not the whole nerve that moves, but an infinitely small part of it. In hot countries, where the tissue of the skin is relaxed, the ends of the nerves are open and exposed to the weakest action of the slightest objects. In cold countries, the tissue of the skin is contracted and the papillae compressed. The little bunches are in a way paralyzed; sensation hardly passes to the brain except when it is extremely strong and is of the entire nerve together.[1]

He had tested the mechanics of his claim by comparing two halves of a sheep's tongue, one of which he had frozen. Observing the 'papillae' on its surface, both through the microscope and the naked eye, he noted how when frozen they retracted and only emerged again as they thawed. He illustrates the cultural consequences of this physiological difference by pointing out how, 'I have seen operas in England and Italy; they are the same plays with the same actors: but the same music produces such different effects in the people of the two nations that it seems inconceivable, the one so calm and the other so transported.'[2] To drive home his point he goes on to note many other such variations around the globe.

He does the same for the influence of terrain, stressing the difference between more and less fertile areas, islands and continents and lands that are scarcely worked at all and others, such as Holland, that are virtually man-made. Among many examples of the consequences of these differences he notes how 'People who do not cultivate the land do not have even the idea of luxury. The admirable simplicity of the Germanic peoples must be seen in Tacitus; art did not fashion their ornaments, they found them in nature. If the family

of the leader was to be marked by some sign, it was again in nature that they had to seek it; the kings of the Franks, Burgundians and Visigoths wore their long hair as a diadem.'[3]

In the end, Montesquieu argues, different factors are more important in different contexts. Overall,

> many things govern men: climate, religion, laws, the maxims of the government, examples of past things, mores and manners; a general spirit is formed as a result. To the extent that, in each nation, one of these causes acts more forcefully, the others yield to it. Nature and climate almost alone dominate savages; manners govern the Chinese; laws tyrannise Japan; in former times mores set the tone in Lacedaemonia; in Rome it was set by the maxims of government and the ancient mores.[4]

Nature is one influence among many and has been a more important factor in some places than others. Montesquieu never discusses visual art directly, but when outlining the culture of extremely free states, in contrast to that of absolute monarchies, he notes that 'their poets would more often have an original bluntness of invention than a certain delicacy of taste; one would find there something closer to Michelangelo's strength than to Raphael's grace.'[5] He was probably well aware that Michelangelo was formed in republican Florence, while the art of Raphael, who was born in ducal Urbino, was principally produced in papal Rome.

Montesquieu's perception of difference had certainly been sharpened by his travels, but his sense of the significance of climate and terrain must have a more precise source. The principal origin of his wealth was wine growing, where weather and soil were the predominant determinants of success. Constantly at the back of his mind, their role, like that of other factors, slowly became clear to him as he accumulated his data. Eventually, at the end of an almost natural process, the picture was complete: 'I followed my object without forming a design; I knew no rules or exceptions; I found the truth only to lose it. But when I discovered my principles, all that I had sought came to me, and in the course of twenty years, I saw my work begin, grow, move ahead and end.'[6] Principles, such as the influence of climate and terrain, had emerged only after looking again and again at the materials he had collected. In his wine-grower's brain such factors were already important; so it was easy for data in other areas to become related to them, slowly forming a pattern. His ideas had not been imposed on the data. They had grown naturally like vines and the neural networks in which they took shape.

10

Winckelmann

Someone else who claimed a fresh view of at least one area of human culture, someone powerfully influenced by Montesquieu, was Johann Joachim Winckelmann (1717–1768). Born in Germany, the son of a poor cobbler in Stendal, a small town on the Elbe, his background could not have been more different from that of the French nobleman, but it too contributed essential dimensions to the neural formation that would make him the founder of scientific art history. Whereas Montesquieu in some sense grew into his role, Winckelmann had to create his. After success at the gymnasium he went on to study theology at Halle and medicine at Jena. There he was taught by G. E. Hamberger, whose mechanical view of the body may have resonated with the cobbler's son. He went on to work as a school teacher and his erudition and mastery of languages secured him a job as a librarian near Dresden, and it was there in 1754 that he had the exposure to art which was to transform both him and his career. More important than the antiquities in the possession of the King of Saxony were the few gems owned by his friend, the artist Adam Friedrich Oeser, and especially the many collected by Philipp Daniel Lippert and copied by him in casts using a new technique. The opportunity to apply the rigorous skills he had developed through the study of language to literally thousands of original and reproduction Greek and Roman works of art had a profound impact, and, in 1755, the year he left for Italy, he published the first sketch of the theory that would make him famous, his *Gedanken über die Nachahmung der griechischen Werke in der Malerei und Bildhauerkunst* (On the Imitation of the Painting and Sculpture of the Greeks).

His debt to Montesquieu's theory of the relation between natural environment and culture is revealed in the first section on 'beautiful nature'. This begins, 'Good taste . . . had its origins under the skies of Greece' and goes on to remind us that 'Minerva chose this land, with its mild seasons, above all others for the Greeks in the knowl-

edge that it would be productive of genius.'[1] The connection
between the environment and the art produced in it was then
explained a few pages later: 'The first development of the Greeks
was influenced by a mild and clear sky; but the practice of physical
exercises from an early age gave this development its noble forms.'[2]
Because of the climate such exercises could be in the nude and this
had two consequences. It discouraged ugliness, which would have
been painfully visible in such conditions, and allowed artists to
improve their taste: 'These frequent opportunities to observe nature
prompted Greek artists to go still further. They began to form certain
general ideas of the beauty of individual parts of the body, as well
as of the whole – ideas which were to rise above nature itself; their
model was an ideal nature originating in the mind alone.'[3] The
freedom of the Greek state was also important, giving them advan-
tages over both the earlier Egyptians and the later Romans, but it
was the warmth and brightness which came with the Greek climate
that drew such beauty from Greek artists.

These observations are expanded and integrated into a more
coherent theory in the much larger and more systematic *Geschichte
der Kunst des Alterthums* (History of Ancient Art) (1764).[4] This work,
conceived and formulated by a shoemaker's son in the galleries and
libraries of Rome, is in many ways even closer to a neuroarthistory
than *On the Imitation*, and begins with a phrase that might echo
Hogarth's writing of eleven years earlier. In it he presents himself as
a hunter for whom 'it is no disgrace . . . not to capture every wild
beast, or to make bad shots'.[5] The author's intention here is above
all to ask his readers to forgive him if he has not covered everything
or has made mistakes, but he probably also hopes to suggest that
his skill, like that of a hunter, is principally visual and based on much
practice. The importance of cumulative visual experience is indeed
the key to the whole book, as he stresses throughout the preface,
and it is on seeing rather than reading that he bases what was des-
tined to be recognised as the first consciously critical and scientific
exposition of art's history.

As he says at the outset, it is 'intended to show the origin,
progress, change and downfall of art, together with the different
styles of nations, periods, artists, and to prove the whole, as far as it
is possible, from the ancient monuments now in existence.'[6] The
emphasis on 'proof' indicates that he will try and demonstrate each
claim that a work is of a particular nation, period or artist by refer-
ence to comparative evidence, such as relating a statue to a date-
able coin. As significant as his insistence on the importance of proof
is his emphasis on the nature of the visual contact he has had with

the works concerned: 'All the pictures and statues, as well as the engraved gems and coins which I have adduced as proofs, I have myself seen and seen frequently, and been able to study.'[7] He has not only seen everything, but seen it often, and such repeated viewing becomes a key to his method, as in his identification of the original pose of the *Belvedere torso* only 'after repeated contemplation'.[8] As we now know, repeated looking would indeed have developed in him neural networks that were better adapted to the study of ancient sculpture than those of his predecessors, particularly, as he repeatedly and mockingly insists, because they had learned all they knew from books. Winckelmann's sense of what was happening in his own head led him to formulate a clear recommendation to anyone trying to follow him in the study of a body of art that he should first make 'them perfectly familiar to his memory' and only then 'read all the ancient authors'.[9] The core activity of the art historian is that of looking at works of art and committing them to memory. The use of the library is secondary. The art historian should work above all with the visual knowledge that he has in his head, or as we would say in his brain.

The art that Winckelmann himself had been hunting was that of ancient Greece, and in order to pursue his game he had to first distinguish it from others, which is why he explains that he will begin with a survey of that of the Egyptians, Phoenicians, Persians and Etruscans. He also has to put it in its context, discussing in his first book 'the origin of art, and the causes of its difference among different nations'. As far as its origin is concerned, his most important claim is that art is not something which began in one place and spread to others:

> there is no sufficient reason for assigning any particular country as the land of its birth, for every nation has found within itself the first seeds of those things which are indispensable; and although art, like poetry, may be regarded as the daughter of pleasure, still it cannot be denied that pleasure is as necessary to human nature as those things are without which existence cannot be continued; and it can be maintained that the art of painting and figuring our thoughts, are older than the art of writing them – as proved by the history of the Mexicans and other nations.[10]

Art is a universal activity, because it produces a pleasure analogous to that associated with the activities most essential for our survival. It is its dependence on this primal drive that makes it older than writing.

Some aspects of human nature are universal, others are the product of the natural environment, and the principles governing

such variation in relation to nature are laid out in chapter three, 'The influence of climate [Himmel] on conformation [Bildung]': 'By the influence of climate we mean the manner in which the conformation of the inhabitants of different countries, not less than their modes of thought, is affected by their situation, and by the temperature and food peculiar to them.'[11] The German word *Bildung* (shaping) expresses the range of types of 'formation', from the physical to the cultural, which Winckelmann sees as dependent on *Himmel*. This word's prime reference is to 'sky'. Its second is to 'climate', from the Greek *klima*, in other words the 'inclination' of the earth's surface, referring to what is now known as latitude. Both references draw attention to factors affecting what the English call climate and its influence on populations.

This influence takes many forms. One is suggested, according to Winckelmann, by the way in which languages vary, with those of the Chinese, Japanese, Greenlanders and some North American tribes lacking certain sounds. This is because 'in cold countries, the *Nerven* [nerves, or more properly 'sinews'] must be more rigid and less active than those that are warmer'. Hence, it happens that all Northern languages have more monosyllables, and are more burdened with consonants, which other nations find it more difficult, partly impossible, indeed, to connect and pronounce.'[12] One Italian, Gravina, he tells us even argued that there was a comparable variation within the dialects of the Italian peninsula, with the northern Lombards at one pole having a harsh and abrupt utterance, and the Neapolitans at the other having a much 'rounder enunciation'.[13] This variation is then presented as parallel to the variation between northern and southern hair, with northern people having hair that is straight, and southern ones more curled, 'so that the greater number of children in Italy are born with fine curling hair'.[14] Rounded vowels relate to curly hair just as stiff northern bristles relate to hard consonants. The favourable influence of the warm south is also apparent in the form of the body and face. For 'just as with flowers, whose fragrance increases in proportion to the dryness of the soil, and the warmth of the climate', in the same way 'that noble beauty which consists not merely in a soft skin, a brilliant complexion, wanton or languishing eyes, but in the shape and form, is found more frequently in countries which enjoy a uniform mildness of climate.'[15] Winckelmann can only hint at the reasons for the correlations he observes and no one today would explain the differences in a similar way, but his general argument that different environments lead to the emergence of different life forms is fundamental to modern ecological theory.

Some of his views have their origins in antiquity, such as his opinion that people's minds vary in similar ways since 'the influence of climate on the mode of thought of a people – with which external circumstances, especially education, the form of government and the mode of administering it, co-operate – is just as perceptible and conceivable as the influence of the same cause on the conformation' of their bodies.[16] Such observations had already become dangerously simple clichés, as Cicero pointed out: 'At Athens the air is delicate, which is supposed to render the Athenians clever. In Thebes it is gross and heavy, and the Boeotians are proverbially sturdy and stupid.'[17] Such notions were based on ancient humoural theory. Winckelmann was able to revive them, using more modern notions of the central nervous system, and apply them to the history of art:

> The mode of thought, as well of Oriental and Southern peoples as of the Greeks, is manifested even in works of art. The figurative expressions of the former are as warm and ardent as the climate in which they dwell, and the flight of their thoughts frequently exceeds the limits of possibility. Hence, these are the brains which conceived the strange figures of the Egyptians and Persians, which united in one form creatures of totally different natures and kinds.[18]

In the case of the Greeks on the other hand, 'Their imagination was not exaggerated like that of the Oriental and Southern nations; and their senses, acting on a brain of delicate structure through the medium of quick and delicate nerves, discovered instantly the several qualities of an object, and occupied themselves especially in considering the beauty contained in it.'[19] Greek art was so good because the Greek optical apparatus was so subtle. For Winckelmann the excellence of Greek, and especially Athenian, art depended not on a particular combination of temperature and humidity of the air but on a distinctive refinement of the neural linkages between the eye and the brain. These are related to climate, but only indirectly.

One of the important subtleties of Winckelmann's general theory is his insistence that the influences of what we would call cultural factors have to be considered alongside those that are natural:

> We must, therefore, on judging of the natural capacity of nations, and of the Greeks especially, in this respect, take into consideration, not merely the influence of climate alone, but also that of education and government. For external circumstances effect not

less change in us than does the air by which we are surrounded, and custom has so much power over us that it modifies even the body, and the very sense with which we are endowed by nature; thus, for instance, an ear accustomed to French music is not affected by the most touching Italian symphony.[20]

The sophistication of his observation lies in its subtle discernment of the way universal inborn aptitudes can be modified by an individual's particular cultural experiences. Long before Baxandall identified the 'period eye' or neuroscientists discovered the neural plasticity on which it depends, Winckelmann defined a 'regional ear' and his description of the way in which it affected the senses and the body came close to recognising its neurological basis.

Winckelmann thus clearly identified four important phenomena. He saw that art owes its origin to a distinctively pleasure-seeking inclination within human nature. Furthermore he not only recognised that artistic activity is influenced by the environment, he also discriminated between influences that came from nature and those that came from culture, and, most critically, related both to sensibilities of the human nervous system. Finally, he used these observations to develop a general theory. This allowed him to claim that it was the recurrence of a similar combination of natural and cultural factors that caused the artistic triumph of Athens to be replicated two thousand years later and a thousand miles away in Florence.[21]

Winckelmann returns to these issues of principle later in his treatise, when, at the beginning of his discussion of Greek art, he tries to understand 'the essential of art'. This section begins with a passage which gives us some glimpse of the writer's prodigious visual memory. Prefiguring a modern image database project, he imagined bringing together before his eyes every work of art made in Greece, whether known from remains or texts, 'Without collecting and uniting them so that a glance may embrace all, no correct opinion can be formed of them.'[22] The emphasis here on vision, or visual imagination, is intended to remind people of the danger of book learning and he goes on to stress that the achievement of the Greeks was only possible because they did not spend too much time reading heavy and obscure books. Instead they looked and they thought, and they did both when they were much younger than people tended to be in Winckelmann's day. This is one reason for the freshness of their perceptions of beauty. Another is the fact that the good weather made them happy and free, and their happiness and freedom made them enjoy festivities at which they showed off their naked beauty to each other: 'The gymnasia and other places

where the young men exercised naked in athletic and other games, and which were the resort of those who desired to see beautiful youth, were the Schools wherein the artist saw beautiful structure; and from the daily opportunity of seeing it nude and in its perfection, his imagination became heated, the beauty of the forms he saw became his own, and was ever present to his mind.'[23] The Greek climate determined their mood as well as the freedom of their naked activities, and this in turn provided artists with the opportunity to repeatedly view the best human bodies and so imprint them on their minds.

Although Winckelmann does not talk here in explicitly neurological terms, he does elsewhere argue that the neural structures can be a real constraint, preventing just such a positive influence from visual experience:

> It is also very probable that the idea of beauty, with artists as with all other men, is conformable to the texture and the action of the nerves of sight. From the imperfect and frequently incorrect colouring of the painter, one must infer, in part, that the colors are so represented and pictured in his eye; for in this particular, the conclusion at which the sect of Skeptics in philosophy arrived is not groundless, who argued from the diversity in the color of the eyes both in beast and man, that our knowledge of the true colors of objects is uncertain. As the color of the humors of the eye might be regarded as the cause of this defect, so the different ideas of the forms which constitute beauty are probably dependent on the nature of the nerves.[24]

The remarkable proposition is that just as ancient philosophers once thought that the perception of colour was affected by the colour of our eyes – which can in fact happen, as in the case of a blood-shot or jaundiced eye – so the nerves of the visual system might have some defect that makes it impossible for them to see forms correctly. Winckelmann is not just using a metaphor here as is clear from the next passage:

> This is conceivable from the innumerable kinds of fruits and the innumerable varieties of the same fruit, whose different shape and taste are elaborated through diverse filaments, by the interlacing of which the tubes are woven, within which the sap ascends, is purified and ripened. Now since there must exist a cause for the many different impressions made even upon those occupied with delineating them, the foregoing supposition may by no means be rejected.[25]

The idea is apparently that just as the different shapes and tastes of fruit can be related to differences in their fibrous structure, so dis-

parities in perception could be due to differences in the fibrous structure of the visual system. Since the analogy is not just with differences of species, but with differences of individuals, Winckelmann seems almost to anticipate genetic theory which acknowledges that all individuals within a species are genetically different. Indeed, since such genetic variances do indeed cause congenital differences in the neural networks that support vision, such as deficiencies in the retinal cones which facilitate the recognition of colour distinctions, this proposition though incorrect, does correlate with modern neuroscience.

What does not relate to modern science is his equally biological theory of beauty. In his desire to extract a canon from Greek art, Winckelmann is scornful of the relativist theories of those who 'found their doubts principally on the notions of the beautiful existing among remote nations, which must be different from ours, in conformity to the difference in the shape of their faces.'[26] He is insistent that slanting eyes, for example, cannot be beautiful,

> because they deviate from the fundamental form of the face, which is a cross, whereby it is divided equally, in length and breadth, from the crown of the head downward, since the perpendicular line passes through the middle of the nose, and the horizontal line through the orbits of the eyes. . . . Such eyes, therefore, when found among us, and in Chinese, Japanese, and some Egyptian heads, in profile, are a departure from the standard.[27]

Winckelmann is evidently, like Hogarth, in pursuit of some absolute standard of beauty of form, one even more geometrical, and uses it to arbitrarily brand as deficient not just some works of art, but whole races.

He has a similarly schematic criticism of the flattened noses of the Chinese, the Calmucks of Mongolia and other distant nations. This 'is also a deviation, for it mars the unity of the forms according to which the other parts of the body have been shaped'.[28] He is even more scornful of the 'projecting swollen mouth which the negro has, in common with the monkey of his land'. This 'is a superfluous growth, caused by the heat of the climate, just as among us the lips swell from heat . . . and in some men indeed from violent anger'. In the same way, 'the small eyes of extreme northern and eastern nations make part of the incompleteness of their growth, which is short and small'.[29] These variations in the human type do indeed relate to climate, though not in the way Winckelmann suggests. The larger size of the lips of Africans is as much an adaptive response to the high temperature of their environment as the smaller size of ours is to cold, and the same reason explains why Innuits have smaller

sized eyes. His claim rests on little more than the ancient Greek notion of the perfection of the mean between two claimed extremes.

Where he is right, though, is in his statement that there are some standards of beauty that are universal: 'Most nations, however, and among them the most cultivated, not only of Europe, but of Asia and Africa, invariably agree as to the general form; consequently their ideas of it are not to be considered as arbitrarily assumed, although we are not able to account for them all.'[30] Tests over the last century have indeed established the universality of some visual preferences, such as those for symmetry about a vertical axis, smoothness and shininess, and evolutionary theory has provided good reasons why natural selection should have ensured the development and transmission of the neural networks in which they are embodied.

Winckelmann, who had studied medicine in his youth and who was a shoemaker's son from Stendal on the Elbe, would have been more aware of the way in which the northern body was concealed and constrained by its coverings than most of his contemporary scholars of ancient art and his homoerotic inclinations would in any case have resulted in a more passionate engagement with Greek art and culture. For him the discovery of the warm climate of Italy would have been even more intoxicating than it would be a little later for Goethe. Having experienced the southern environment which contrasted so dramatically with that of his native Germany and having read the wine-grower Montesquieu's theory of the influence of climate and terrain, he was provoked to attempt to answer a question that had been at the back of many accounts of art since the time of the Romans: what was the source of Greek art's unique beauty?

Modern neuroscience would certainly lead us to expect that in ancient Greece the experience of male nakedness, which was found in no other cultures around the Mediterranean at the period, would at the very least have heightened awareness of the male body's attraction. Besides, the repeated viewing of the body would also have affected people's minds exactly as Winckelmann suggested. The more men looked with attention at each other's bodies the more richly connected the neural networks involved would have been, with predictable consequences for visual preferences. Statues made by artists with such networks would indeed have possessed better and more normative anatomies. Winckelmann, whose own neural networks had been reconfigured by exposure to a larger number of ancient works of art than those of anyone earlier, had indeed unconsciously come to understand one of the neurally based secrets of Greek art's success.

11

Kant

Immanuel Kant (1728–1804) was not an emergent art historian, as Winckelmann was, but his writings on philosophy in general and on aesthetics in particular were equally innovative and in some ways just as influential on the subsequent development of the history of art. Like Winckelmann he was the son of a craftsman, in his case a saddler, but, unlike his slightly older contemporary, he never travelled, living all his life in his native Königsberg, modern Kaliningrad, now in Russia, then in Prussia. He may have derived some confidence in the advantages of living in this area of the eastern Baltic from its association with the great Copernicus. He was certainly proud to claim that his ideas, like those of the astronomer, had revolutionary implications. Copernicus had transformed our view of nature by showing that the earth went round the sun rather than the sun round the earth. Now Kant was to argue that our understanding of cognition should also be reversed. Instead of thinking that knowledge comes from our experience of objects, as earlier writers such as Locke had claimed, our comprehension of objects is only possible because of the ways we have of knowing them. These include our 'forms of sensibility' and our exploitation of categories such as 'space' and 'time'. Although the argument is presented as a philosophical one, it is implicitly biological, to the extent that it argues that our knowledge of the world depends on the possession of a set of capacities which are inborn and universal, being present in all human beings. Kant thus replaces both Locke's blank sheet view of the mind and Descartes' notion of pure reason, with a conception of the mind as possessing inherent properties which are responsible for its most important operations.

Kant could not have known that the reason why we possess such distinctive inborn sensibilities such as those for space and time is because of their selective advantage. When our primate ancestors over thirty million years ago acquired a third set of cones enabling the colour discrimination that made it possible for them to shift from

an omnipresent leaf diet to one of fruit and nuts which was much richer and more seasonally available, it created a situation in which an understanding of space and time became critical for the mapping of resources. This created a strong selective pressure for neural equipment in which knowledge was co-ordinated around those axes. It was Kant who, although ignorant of their evolutionary origin, first realised the fundamental importance of such 'cognitive maps' in man's mental make-up.

Kant did not present his view of the mind in the terms of the natural sciences, but the tradition to which he was contributing was one that did not separate philosophy from science. Both Descartes and Locke had integrated the two fields as had two other admired predecessors, Isaac Newton and Gottfried Leibniz. Much of Kant's own earliest work was in the field of natural science and he contin- ued to teach subjects such as physics and geography long after his appointment as professor of philosophy at the University of Königsberg. He was also happy to think of the mind as seated in the brain. It is thus not inappropriate to consider his thought in the *Critique of Pure Reason* (first version 1781) as a contribution to the redefinition of human nature.

Kant often talked of our brains and in many ways his view that knowledge depends on 'forms of sensibility' and categories such as space and time is a claim about the way in which the brain works. In this sense he anticipates the view which developed during the nine- teenth and twentieth centuries in response to the unfolding knowl- edge of neurobiology that the brain has many capacities which are indeed inborn and universal in the way that he describes. The sep- arate functions of short- and long-term memory are examples of inborn faculties utilised for dealing with time. The cognitive maps which we now know we have in our brains do the same for space. Although Kant did not explore this line of thinking, he made it easier for his heirs in the nineteenth century to find in the developing science of neurobiology evidence of his notion of inherent mental properties.

Kant's stress on the inborn as opposed to the acquired has an effect on his aesthetics as well as his epistemology. Kant's aesthet- ics is founded on a separation of handicraft from fine art. Art is an ability, not a science. Nor is it based on knowledge, 'For there is no science of the beautiful. . . . For a science of the beautiful would have to determine scientifically, i.e. by means of proofs, whether a thing was to be considered beautiful or not.'[1] He goes further to say, 'Fine art . . . is a mode of representation which is intrinsically final, and which, though devoid of an end, has the effect of advancing the

mental powers in the interests of social communication.'[2] This defi-
nition of the best art as devoid of an 'end', which was to haunt both
the producers and the viewers of art for the next two hundred years,
proposes not only that art has no intended utilitarian function, but
that the viewer has no 'interest' in it, besides the aesthetic. For Kant
fine art in its highest form can only be produced by a genius and
geniuses are born not made. Although training and a knowledge of
rules are necessary for the genius to make his art, the roots of genius
lie in nature. It is nature, indeed, working through such a genius, that
provides the exemplars for successive phases of art: 'Nature in the
individual (and by virtue of the harmony of his faculties) must give
the rule to art' – in other words, fine art is only possible as a product
of genius.[3] Just how mysterious is this quality of genius is apparent
from the passage where he distinguishes the genius from someone
whom we call 'a man of great brains' because of what he has con-
tributed to art and science. The principal attribute of a genius is
above all originality and the ability to produce 'aesthetic ideas'. Such
an ability is constituted by the presence of such faculties as 'soul'
and 'imagination':

> 'Soul' [*Geist*] in an aesthetic sense, signifies the animating princi-
> ple in the mind. But that whereby this principle animates the
> psychic substance [*Seele*] – the material which it employs for that
> purpose – is that which sets the mental powers into a swing
> that is final, i.e. into a play which is self-maintaining and which
> strengthens those powers for such activity. Now my proposition is
> that this principle is nothing else than the faculty of presenting
> aesthetic ideas. But, by an aesthetic idea I mean that representa-
> tion of the imagination which induces much thought, yet without
> the possibility of any definite thought whatever . . . being ade-
> quate to it, and which language, consequently, can never get quite
> on level terms with or render completely intelligible.[4]

Although the use of terms such as 'genius', 'soul' and 'imagination'
looks back to earlier writers, Kant is here involved in giving them new
applications.

Above all he wants to suggest how the integration of genius, soul
and imagination can lead to the production of works that produce
'much thought' yet not a thought that can be represented in lan-
guage. The most important aspect of his argument for a view of the
human mind is that he imagines that, when it is operating at the
highest level, each of the arts sets its own terms, and is not trans-
latable into any other. In terms of the visual arts, this means that each
medium has its own terms through which it is able to generate pow-

erful mental activity. Kant then realises that this encouragement of genius, originality and the free play of the imagination can lead to excess and in order to prevent this happening he invokes taste, which he had earlier played down as a lower level faculty.

The merit of Kant's arguments in terms of neuropsychology is that he imagines a response to art not just in terms of a taste that has been formed by education, but in terms of a mental reaction that depends rather on a combination of internal resources. These are in some ways as powerful as the resources that brought the artwork into being in the first place. Both sets of resources are inborn and, as we can now say with increasing clarity, are neurally constituted. Kant plays down the established notions that the artist requires aesthetic instruction and that the viewer's sensibilities to aesthetic pleasure have to be acquired, and instead gives pre-eminence to higher qualities, aesthetic ideas which he sees as both generated by the artist and recognised by the viewer using faculties that are innate. Hogarth, Burke and Winckelmann had all implicitly acknowledged the importance of some of the brain's inherent properties when they asserted that particular preferences and reactions were inborn. Kant goes much further. As he argues at length, the brain's inherent properties include those that are at once most fundamental and most complex.

12

Marx

Burke's interest in universal human traits grew out of his feeling that the rise of notions such as taste and reason had concealed the extent to which the most important aesthetic responses were universal and inborn. Kant's interest in aesthetic ideas represents a more philosophical reflection on the possible bases of such responses. Karl Marx (1818–1883) had a similar interest in the inborn, but for different reasons. The son of a lawyer in Trier, he studied in Bonn and Berlin, before beginning a career in journalism and becoming increasingly involved in the socialist politics that would absorb him for the rest of his life. The principal instruments of his political activity were the books and unpublished manuscripts that he produced, especially during his periods of exile, first in Paris and Brussels, and then, from 1849, in London. A continual theme of his writing was his critique of the way the history of social formations had led to a situation where man's humanity was denied. His pursuit of this theme led him to make a number of fresh reflections on the universally human.

His conclusions were far from simple. Man is like all animals in being 'identical with his life-activity. . . . An animal forms things in accordance with the measure and the need of the species to which it belongs, while man knows how to produce in accordance with the measure of every species and knows how to apply everywhere the inherent measure to the object. Man, therefore, also forms things in accordance with the laws of beauty.'[1] Although he is unclear about the nature of the process by which it happened, he is able to assert that: 'The forming of the five senses is a labor of the entire history of the world down to the present.'[2] The extent to which man's enjoyment of his senses is affected by the social order is illustrated by the remark that: 'the dealer in minerals sees only the mercantile value but not the beauty and the unique nature of the mineral: he has no mineralogical sense. Thus, the objectification of the human essence in both its theoretical and practical aspects is required to

make man's sense human, as well as to create the human sense cor-
responding to the entire wealth of human and natural substance.'[3]
In his reference to a 'mineralogical sense' Marx seems to hint at the
existence of a set of inborn sensual faculties and this idea surfaces
again fifteen years later in a discussion of the way precious metals,
because of their softness, stand outside a system of use value:

> Furthermore, gold and silver are not only negatively superfluous,
> i.e. dispensable articles, but their aesthetic properties make them
> the natural material of luxury, ornamentation, splendor and wealth.
> They appear, in a way, as spontaneous light brought out from the
> underground world, since silver reflects all the rays of light in their
> original combination, and gold only the color of highest intensity,
> viz. red light. The sensation of color is, generally speaking, the
> most popular form of the aesthetic sense.[4]

Marx here implies that gold and silver appeal to a faculty shared by
everyone. He comes close to giving it a natural basis by saying that
silver is valued because it reflects white light, and so the whole spec-
trum, while gold is revered because it only reflects red, the visible
hue with the longest wavelength. In declaring that the sense of
colour is the most common aesthetic response Marx makes an
observation that is in line with recent evolutionary theory and neu-
roscience. This, as noted in the previous chapter sees colour vision
as a genetically defined capacity selected for because it enabled our
primate ancestors to occupy a more privileged ecological niche by
abandoning a leaf diet and becoming fruit and nut eaters.

Marx did not know that the origin of this response was a dietary
shift by our simian ancestors and he can have had no sense of the
role of adaptiveness in Darwinian evolution, whose founding text,
The Origin of Species, was published in the same year, 1859.
However by 1876 Friedrich Engels in his essay 'The Part Played by
Labour in the Transition from Ape to Man' brilliantly summarises the
evolutionary history of labour's prime instrument, the hand:

> At first . . . the operations for which our ancestors gradually
> learned to adapt their hands during the many thousands of years
> of transition from ape to man could have been only very simple
> . . . but the decisive step was taken: the hand had become free
> and could henceforth attain ever greater dexterity. . . . Thus the
> hand is not only the organ of labour, it is also the product of labour.
> Only by labour, by adaptation to ever new operations, by inheri-
> tance of the acquired special development of muscles etc. and by
> the ever renewed employment of his inherited finesse in new,

more and more complicated operations, has the human hand attained the high degree of perfection that has enabled it to conjure into being the paintings of a Raphael, the statues of a Thorwaldsen, the music of a Paganini.[5]

This positive side of evolution is, however, balanced by its negative consequences: 'First labour, after it and then with it, speech – these were the two most essential stimuli under the influence of which the brain of the ape gradually changed into that of man, which, for all its similarity is far larger and more perfect.'[6] This brain allowed the development of the mind. Soon some people were making others work for them and,

> All merit for the advance of civilization was ascribed to the mind, to the development and activity of the brain. Men became accustomed to explaining their actions from their thoughts instead of from their needs – which in any case are reflected, come to consciousness, in the mind – and so there arose in the course of time that idealistic outlook on the world which, especially since the end of the ancient world, has dominated men's minds.[7]

Hence the curse of ideologies.

Marx had realised the power of ideology as a young man and, in *The German Ideology* (1845), he had composed a savage critique of the way in which human beings generate their own 'mental production . . . as the direct efflux of their material behaviour', using a biological analogy: 'If in all ideology men and their circumstances appear upside down as in a camera obscura, this phenomenon arises just as much from their historical life-process as the inversion of objects on the retina does from their physical life-process.'[8] Again and again Marx and Engels distinguish thought, as embodied in language, from reality.[9] Indeed their whole argument is that it is only possible to develop a truly human society by criticising the conceptual systems expressed in language by priests, lawyers, philosophers and attending instead to the way things really are: 'one has to devote oneself like an ordinary man to the study of actuality. . . . Philosophy and the study of the actual world have the same relation to one another as masturbation and sexual love.'[10] As this image suggests, Marx and Engels argue that man's nature has to be understood before we can comprehend the rise of the twin evils of the division of labour and ideology, and it has to be understood above all by observation.

Discussing the origin of society they say that 'this beginning is as animal as social life itself at this stage. It is mere herd consciousness,

and at this point man is only distinguished from sheep by the fact that with him consciousness takes the place of instinct or that his instinct is a conscious one.' With the consequent increase of population comes increased productivity:

> With these [factors] there develops the division of labour, which was originally nothing but the division of labour in the sexual act, then that division of labour which develops spontaneously or 'naturally' by virtue of natural predisposition (e.g. physical strength), needs, accidents, etc etc. Division of labour only becomes truly such from the moment when a division of material and mental labour appears. (The first form of ideologists, priests, is concurrent).[11]

For Marx and Engels it is impossible to understand the ills of history without first understanding nature.

This nature is not the spurious nature of the ideologists. Many phenomena which we think of as natural are not, and this is not just in society, but in the natural world as well. In the case of Germans and their ideology the clearest example is the cherry tree, whose fruit was central to their cuisine: 'The cherry-tree, like almost all fruit-trees, was, as is well known, only a few centuries ago transplanted by commerce into our zone, and therefore only by this action of a definite society in a definite age.'[12] When contemplating nature we have to consider the way in which it has been changed by man. When considering ideology we have to always be aware of things 'as they really are and happened'.[13] There is thus no necessary opposition between man and nature. Man has always 'had before him a historical nature and a natural history'.[14] Marx and Engels understood that the idea of nature and the natural world should be viewed critically, since both the concept of nature as deployed by ideologists and the reality of the natural environment as shaped by farmers are always the product of social interventions at different places at different times. They were, however, just as clear that there was such a thing as a nature that was not produced by society and that any theory of society had to be based on an awareness of this particular nature of man.

What this means for the history of art is hinted at in Marx's *Introduction to a Critique of Political Economy* written in 1857. After noting that 'the starting point' of any understanding of production 'is of course the naturally determined factors; both subjective and objective. Tribes, races etc.', he goes on to attempt an explanation of the high status of Greek art long after the primitive social conditions that produced it had become out of date.[15] Greek art, he argues, is based in Greek mythology and that mythology was an

attempt to subdue the forces of nature in the imagination at a time when man's relation to nature, explicitly defined as 'all physical phenomena, including society', was problematic.[16] Once man had taken control of nature, as he had in Marx's time through railways, the electric telegraph, printing machines and so forth, mythology disappears. The appeal of Greek art lies in it being a product of the childhood of humanity: 'Why should not the historical childhood of humanity, where it attained its most beautiful form, exert an eternal charm because it is a stage that will never recur?'[17] Although Marx does not go into the reasons why this should be so, he clearly feels that aesthetic preferences should sometimes be explained by reference not to ideologies and notions of social development but to psychological affinities based on the idea that the life of society is like the life of an individual. We like Greek art because we like the naivety of the child.

13

Ruskin

Writers like Burke, Kant and Marx all emphasised in different ways the innate, distancing themselves from the blank paper view of the mind favoured by Locke. John Ruskin (1819–1900), the son of a wine merchant, who shared with Marx an interest in socialism, but whose passion for art set him apart from all his contemporaries, returned to Locke with a new enthusiasm. Reacting against the views of his predecessors, it was a quotation from Locke's *Essay* that he used to support one of his most important ideas, the notion that many people fail to look at things properly:

> The first great mistake people make in the matter, is the supposition that they must see a thing if it is before their eyes. They forget the great truth told to them by Locke, book ii, chap. 9, §3 – 'This is certain, that whatever alterations are made in the body, if they do not reach the mind, whatever impressions are made on the outward parts, if they are not taken note of within, there is no perception. Fire may burn our bodies, with no other effect than it does a billet, unless the motion be continued to the brain. . . . How often may a man observe in himself, that while his mind is intently employed in the contemplation of some subjects and cautiously surveying some ideas that are there, it takes no notice of impressions of sounding bodies, made upon the organ of hearing, with the same attention that uses to be for the producing the ideas of sound.'[1]

As Ruskin goes on to say, what is true of the ear is much more true of the eye. The eye is always active as a 'bodily organ', but we rarely give attention to what it sees: 'And thus, unless the minds of men are particularly directed to the impressions of sight, objects pass perpetually before the eyes without conveying any attention to the brain at all; and so pass actually unseen, not merely unnoticed, but in the full, clear sense of the word, unseen.'[2] Some people do not see things properly because they have other concerns, others because

their sensations are naturally blunt, and in the latter case if they are distracted as well, 'their faculties of perception, weak originally, die of disuse'.[3] The point he makes here about the importance not just of looking, but of looking with attention, had first been made by al-Haytham, and has recently been confirmed by neuroscience. It is literally true that looking with attention stimulates the growth of connections between the neurons involved in a particular perceptual act, while looking without attention may allow connections that have been formed by earlier exposure to die back.

Ruskin gives a telling example of the difference between his two ways of looking when he criticises the way northern Europeans typically represent the skies of the south. Inspired by what has been 'said and sung of the Italian skies' they wrongly believe that 'they are more blue than the skies of the north'. Such is the strength of this belief that people even 'think that they see them so; whereas the sky of Italy is far more dull and gray in colour than the skies of the north and is distinguished only by its intense repose of light.'[4] People are so convinced of their knowledge that, even if they go to Italy and experience its sky as it really is, they will still think of it as being blue and will praise a painting that shows it that way and criticise one that shows it the way it really is: 'And this influence of the imagination over the senses, is peculiarly observable in the perpetual disposition of mankind to suppose that they see what they know, and vice versa in their not seeing what they don't know.'[5] The act of seeing cannot be taken for granted.

Several examples are given immediately. A child will draw the corners of houses in the shape of a 'T' and will not give them the oblique angle they have to the eye unless he looks at the corner repeatedly and with attention: 'And the Chinese, children in all things, suppose a good perspective drawing to be as false as we feel their plate patterns to be, or wonder at the strange buildings which come to a point at the end.'[6] The suggestion that other nations see like children is further demonstrated by reference to the supposed inability of American Indians to see shading: 'The eye of a Red Indian, keen enough to find the trace of his enemy or his prey, even in the unnatural turn of a trodden leaf, is yet so blunt to the impressions of shade, that Mr Catlin mentions his once having been in great danger from having painted a portrait with the face in half-light, which the untutored observers imagined and affirmed to be the painting of half a face.'[7] The argument here is based on several incorrect assumptions that would not be shared by many today, such as that all art should be attempting to record optical experience and that similarities between the art of European children and Chinese

adults share a common origin, but he does, unwittingly, draw atten-
tion to a phenomenon of fundamental importance for an under-
standing of art, that people in disparate communities not only make
art in different ways, but actually 'see' differently. What he would
have found hard to accept are the demonstrations reported later in
this book that Australian aborigines and African 'Bushmen' are much
better at providing a 'true' description of the Müller-Lyer figure.
Ruskin may have been convinced that it was the Europeans' ability
to observe and represent oblique lines, but, as we now know, it is
precisely the oblique angles at the end of the one line that prevent
even the most alert European from seeing it correctly. If our neural
networks have been fundamentally configured by some general
feature of our experience no amount of intense looking at individ-
ual objects will correct the errors this leads to.

 These examples, therefore, do not really directly support his point
about the importance of looking with attention, however, later pages
on Ruskin's hero, Turner, prove to do so, and in interesting ways. One
of his most remarkable claims is that 'all great painters, of whatever
school, have been great only in their rendering of what they had seen
and felt from early childhood; . . . The Madonna of Raffaelle was born
on the Urbino mountains, Ghirlandajo's is a Florentine, Bellini's a
Venetian', a specific point which he immediately generalises into the
fearless assertion

> that it is impossible that it should ever be otherwise, and that no
> man ever painted or will paint well anything but what he has early
> and long seen, early and long felt, and early and long loved . . .
> Whatever is to be truly great and affecting must have on it the
> strong stamp of the native land . . . if we are now to do anything
> great, good, awful, religious, it must be got out of our own little
> island, and out of these our times, railroads and all; if a British
> painter . . . cannot make historical characters out of the British
> House of Peers, he cannot paint history; if he cannot make a
> Madonna out of a British girl of the nineteenth century, he cannot
> paint one at all.[8]

This might all seem like a jingoistic rant, but it is founded on the
rational conviction that you will not see something truly unless you
have looked at it often with love and attention, because, following
Locke and anticipating recent neuroscience, Ruskin asserts that
such intense looking is necessary to really have an impact on the
brain.

 Ruskin then goes on to observe that, while this is certainly true of
figure painting, it is less true of landscape. This is because landscape

is, in its fundamentals, less variable whether through space or time, 'so that feelings educated in Cumberland, may find their food in Switzerland, and impressions first received among the rocks of Cornwall, be recalled upon the precipices of Genoa.'[9] His idea is that a landscape sufficiently similar to one that a person has got to know deeply can be experienced in the same way. In terms of modern neuroscience, we would say that neural networks formed by exposure to a particular type of landscape, for example high mountains or a rocky coast, will also help in the viewing of another, providing it is sufficiently similar.

Ruskin then turns to Turner and asks himself what scenery had most deeply affected him, indeed affected him so deeply that its influence can be traced throughout all his works. He comes to the conclusion that it is that of Yorkshire: 'Of all his drawings, I think, those of the Yorkshire series have the most heart in them, the most affectionate, simple, unwearied finishing of the truth.' His affinity with Yorkshire can be traced not only in the drawings themselves,

> but in the peculiar feeling of the painter for rounded forms of hills; not but that he is right in this on general principles, for I doubt not that, with his peculiar feeling for beauty of line, his hills would have been rounded still, even if he had studied first among the peaks of Cadore; but rounded to the same extent and with the same delight in their roundness, they would not have been. It is, I believe, to those broad wooded steeps and swells of the Yorkshire downs that we in part owe the singular massiveness that prevails in Turner's mountain drawing, and gives it one of its chief elements of grandeur.[10]

This profound influence is effective when treating other mountains, but when it comes to representing a place like Florence it leads to failure. This is a result of the effort needed 'to force the freedom and breadth of line which he learned to love on English downs and Highland moors, out of a country dotted by campaniles and square convents, bristled with cypresses, partitioned by walls and gone up and down by steps.'[11] Neural networks adapted to the perception of rounded landscape forms are ill-equipped to deal with an environment characterised by angular landscape features and cuboid buildings. Ruskin's awareness of how intense visual experiences can affect our brain enables him to go far beyond Hogarth's general notion of a line of beauty, which has universal validity because it is omnipresent. Turner's natural inborn preference for a particular type of curved line has been intensified by experiences that were purely local. When the sensibility thus formed is exposed to similar sur-

roundings elsewhere, the effect works well, but, when the new environment constitutes an abrupt contrast, the product, even of the master, is enfeebled.

These principles help to explain why Turner is very good at painting France, which is close in character to England, but less good at Switzerland and Italy, which are not. In France he can capitalise on his English history of intense looking at leafy trees. As soon as he has to represent pines they may be so bad as to be pitiful. The same is true of the Alpine rose, the chestnut, the olive tree and the vine. These tendencies, however, are not a sign that he was a bad artist, rather the reverse: 'I adduce these evidences of Turner's nationality . . . not as proofs of weakness, but of power; not so much of want of perception in foreign lands, as strong hold on his own will; for I am sure that no artist who has not this hold upon his own will ever get good out of any other.'[12] These failings are only a proof that he had been robustly formed by his homeland.

There are further examples, and when Ruskin notes that the rocks of Turner's *Jason* could have come from a quarry in Warwickshire, that in the *Fifth Plague* the pyramids of Egypt look like brick kilns and the fire on the ground looks like burning manure, that the landscape of the *Rape of Proserpine* looks more like the setting for the actions of men with spiky hats and carabines and that the trees of Palestrina look more like an avenue at Hampton Court, he is only pushing the point home.[13] The more the artist has looked with love at England, the more English elements will keep cropping up in his portrayals of other climes. Venice is the only foreign setting in which he consistently thrives, and, as Ruskin suggests towards the end of *Modern Painters* in his comparison of Venice and London at the start of 'The Two Boyhoods' (those of Giorgione and Turner), this is because the two great maritime cities, for all their differences, had much in common.

In 'The Two Boyhoods' Ruskin goes on to credit the strength of many of Turner's masterpieces to his upbringing just off Covent Garden, with its market and its location only yards from the Thames. Throughout his life the artist

> attaches himself with the faithfullest child-love to everything that bears an image of the place he was born in. No matter how ugly it is – has it anything about it like Maiden Lane, or like Thames' shore? If so it shall be painted for their sake. Hence to the very close of life, Turner could endure ugliness which no one else, of the same sensibility, would have borne for an instant. Dead brick walls, blank square windows, old clothes, market-womanly types

of humanity – anything fishy and muddy, like Billingsgate or Hungerford Market, had great attraction for him; black barges, patched sails, and every possible condition of fog.[14]

One particularly common sight for the boy brought up by the market was litter and Turner's paintings are often full of it. Ruskin even notes that the last words the artist ever spoke to him about one of his works were an exclamation about St Gothard noting 'that litter of stones which I endeavoured to represent'.[15] Subject after subject comes out of those early memories, the oranges of *The Golden Apples of the Hesperides* and *The Meuse: Orange Merchantmen Going to Pieces on the Bar* are those he had seen in the market, and ships like those in *The Death of Nelson* and *The Fighting Temeraire* are based on those he had seen below London Bridge. Turner's intense looking at London was as important a source for the strength of his later representation of people, objects and water as his intense experience of the Yorkshire landscape was for his depiction of landscape. In both cases the power of his work came from the intensity of his early experiences.

Ruskin's sensitivity to the impact of environment on the mind is unique and is likely to be connected to exceptional features of his own youth, as described in *Praeterita*. His father, a leading wine merchant, took his young son with him every summer when he spent two months driving round England in a specially adapted cart, delivering stock to his clients. On those journeys, which constituted an initiation into his business, Ruskin's father will surely have talked of wine, drawing attention to the critical role of such environmental factors as climate and soil in determining the characters of the different vintages. He is also likely to have talked of paintings, of which he was an avid collector, helping to increase the young Ruskin's consciousness of differences in art and landscape as well as in wine. Such travels were exceptional for a child in the early nineteenth century as was Ruskin's tour of Paris, Waterloo and Brussels at the age of six, which was the first of many made possible by a speedy new transport system which linked steamboat lines and train routes. By the time he was a young man Ruskin will have seen more landscapes and more art than most of his contemporaries. As an artist he will also have repeatedly tested his skills of observation in front of different scenes. As a result his neural networks will have increasingly predisposed him to reflect on the relation between art and the environment. The product of those reflections are the theories on the relation between visual experience and painting which constantly resurface in his writings. It is intriguing that Ruskin's highly original

ideas on artistic difference, like Montesquieu's equally original ideas on cultural difference, ultimately owe their origin to an understanding of variances in wine.

Another parallel with Ruskin is provided by his slightly older contemporary, Charles Darwin. Darwin built a new systematic theory of nature out of the extraordinary sequence of experiences of different animals in different environments to which he was exposed on the exceptional voyage of *The Beagle*. Ruskin built his similarly systematic theory of art out of a chain of environmental experiences which was also, in its more modest way, exceptional. Just as Darwin's biological theories have been confirmed and corrected by much later discoveries in the fields of genes and genetics, so those of Ruskin can now be confirmed and corrected in the light of recent revelations about neurons and neuroscience.

14

Pater

Walter Pater (1839–1894), Ruskin's younger contemporary, shared many of his interests, but his more elite inclinations and professional affinities as an Oxford academic caused him to be less interested in principle and more concerned with the personal. His sense of the personal was affected by his life story. Born the son of a doctor in London's Docklands, after his father's death he moved to the country, before going to school in Canterbury, where he was affected by the beauty both of the cathedral and of the surrounding countryside. The sensory alertness he developed there was later to lead to him becoming a prominent member of the aesthetic movement. It also intensified all his experiences. In the preface to his influential collection of essays chiefly on art, first published as *Studies in the History of the Renaissance* (1873), he asserts that in order to see something as it really is 'one has to know one's own impression as it really is. . . . How is my nature modified by its presence and under its influence? . . . one must realise such primary data for oneself or not at all.'[1] For him the way to get to know something was to get to know one's own individual response to it, and that meant acknowledging the specificity of the response of different senses.

This has implications for his relation to all the arts. As he says at the beginning of the section 'The School of Giorgione', which was added to the third edition, he is against the idea that all the arts, poetry, music and painting, are 'but translations into different languages of one and the same fixed quantity of imaginative thought', insisting instead that a realisation that 'the sensuous material of each art brings with it a special phase or quality of beauty, untranslatable into the forms of any other, an order of impressions distinct in kind – is the beginning of all true aesthetic criticism.'[2] This means not just separating painting from poetry, and painting from sculpture and architecture, but within painting separating drawing from colouring. Although he never explains the basis of his claim, it is clear that it is the product of intense self-awareness and probably reflects a sense

of the way in which different categories of material resonate with each other inside us. The abstract notion of this resonance is confirmed by his general claim that the arts can relate to each other, but less like language and poetry and more as pure sound, like music: 'All art constantly aspires to the condition of music. For while in all other kinds of art it is possible to distinguish the matter from the form, in music they can become perfectly identified.'[3] His argument that we have different responses to different categories of phenomena, and that if there is a model for the overall response it is that evoked by music, invites the reader to concentrate on the response to purely abstract form. This has the advantage of allowing Pater to play down those features that earlier writers had emphasised. Morality of content is replaced by abstraction of form, an intellectual response substituted by one that is sensual.

The fundamental character of this shift was already apparent in another essay in the volume, that on Winckelmann, originally published in 1866. In its last paragraph Pater asks how modern art can relate to the needs generated by modern life and comes up with an answer that reinserts humanity into the whole system of nature:

> The chief factor in the thoughts of the modern mind concerning itself is the intricacy, the universality of natural law, even in the moral order. For us, necessity is not, as of old, a sort of mythological personage without us, with whom we can do warfare. It is rather a magic web woven through and through us, like that magnetic system of which modern science speaks, penetrating us with a network, subtler than our subtlest nerves, yet bearing in it the central forces of the world.[4]

Just as we have to learn to understand how natural law transcends morality, so we have to experience necessity, not as something to combat outside ourselves, but as something like a network running throughout our being and integrating us with the whole world. Pater is vague about whether he is thinking more in terms of the magnetic theories current at the time or of the networks of nerves that were then becoming ever more visible, but whichever image is uppermost in his mind the reader is left with the sense that our relation to the world is best understood as physical and sensual.

In the conclusion to 'Poems of William Morris' (1868), which was to become the conclusion to the first edition of *Studies in the History of the Renaissance*, he went even further. In pursuit of an understanding of modern thought he invites the reader to imagine just looking at nature:

What is the whole physical life in that moment but a combination of natural elements to which science gives their names? But those elements, phosphorus and lime and delicate fibres, are present not in the human body alone: we detect them in places most remote from it. Our physical life is a perpetual motion of them – the passage of the blood, the waste and repairing of the lenses of the eyes, the modification of the tissues of the brain under every ray of light and sound – processes which science reduces to simpler and more elementary forces.[5]

Pater here views the human being as a mass of chemicals, the life of whose different parts is governed by scientific laws. This view prepares for his most strikingly materialist image when he claims that 'success in life' is 'to burn always with' a 'hard gem-like flame'.[6] Man is at his best when he burns with an intense flame such as that produced by the famous Bunsen burner discovered in 1855. Man is not only made of chemicals, he can burn like a gas.

Much more important, in terms of its implications for his approach to art, is his notion that the tissues of the brain are modified by every ray of light. Pater is only extrapolating from the growing awareness that the brain was somehow physiologically affected by sensory experiences, but the conclusion he comes to is startlingly close to modern understanding of the brain's plasticity. One can feel how this approach to the brain contributes to an understanding of the history of art in his account of Raphael, published in 1892. Raphael's success was not due, as is often suggested, to 'luck' and 'genius' but to his possessing 'the attitude of the scholar'. It was this attitude that led him to study carefully in each of the environments in which he spent time, Urbino, Perugia, Siena, Florence and Rome, incrementally acquiring powers until he emerged at the end as a 'genius by accumulation'. Reaching for a way of presenting the artist's achievement in his short life of thirty-seven years he describes him as something like a super computer: One way of getting some clearness in our picture of him

is to distinguish the various divergent outlooks or applications, and group the results of that immense intelligence, that still untroubled, flawlessly operating, completely informed understanding, that pure cerebral power, acting through his executive, inventive or creative gifts, through the eye and the hand . . . In that way, you may follow him along many various roads till brain and eye and hand suddenly fail in the very midst of his work – along many various roads, but you can follow him along each of them distinctly.[7]

Pater visualises Raphael as operating in a number of modes, almost resembling computer programs, each carefully developed in such a way as to allow him to reach maximum effectiveness in a different work of art.

The process involved is described in specific detail in his autobiographical essay 'The Child in the House' (1878). The story consists in 'the noting . . . of some things in the story of his spirit – in that process of brain-building by which we are, each one of us, what we are.'[8] For example, he remembers seeing flowers fall from the lime tree, observing 'How insignificant, at the moment seem the influences of the sensible things which are tossed and fall or lie about us, so, or so, in the environment of early childhhod. How indelibly, as we afterwards discover, they affect us.'[9] As the story of his childhood proceeds he goes on to use a system of imagery that compares the brain's fibres to those found elsewhere in nature. Recalling how 'in the process of our brain-building, as the house of thought in which we live gets itself together, like some airy birds-nest of floating thistledown and chance straws, compact at last, little accidents have their consequences', he remembers how one summer's evening he filled his arms with the crimson flowers of a red hawthorn and how this affected him deeply. That night he dreamed of a magic roadway of crimson flowers, and always afterwards was reminded of that experience, not only by such flowers, but by 'the goodly crimson, still alive in the works of the old Venetian masters or old Flemish tapestries'.[10] Since it was the abstract colour of the flowers, as much as anything, that had lodged in him through the process of 'brain-building', anything that shared that colour brought the original experience back to life. Such brain-building in childhood can have a vital role in shaping the artistic preferences of our maturity. What Pater is telling us is that our neurological history is made up not only of the accumulated intellectual concentration of a Raphael, but of the chance sequence of our sensuous and emotional encounters.

Pater, the doctor's son, who had been brought up surrounded by pets and greenery in the Kent countryside, had already learned from Ruskin to look intently at nature and art before he discovered in Winkelmann a passion, like his own, for the male body. In Oxford he would also have learned of the latest science, of chemistry and physics and especially of the biology of the nervous system, science that helped him to understand the intensity of his sensual experiences and the power of memory in the formation of the individual. It was this conjunction that provided him with the terms he used, whether to explain the past success of an artist like Raphael or to prepare his younger contemporaries for their own future achievements.

15

Taine

A figure of comparable personal originality to Ruskin, but more informed and in tune with his age, and almost equal to Marx or Darwin in his influence at the time, was the Frenchman Hippolyte Taine (1828–1893). The son of a lawyer in the Ardennes, his education took him to Paris, where he eventually became a student at the École Normale. Exceptionally energetic, his ambitions for an academic career were frustrated by his political views and independence of mind, but his freedom allowed him to travel to England and Italy and to write on many topics before he eventually, in 1864, succeeded Viollet-le-Duc as professor of aesthetics and history of art at the École des Beaux-Arts.

Taine digested a vast amount of the scientific knowledge of his time and tried to apply a scientific method to the study of all areas of human behaviour. As he said in the preface to the second edition of his *Essais de critique et d'histoire* (1866), his desire was to create 'an analogy between natural history and human history'.[1] An important step in this enterprise was the writing of *De l'intelligence* (1870). As he states in the preface, he has attempted to establish the physical process that leads from sensations to thought to knowledge:

> We have attempted to construct or sketch out the whole theory of elementary sensations, to advance beyond the ordinary bounds, up to the limits of the mental world, to indicate the functions of the principal parts of the brain, to conceive the connection of molecular nervous changes with thought. Other abnormal cases, borrowed both from students of insanity, and from physiologists, have enabled us to explain the general process of illusion and rectification, whose successive stages constitute our various kinds of knowledge.[2]

Taine's materialist approach leads him to see words such as 'reason', 'intelligence' and 'will', key terms in contemporary debate, as just literary metaphors:

All that observation detects physiologically in the living being are cells of different kinds, capable of spontaneous development, and modified in the direction of this development by the concurrence or antagonism of their neighbours . . . Just as the living body is a polypus of mutually dependent cells, so the active mind is a polypus of dependent sensations and images, and in the one case, as in the other, unity is nothing more than a harmony and an effect.[3]

Taine's view of the brain as a complex 'polypus' made up of cells arranged in differentiated areas was based on the latest work on the physiology of the nervous system and in particular on the observations on the loss of mental capacities produced by head wounds in man and vivisection in animals. These allowed him privileged insights into the brain's miraculous complexity and integration.

Much of what he says corresponds with the science of today, as for example his recognition that the grey matter of the outer cortex is crucial to intelligence, but, while he was of the opinion that any area of the cortex could take over the work of another, we now know that the cortex too is liable to a high degree of specialisation. In other cases his description, although basically correct, is too crude to capture the complexity of the brain's operations. Typical is his use of the term 'image' as the principal vehicle for the brain's operations. Describing a bird's nesting instinct he describes how, 'at the sight of straw, hair and wool, the notions of their combination and usage arise in him without preliminary experience' by 'the play of an hereditary mechanism; it is an order of representations – that is to say, of grouped images; and therefore if the images are destroyed, it – that is the instinct – is destroyed.'[4] Today it is difficult to locate such instincts, but it is possible to understand with some precision the interrelation between the visual and motor systems on which they rely for their implementation.

The term 'image' is one fundamental to Taine's view of the mind and it occupies book two, following on from book one on 'signs'. By an image he means the trace left in the brain by some sensation. Once established it becomes a substitute for the sensation and gives us all sorts of remarkable abilities. It allows the chess player to play blindfolded, the painter to copy an absent model, the musician to hear a score when he looks at it, and it allows us to experience the same emotions as we would if the real chess board, model or symphony were experienced by our senses: 'It provokes the same instinctive movements and the same associated sensations.'[5] Images are thus acquired perceptions that become the basis of our knowl-

edge of the past, the present and the future. For Taine they are the psychological manifestation of physiological experience and there can be little doubt that the reason he gives them such prominence in his theory is because so much recent work on hallucination, dreaming and memory had demonstrated the richness and autonomy of inner visual experience. It was these discoveries which not only inspired him to give mental imagery such importance in *De l'intelligence*, but also gave him the interest in visual art that led to his appointment at the École des Beaux-Arts.

The close relation between his work on physiology and psychology and his study of art comes out clearly in the course of lectures that he delivered at the École between 1864 and 1869, and which were published first separately and then, from 1882, cumulatively, in the *Philosophie de l'art*. If the brain is regulated by rules, so are its products. As he says in the preface, art seems to be typically the product of chance, as capricious as the wind: 'Still, like the wind, it has its precise conditions and its fixed laws.'[6] What this means becomes clear immediately. All works by a single artist have much in common, so do works by other artists of the same place and period, and the reason for this is that their public shares the same formation as the artists. The way different communities develop in different places is comparable to the way the different trees that we find as we travel from south to north all grow in different environments. It is the same with art: 'The products of the human spirit, like those of live nature, can only be explained by their milieu.'[7] The traditional notion that plants grow in different environments had recently been brought within a scientific system of worldwide application, especially by Alexander von Humboldt's use of isotherms to explain the extraordinary localisation of particular plants in the highlands of South America. Taine is looking for an equivalent system in the field of culture.

There are many consequences of this scientific approach, but one is spelled out at the start. This new science does not say: 'Despise Dutch art, it is too coarse, and only taste the Italian.'[8] Instead it has 'sympathies for all forms of art and for all schools, even for those which are the most opposed', just as botany studies all plants with an equal interest. He continues, 'It is itself a sort of botany, applied not to plants, but to the work of men. As such it follows a general movement which today brings closer together the moral and natural sciences, and which, giving to the former, the principles, the caveats, the directions of the latter, gives them the same solidity and assures them the same progress.'[9] Taine's reference to botany reminds us that Montesquieu's original argument that culture was strongly influ-

enced by climate and terrain was probably inspired by his awareness of the importance of such features for a wine-grower. Based on his greater knowledge Taine could now give Montesquieu's hunch a scientific basis and attempt to create a new human botany. He could even hope that his history of art would not just have analogies with science but actually meet scientific criteria.

Following up on his desire to bring art history closer to natural history, Taine realised that he had to give a new prominence to the role of nature in shaping culture and that meant paying particular attention to the natural environment. To explain what this meant he argued that just as you find the essence of a lion in its carnivorous diet so you find the essence of the Low Countries in the fertile river deposits that enriched its soil, the geologist's alluvia (*alluvions*): 'From this one word are born an infinity of particularities that make up all the manner of being of the region, not only the external appearances of that which it is in itself, but the spirit and the moral and physical qualities of its inhabitants and their works.'[10] Taine goes on to describe the cloudy skies, the green landscape, the cattle, the brick houses set with glazed pottery outside, the brown barrels and yellowish glasses inside, and the cleanliness and phlegm of the people. All are a product of a moist and fertile soil and humid atmosphere. Together they make up its essential character, and it is to bring out this character of the whole and the objects of which it is made up that art exists. Artists of all kinds, poets, painters and musicians, can capture this 'character' because they take from objects an 'original sensation' (*sensation originale*). In other words, the 'thinking and nervous machine feels the repercussion of the shock. Involuntarily the individual expresses his inner sensation; his body makes a gesture, his attitude becomes that of a mimic, he needs to represent the object to the outside as he has conceived it.'[11] Taine evidently here thinks of the brain as he describes it in *De l'intelligence*, in terms of a sensitive mass of cells, ready to receive impressions that will transform it.

Later in his lectures on the painting of the Low Countries in part three he illustrates his point. Although the environments of the Low Countries and of Venice share a predominant element, water, which means that they have a generally similar effect on the eye and consequently on the art with which they are associated, the combined impact of the greater brightness of the sun in Venice and the different materials, such as marble, on which it shines, results in an effect which is significantly distinctive.

The extent to which such differences can shape a whole culture comes out most clearly in his discussion of Greek sculpture in part

four: 'In this case too it is the physical structure of the land that has left on the intelligence of the race the imprint that we find in its works and in its history . . . The eye grasps effortlessly the shapes of objects and takes from them a clear image.'[12] The fact that bare rocky mountains are everywhere only strengthens the effect, which is especially characteristic of Attica where the air is particularly clear: 'It is thus that nature, by the forms with which it populates his spirit, inclines immediately the Greek to firm and clear conceptions.'[13] The Greek mind is shaped directly by the Greek climate and landscape and so too are all its products, implicitly ranging from art to philosophy.

With his new knowledge of the brain's sensibility to impressions, Taine was able to take perceptions that had long been current, give them some scientific basis and, by using that basis, expand on them. Several sixteenth-century writers, from Paolo Pino to Giorgio Vasari, had claimed that while Florentine art was characterised by line, Venetian art was characterised by colour, and Taine can now suggest why this was so. Similarly, he was able to build on the ancient cliché that Attic oratory was more clear and pure than other schools, such as the Asiatic, and Winckelmann's notion that the distinctive features of Greek art were attributable to its climate, by pointing out how the general character of visual experience in Greece was most evident around Athens. The new element in his approach is the underlying idea that such experience has a decisive impact on the individual's mental formation, and that impact is governed by physiological principles.

Taine's theory of the Greek mind in part four of the *Philosophie* is presented in its first chapter, entitled, unlike the comparable chapters of earlier parts, 'Race', and, although he does not really explain what he means by the term, he is at pains to suggest why, in the Greek case, it is more appropriate to use such a word, with all the biological overtones that soon were to become so dangerous. As he says at the beginning, 'A people always receives its imprint from the land that it inhabits; but this imprint is that much stronger the more uncultured [*inculte*] and childlike [*enfant*] it is at the time when it settles down.' The Greeks did not have much culture when they settled in the Aegean and that was why they were so affected by it. When the French and the English settled in other continents than Europe they took with them everything from arms to ideas, in other words 'an ancient and complete civilization, and so they could maintain their acquired type and resist the influence [*l'ascendant*] of their new milieu'.[14] As the term 'acquired' makes clear there is nothing inborn in the French and English that will protect them from the influence of the new environment, the only thing that insulates them is

their culture. Although there is much in the *Philosophie* that conveys what we would now call racism, and in the case of the Greeks he uses the term 'race' directly – just as the use of such terms as 'phlegm' reveals the shadow of humoural theory and *ascendant* recalls astrology – his general framework causes him to give a much smaller role to internal, inborn and inherited characteristics than to external factors such as environment and culture. The principal reason for such an avoidance of the larger pitfalls of prejudice was his knowledge of the way in which the brain worked and, above all, his recognition of what we would now call its plasticity.

This recognition of the brain's susceptibility to external influence was not new. It has already surfaced several times in this book, but developments in neurology during the 1850s and 1860s, such as those that culminated in Camillo Golgi's staining techniques, which had revealed the ever more refined 'molecular' structure of the nervous system, allowed him to sense the brain's susceptibility to passive exposure to the environment in a way that anticipates modern views. It was Taine's knowledge of these developments that allowed him to differentiate the properties of the minds of the infant and the adult. We would not now be as ready to use an analogy relating to the infant mind to explain the degree to which the ancient Greeks were affected by their natural environment, but there are ways in which it is appropriate to apply it in this context. A community, such as that of the pre-classical Greeks, that does not already possess a socially transmitted world view and an elaborate toolkit of material resources is indeed more likely to be shaped in its attitudes by passive exposure to the natural environment. Taine's knowledge of the brain was rudimentary in comparison to that available today, but it did reveal to him the subtlety of its structures. Nor should the art historian forget that the same discoveries about the refinement of our neural networks that inspired Taine's perceptive views on our susceptibility to purely passive exposure to the environment were one element in the context for the recognition in the 1870s of a movement of 'Impressionism'.

16

Vischer

In 1872 Charles Darwin published his book on *The Expression of the Emotions in Man and Animals*, which made use of the French doctor Guillaume Duchenne's detailed anatomies of the face's musculature, and a year later in Germany there appeared another important work which also drew on recent medical knowledge and was in some ways more influential entitled *Das optische Formgefühl: Ein Beitrag zur Aesthetik* (On the Optical Sense of Form: A Contribution to Aesthetics), published in Leipzig in 1873. This book by Robert Vischer (1847–1933), which was his doctoral thesis for the University of Tübingen, was only the latest in a series of works by German thinkers that used new medical knowledge as a basis to think afresh about art.

Arthur Schopenhauer was one of the writers who went furthest in this direction in his *Die Welt als Wille und Vorstellung* (The World as Will and Representation) (first volume published in 1819, the second in 1844).[1] Drawing particularly on the *Recherches physiologiques sur la vie et la mort* (Physiological Researches upon Life and Death) of Xavier Bichat he developed the idea that image making had a neurological basis. 'What is imagination? A very complicated physiological occurrence in an animal's brain, whose result is the consciousness of a picture or image at that very spot.'[2] Great artists are people in whom the anatomy of the brain is so subtle that they can produce sharper and more refined images. In the following decades doctors became more and more interested both in psychology generally (Wilhelm Wundt) and in the neural basis of perception in particular (Helmholtz), but it was the aesthetician and art historian, Robert Vischer, who most successfully integrated biology and aesthetics by relating the ideas of his father, Friedrich Theodor Vischer, on empathy to the work on dreams by Karl Albert Scherner. The young Robert's ambitious new theory of aesthetics did not inaugurate a great career. His progression through the academic hierarchy was slow and his later writing undistinguished. But his invention of

the expressive term *Einfühlung* for the concept of empathy inspired
a whole generation and set the tone for many of the art historical
debates of the next fifty years.

 Vischer for the first time distinguishes a more passive looking from
a more active scanning, noting how the latter leads to the involve-
ment of the hand, as when a child reaches for the moon.[3] He is now
able to begin to explain the visual preferences, which people, since
Plato, had seen as based in abstract mathematics, in biological
terms, noting explicitly, for example, that we find symmetry about
a vertical axis much more appealing than symmetry about a hori-
zontal axis 'because of the analogy of the body'.[4] Of much more
far-reaching importance, however, is his use of Scherner's work on
dreams as the basis for a wide-ranging account of how we symbol-
ically and empathetically relate to our environment. As Scherner
had claimed, the images in dreams 'serve only to mirror subjective
moods, which they do as follows: the stimulated parts (nerves,
muscles) are imitated by analogies to their shape (usually on an
enlarged scale) with the help of an object only remotely similar . . .
using the representation of a house and its parts, in particular, to
allude to the body as a whole or its parts.'[5] This idea Vischer applies
to our waking life. As he says, 'Thus I project my own life into a life-
less form' with the result that when he sees a very small object such
as a star or flower he feels compressed and

> When on the contrary, I see a large or partially overproportioned
> form, I experience a feeling of mental grandeur and breadth, a
> freedom of will . . . More specifically, the compressed or upward
> striving, the bent or broken impression of an object fills us with a
> corresponding feeling of oppression, depression, or aspiration, a
> submissive or shattered state of mind.[6]

Such empathy means that we can feel a particular cliff as defiant, or
'in the branches of a tree we spread our arms longingly'.[7] Artists rely
on such a capacity:

> Like the subjective observer engaged in a responsive feeling, the
> artist always works from the outside in. This internalizing process
> may at the same time relate either to the viewer's imagination or
> objectively to a represented, apparent or real individual content
> (attentive feeling for the purpose of empathetic feeling). The
> artist, however, can reshape such content only internally (as with
> the composition derived from immediate feeling), that is, in
> advance of his representation of it. The way in which he represents
> it will always have a stylistic and subjective value of its own.[8]

Vischer does not go far in applying his approach to art history although he talks of the 'stormy character and rushing energy of Rubens' technique'[9] and the 'silent mysticism' and 'organic purity' of Raphael and Dürer,[10] but his ideas had an enormous effect through his successors Johannes Volkelt and Theodore Lipps on art historians such as Heinrich Wölfflin.

The most important achievement of Vischer and the other students of empathy was that they realised that seeing involves more than the eye and the brain, engaging the whole person. The study of dreams, in which the eye was not involved, but in which the imagined visual experience could be related to the dreamer's experience of his or her own body, alerted people to the possibility that the body might be involved in truly optical vision. And this new awareness was sustained by the growing understanding both of the parallelism of the motor and sensory networks and of their interrelation in the head. In places like China, with their different theory of corporeality, such an awareness had been around for a long time. In Europe it was new. It was also correct, as evolutionary theory might lead us to expect and modern neuroscience has shown. Humans learn rapidly and socialise easily because of an inborn inclination to follow in the brain the movements and emotions of those around them. In 'mirror neurons' neuroscientists have uncovered some of the basic physiological and psychological mechanisms involved in such empathy.

Göller

The work of Adolf Göller (1846–1902) was almost unknown in the late twentieth century, until his most remarkable work was translated into English and edited by Harry Mallgrave.[1] As a professor of architecture, Göller's concerns were much more focused on the formal issues of his discipline than were Robert Vischer's, but this concentration allowed him to produce one of the clearest and most systematic studies of the relation between the history of art and human nature. His ideas were applied most widely in his major publication, *Die Entstehung der architektonischen Stilformen: Eine Geschichte der Baukunst nach dem Werden and Wandern der Formgedanken* (The Origin of Architectural Styles: A History of Architecture According to the Origin and Development of Ideas of Form) (1888). They emerge most clearly, though, in the lecture 'Was ist die Ursache der immerwährenden Stilveränderung in der Architektur?' (What is the Cause of Perpetual Style Change in Architecture?). This was delivered originally at his institution, the Stuttgart Technische Hochschule, and published in a volume of his essays in 1887.

The lecture begins with a contrast between the wealth of the products of nature and the similar riches of the creations of the human hand. It then moves quickly onto a celebration of human vision: 'Within ourselves have emerged the tiny optical apparatus that reflects the mightiest phenomena within a minute compass and also the awesome faculty that carries optical images into our consciousness and enables us, with a sense of delight, to extract the beauty of form from outline and light and shadow.'[2] This prepares for a reflection on evolution as a feature both of the natural environment and the world of human creations, and the admission that, while people have long reflected on the laws governing nature, they have not thought enough about the laws governing changes in the human sense of beauty.

Reminding his audience of the sequence of European architectural styles that led to their present stylistic situation he remarks, 'We

know what is happening, but we cannot stop it. It is only too obvious that we are following a law, the same law that once pushed the High Renaissance itself into the Baroque, the early Gothic into the late Gothic – the same law that has carried every other style from ascent to flowering and from flowering to decay.' It is this law that will be Göller's topic: 'I shall endeavour to identify the psychological causes from which our sensibility to the beauty of the decorative forms of any architectural style changes with time and to show how the individual's attitude to individual form accounts for the inevitability of the perpetual style change in architecture.'[3] He will not discuss painting or sculpture because with those arts the form is indissoluble from content. He will instead concentrate on architecture, because only with architecture is it possible to distinguish 'pure form' as something which can please us without evoking thought. As he says,

> the pleasure of pure form is still an unsolved riddle of science . . . with pure form, feeling is presented without thought; here the course of meaningless lines, the relation of meaningless proportions, the play of meaningless light and shade, is sometimes a source of great pleasure, sometimes entirely indifferent to us. Vainly do we in either case ask the reason why. Vainly do we search our minds for the explanation of a feeling that has nothing to do with thought.[4]

It is this problem that he sets out to solve.

First, though, he has to dispose of a solution that has already been offered by others, one based in the mechanics of vision. Any explanation, he argues, has to take into account the nature of the visual process:

> We know that the observer's eye, in following the lines of the form, will turn back and forth, up and down, by means of its muscles; we know that the light rays fall on the retina of the eye and stimulate the ramification of the optic nerve; we know that this stimulus is conveyed by the optic nerve to the brain. What happens there is still unclear as a mechanical process: it is the conscious imagining [*Vorstellung*] of form. If the form is beautiful as pure form, pleasure appears in none of the first three processes but only in the last – in the conscious imagining.[5]

Given this process he considers the suggestion that pleasure in form is connected with some 'pleasurable feeling in the eye's motor system'. It may be true that we prefer looking at straight lines and regularly curving lines rather than broken straight lines and irregular

curves, but this cannot be due to the 'physical process of muscular movement', partly because the muscular movement would vary depending on the position of our head and partly because proportion, which is an important source of pleasure, is not associated with muscular movement at all. The pleasure, in other words, is rooted not in the physiology of the muscles, but in the mind, and so, implicitly in the physiology of the brain.[6]

It is this intellectual pleasure that is his concern. The principle concept he relies on for this is the idea of the 'memory image' (*Gedächtnisbild*), that is the image of something that we slowly build up in our memory after repeated viewings: 'The mental work that we do in forming the memory image of a beautiful form is the unconscious mental cause of the pleasure we take in that form.'[7] The process involved is like that through which we are 'imprinted' with beautiful forms during our education. In other words, 'The individual's sense of form is dependent on memory content, that is to say, on images of forms seen earlier and retained in the memory.'[8] The process is not simple. For example, with a large object which has many views it takes a lot longer to build up the necessary series of memory images. What is important, however, is that when, in the end, the image is complete, the pleasure immediately diminishes, producing a third law: 'Our pleasure in the beauty of a meaningless form diminishes when its image becomes too clear and complete in our memory. It is this far-reaching psychological law of "jading" [*Ermüdung*] of the sense of form, which imposes perpetual style change on architecture.'[9] The remorselessness of this law is illustrated by the way in which it applies to all forms even the most beautiful:

> Architectural history shows that everywhere, even with the noblest forms, jading is inevitable. Those Doric columns of the golden age of Greek architecture were soon no longer slender enough; the Roman entablatures and capitals of the first century were soon no longer rich enough; the facades of the High Renaissance were soon too flat! How are we to explain the abandonment of the most beautiful forms created by the masters of the greatest ages of architecture and their replacement by others that, in our opinion, have lesser value? Is there any explanation other than that jading is independent of the value of the form?[10]

However, it is equally important that in the case of a work such as a painting or sculpture – or even a cathedral – where viewing brings with it reflection and deep intellectual feeling, the jading does not take place. The law applies only to forms that mean nothing but

form. Göller's argument is not as seamless as he would like. Clearly it is questionable whether it is possible to separate off form as form in architecture in this way and impossible in the other arts, but the principle that the building up of a memory image leads eventually to jading is a clear one. The neurological processes he assumes are now widely recognised, although today they would be presented rather differently.

The best example of the way in which Göller's theories fit with the findings of modern neuroscience is in his consideration of the way architects avoid jading. One way is simply to use familiar elements to make different compositions. Another is to use them in different combinations. A third is simply 'to intensify [*steigern*] the charm of old forms' by lengthening the proportions, increasing the ornament, deepening the shadow, multiplying the mouldings or the verticals or the horizontals.[11] This last approach is close to that now analysed under the heading of the 'peak shift' phenomenon. The term originated in the 1950s when it was shown, using 'peaks' on graphs, that pigeons who were rewarded for pecking at a colour of a particular wavelength and not rewarded for pecking at another colour would peck most enthusiastically if the wavelength of the first colour was changed in a direction away from the wavelength that brought no reward. In later experiments more relevant to the study of artistic response it was similarly shown that rats which are trained to associate a reward with a rectangle rather than a square will react even more positively if one dimension of the rectangle is extended to make it look even less like a square. Both sociobiologists and neuroscientists have used the phenomenon to explain stylistic change in art.[12]

Göller makes interesting qualifications of his law. For example, he claims that older designers are more likely to avoid jading by introducing new compositions and combinations, while young ones with their less well-formed memory images are more likely to just try to intensify existing features, a predisposition also more apparent in lay people for similar reasons. He evidently regarded such a process of intensification as particularly dangerous because it was easy for people to go on changing until they have gone too far in a particular direction. Yet another qualification is that the more buildings that are built in a particular period the faster the change will occur, as happened in the Middle Ages, or in Göller's own time. As a result it is possible to put all these factors into something resembling a scientific equation: 'The pace of progress varies in the different centers of a style, depending on the level of building activity and on the involvement of older and younger talents. In this way, more or less

significant centers are formed that dominate a particular region and establish a local stylistic trend.'[13] No examples are given to illustrate or demonstrate the claim, but it is clear enough to allow readers to test it against their own experiences should they so wish.

The same is true of an equally clear claim, one that can be thought of as drawing together the observations of Winckelmann, Ruskin and Taine and giving them a much more systematic formulation: since local experiences are so important, there can be no universally valid assessment of the beauty of architectural form:

> If we find a similar sense of form among members of a narrow circle, it is because the images of the same landscape, the same works of their ancestors, the same domestic and communal lives, and in particular the same architectural works have influenced their sense of form, and the unanimous judgement of those members is then assumed to be a kind of objective knowledge. Thus there exists a certain collective sense of form among contemporary members of a family, of a school, of a city, of a nation, and of humanity as a whole. But the wider we draw the circle, the less will be the agreement and the greater will be the differences in the individual sense of form; the longer the circle subsists, the greater will be the change that takes place between the beginning and the end.[14]

This paragraph is perhaps the most remarkable in the whole essay and one of the most perceptive in the history of art.

Thinking in terms that are much broader than those used in the rest of the text, he uses the idea of the 'memory image' to argue that anything in the visual environment, landscape, material traditions, the apparatus of people's private and public lives is liable to influence their visual tastes. Anything that an individual looks at frequently is liable to lead to the formation of memory images in his or her brain and cumulatively these memory images will lead to the establishment of a distinctive 'sense of form'. Such a sense of form will then be shared with all other individuals who have similar visual experiences. And this allows it to be applied at a range of levels from the family, through the school, city and nation to humanity. It is sufficient that people share the space where the experiences are located. Also important is sharing the same time, although, given the way memory images accumulate to create a sense of form, there will usually be a great measure of continuity. Göller's 'sense of form' thus anticipates features of Baxandall's 'period eye', but significantly does not stress the conscious social formation so crucial for Baxandall's 'social history of style'. Instead, he emphasises the purely

passive exposure to the visual environment, the impact of which is indeed much easier to confirm using modern neuroscience. The disappointment is that the claim is purely theoretical. Unlike Baxandall, he gives no examples of such a 'sense of form' in practice.

The essay ends with some reflections on the consequences of 'jading', beginning with the observation that, although it may seem a bad thing because it has meant the death of great styles, it has in fact been beneficial in preventing stagnation and promoting innovation: 'The jading that affects the sense of form is not inimical to architecture; on the contrary it is essential to its development.'[15]

The clarity and coherence of Göller's theory is largely a product of his concentration on a single art form, architecture, and the breadth of his knowledge of that art form. Architects in late nineteenth-century Germany had a greater knowledge of architectural forms than those of any other place or period. Not only were they aware that there had been a rapid sequence of styles in their own territories, frequently influenced by external traditions, they were also able to travel by train taking in many examples in a short period. This allowed them to follow the sequences of monuments within Germany as well as acquire an awareness of foreign traditions by pursuing them to their roots in Italy, France and elsewhere. Students of the visual arts of Göller's generation, especially German students, given their country's central position in Europe, were, like Darwin on *The Beagle*, exposed to a wider range of data in the field of their primary expertise than anyone had been previously. As a result they would have unconsciously become more and more sensitive to patterns of variation through time and from place to place. Picking up on sensibilities that were emergent in Ruskin and Taine, who experienced similar privileges, but to a lesser degree, and being, through the influence of scientists such as Helmholtz and Heinrich Hering, more conscious of the new understanding of the brain, writers like Vischer, Göller and Wölfflin sensed patterns of variation in artistic behaviour that remained unperceived by others with a narrower knowledge. They were also conscious enough of their own neural make-up to explain them in neuropsychological terms.

For someone such as Göller whose professional position gave him an interest not in all the arts, but in architecture alone, the formulations that resulted could be startlingly clear. Since the data he was working with came from a single field it was more easily synthesised. As he went from city to city, from building to building, he would have unconsciously experienced the formation of a plethora of memory images in his own brain before he used the idea of memory image

formation as the basis for his theory of architectural change. It was because of this convergence in his experience of architecture that he could build such an ambitious theory. It was also, however, sadly, because of his isolation in that field that his ideas had relatively little impact, although, as we shall see, they were powerful enough to be attacked immediately after their publication by Heinrich Wölfflin.

18

Wölfflin

Heinrich Wölfflin (1864–1945) had been exposed to a similar conver-
gence of circumstances as Göller. Indeed, the same factors would
have affected him more intensely. Being younger, the new knowledge
of the brain would have affected him more deeply, and, coming from
Switzerland, centrally placed between Germany and Italy, Austria and
France, he was in an even better position to enjoy the benefits of the
advancements in rail travel. He also benefited from the improved
access to images of works of art made possible by photography. And
all this meant more to him because he was trained partly as an art
historian, first in Basel with Jakob Burckhardt (1818–1897), and then
in Berlin and Munich. Wölfflin began working along similar lines to
Göller, developing his own new theory about the response to art, and
especially architecture. This was articulated in a brilliant short doc-
toral dissertation *Prolegomena zu einer Psychologie der Architektur*
(Prolegomena to a Psychology of Architecture) (1886), when he was
only twenty-two, a year before Göller's essay.

His starting point is the need to explain why everybody feels the
expressive power of architecture. Laymen find that buildings have
moods and art historians find that they illuminate the characters of
periods and peoples.[1] Like Göller he noted how some have suggested
that this is an optical phenomenon, reflecting the different ways in
which the muscles of the eye react to curves and zigzags, but for Wölf-
flin this is simply not adequate to explain the richness and complexity
of our response to architectural forms. Wölfflin is sympathetic to Robert
Vischer's idea of a bodily reaction, but feels that what he is discussing
is an imaginative, that is a mental, rather than a physical, response.

In his view we have to consider that the whole body is involved:
'The optic nerve-stimulation directly causes an excitation of the
motor nerves, which produces a contraction of particular muscles.'[2]
Wölfflin here for the first time explicitly describes a visual experience
in terms of an interaction of the visual and motor system. However,
he is also anxious to stress that the reaction stimulates not just bodily

movement but emotion. Emotional expression involves the whole body, not just face muscles or extremities, and he points out again what Alberti had noticed, that when we see someone else experiencing an emotion such as pain we too are affected by it in the same way, even feeling pain in the same place. A child cries when it sees someone crying and we feel pain when we see someone undergoing an operation. The depth of our response is illustrated by the way our own breathing may be affected by being aware of someone else's. Of course, if we are in control of ourselves we can limit this response, which is why 'He who has not the ability to temporarily stop thinking about himself, will never enjoy a work of art, still less be able to make one.'[3] Wölfflin's recognition of the importance of relaxing consciousness when either responding to or making a work of art, is new and follows directly on from his awareness that the nervous system has a life of its own. The role of a purely rational response is repeatedly played down.

Having established that it is with our bodies that we react to buildings emotionally, Wölfflin goes on to give some examples of how this works. In the field of proportions, horizontal things 'rest', vertical things 'stand', the square which is in between is 'clumsy, ponderous, contented, boring, good natured, stupid' (fig. 17). As a result we experience a 'progress from the corporeal to the moral to the intellectual'.[4] The connection between form and feeling is also illustrated by the way in which lines relate to the tempo of breathing. While the idea that our reaction to lines is determined by eye movements carries little weight in his view, the observation that the

varying height of the waves in a line suggests variations of speed of breathing can be widely applied, and not just to individual people but to whole cultures:

> In relation to the significance of tempos of breathing for the expression of moods, this point is very important for historical characterization. One can observe that the older a people is the faster it begins to breathe in its architecture, the more excited it becomes. How quiet and restfully run the lines of an early Doric temple . . . Then in the Ionic there is a quicker mobility . . . and as ancient culture comes to its end, the more it pursues a febrile, hasty movement. Peoples that from the very beginning are quick of blood go the furthest. One thinks of the suffocating pace of the lines in Arabic decorations. Unfortunately I must here content myself with hints, a historical psychology, much more a psychological art history would have to be able to follow the growing speed of lines in all exactitude and would certainly find that the development always comes first in decoration.[5]

Wölfflin here himself attains such a speed of argument that he almost loses himself as he is swept along by his idea, but his claim is important in its theoretical ambition, since it provides a grid to cover both peoples and periods. Peoples have characters of different 'speeds' and whatever the original speed of a community it will only get faster. As he himself accelerates, he relies more and more on assertion. The basic proposition that lines with waves of different sizes affect us in predictable ways may be founded in a supposedly scientific claim that such waves represent in some sense breathing of different speeds, and so different speeds of movement, but the inference about the differentiation of peoples and the regular way they 'age' is only an unsubstantiated assertion.

As an example of the relation between proportion in architecture and peoples Wölfflin goes on to oppose the Italian Gothic style, which represents 'the national preference for wide and restful proportions' to a northern European urge for height and for towers, and goes on to propose a general theory that 'in the history of the proportions of gables . . . we can follow the whole development of world views'.[6] Gothic architecture in general he sees as particularly expressive and taking his cue from Goethe, who claimed in his essay on architecture (1788) that an increase in the slenderness of columns gives the mind a greater sense of elevation and freedom, he asserts: 'Greater elevation and freedom! That is also the impulse that transformed the Romanesque style into Gothic forms.' We can sense his greater respect for Gothic in the emphasis he gives it in the drawing

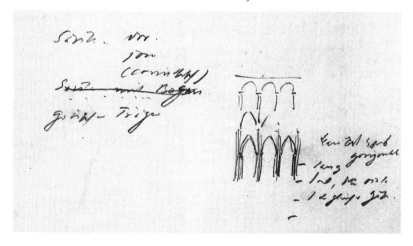

18 Arcades with round and pointed arches, Heinrich Wölfflin, *Prolegomena zu einer Psychologie der Architektur*, 1886

comparing round and pointed arches at the end of the proofs of the *Prolegomena* (fig. 18).[7] He is contemptuous of functionalist explanations of the pointed arch voiced by those who think that people who see more in the style are 'ridiculous dilettantes'. Indeed, to prove his point that there is a connection between bodies and architecture he goes on to note how in northern paintings the figures are all attenuated and stiff. Again, although he is not clear what the nature of the connection is, he is confident that he has found a general rule which can be applied across different cultures, as in his subsequent claim that in 'mature cultures' ornament dominates material, as can be seen in Gothic, Arabic and Late Roman architecture.[8] In such an architecture of excitement the viewer is required to respond with every muscle. In the final section the overall principle is reasserted: 'An architectural style represents the deportment and movement of the people of the period.' Also reasserted is the need for a more exact science of art history based in psychology: 'This would allow art history to relate the individual to the general and to laws. Psychology is far from the stage of perfection that would allow it to offer historical characterization [*geschichtlichen Karakteristik*] as a systematic method [*Organon*], but I don't believe that goal to be unobtainable.'[9]

Taine had talked generally of developing a more scientific approach to art, and now Wölfflin attempts to realise the project. While Taine was interested in the human nervous system generally, Wölfflin focuses on one particular aspect of its operation, the way in which it ensures that when we see something we are liable to react to it with our whole

body. When we look at a building, all our muscles are affected and so is our breathing. His approach to art is thus more concretely rooted in biology than any other proposed earlier and allows him to make general rules for the ways in which different types of building affect us. Its most obvious limitations lie in the reliance on concepts that are only metaphorically biological. When Wölfflin talks of a *Volk*, people, it is never clear whether he is talking of a biological race or a cultural community, and when he talks of a culture 'ageing' or 'maturing' he never explains how such a culture or process is defined. Still, this does not deprive his method of its claim to be more scientific than anything before, both in its basis in a universal human biology and in its applicability to all architecture, ornament and art.

Two years after his doctoral dissertation, and still only aged twenty-four, Wölfflin published his *Habilitationschrift*, *Renaissance und Barock* (Renaissance and Baroque) (1888), a work that was to become far better known than the more ambitious, but unpublished, 'Prolegomena'.[10] Indeed, the success of this new book, like that of its equally famous successor *Die Klassische Kunst: Eine Einführung in die Italienische Renaissance* (Classic Art: An Introduction to the Italian Renaissance) (1899), is due largely to its non-theoretical nature, as a clear, well-informed and sensitive account of Italian sixteenth- and seventeenth-century architecture. However, the theoretical element, part two, entitled 'The Causes of the Change in Style', does return to some of the arguments of the 'Prolegomena' and takes issue with Göller. Like Göller, Wölfflin begins with a question, or rather two: 'Why did the Renaissance come to an end? Why was it followed, particularly, by the Baroque?'[11]

In answering these questions he first dispenses with the two current explanations, one, the idea that people's sensibility became 'blunted', the other that the sensibility simply changed due to a change in the spirit of the age. In the case of the 'blunting' thesis he clearly has Göller above all in mind and goes along with him up to a point:

> The basic assumption of this theory is correct. It is quite true that the organs of perception are numbed by an effect which is too often repeated. Our empathetic response to this effect becomes less intensive, forms lose their power to impress because they no longer invoke this response; they are played out and lose their expressiveness. This diminished empathy could be called a 'jaded formal response'. While it seems doubtful that this process is due entirely to a 'clearer memorized image' [as Adolf Göller would have us believe], it is feasible that this jaded response should necessitate more powerful effects.[12]

Wölfflin can go along with the idea of blunting, but it cannot be restricted to the area of pure form: 'If . . . the baroque style sometimes had recourse to extravagantly powerful effects, the reason is rather a reaction to a general numbing of the nerves, and not to a jaded formal perceptiveness.'[13] Moreover, Göller's concept of jading does not explain why the new style has such a pronounced and new character. According to his idea we would rather expect late sixteenth-century art to develop in many directions as each architect sought to refresh it in a different way. Equally unsatisfactory, in Wölfflin's view, is the attempt to explain the new style in terms of some 'spirit of the age', in the way that Gothic has been explained in terms of feudalism, scholasticism or the life of the spirit. As Wölfflin mockingly observes:

> But we still have to find the path that leads from the cell of the scholar to the mason's yard. In fact little is gained by enumerating such general cultural forces, even if we may with delicate perceptiveness discover some tendencies similar to the current style in retrospect. What matter are not the individual products of an age, but the fundamental temper which produced them. This, in turn, cannot be contained in a particular idea or system; if it were it would not be what it is, a temper or a mood.[14]

It is this definition of stylistic change, not in terms of a change of form, but of a more general and all-embracing change, that alters the nature of the debate.

What he needs is a broader approach to style and he finds it in the idea of empathy outlined in the 'Prolegomena':

> we must proceed from a psychological fact which is both familiar and easily checked. We judge every object by analogy with our own bodies. The object – even if completely dissimilar to ourselves – will not only transform itself immediately into a creature, with head and foot, back and front; and not only are we convinced that this creature must feel ill at ease if it does not stand upright and seems to fall over, but we go so far as to experience, to a highly sensitive degree, the spiritual condition and contentment or discontent expressed by any configuration, however different from ourselves. We can comprehend the dumb, imprisoned existence of a bulky, memberless, amorphous conglomeration, heavy and immoveable, as easily as the fine and clear disposition of something delicate and articulated.[15]

Nor is the relationship one way. We can only see the object in terms of our own feelings: 'We always project a corporeal state conform-

ing to our own; we interpret the whole outside world according to
the expressive system with which we have become familiar from our
own bodies. That which we have experienced in ourselves as the
expression of severe strictness, taut discipline or uncontrolled heavy
relaxation, we transfer to all other bodies.'[16] This being so, this must
be how we relate to architecture: 'Whether a man's habits of deport-
ment are light and playful or solemn and grave, or whether his
attitude to life is agitated or calm; . . . architecture expresses the
Lebensgefühl of an epoch.'[17] What Wölfflin suggests is that people
make buildings which reflect their own bodily feelings.

 This argument he then applies to the explication of Baroque:

> To explain a style then can mean nothing other than to place it in
> its general historical context and to verify that it speaks in harmony
> with other organs of its age. The point of departure for our inves-
> tigation of the origins of Baroque will therefore be the most anal-
> ogous comparison, that of the conception and representation of
> the human figure in the representational arts, rather than a general
> *kultur-historisch* [culture-historical] sketch of the post-Renaissance;
> and the point of comparison will be the general appearance.[18]

Since the key to understanding style change in architecture is an
understanding of habits of deportment as shown in the representa-
tional arts, Wölfflin now turns to the history of painting to show that
the increasing massiveness of Baroque architecture is matched by a
similar increase in the massiveness of the human body, as illustrated
for example by the contrast between Raphael's *Galatea* and that of
Agostino Carracci. He even, at one stage, locates the origin of this
trend in one man: 'If the fate of art in general can be said to rest in
the hands of a single man, then the origins of this new art may be
traced to none other than Michelangelo.'[19] Clearly, though, the trend
is so widespread in poetry and music, as well as art, that Michelangelo
can only be seen as a symptomatic character. Moreover, in spite of his
earlier warning about a *kultur-historisch* approach, other factors are
seen to play their role, such as the spirituality that comes from religion.

 In the end, therefore, the advantage of Wölfflin's approach is less to
provide an explanation of change, than to offer a way of seeing change
as a widespread phenomenon affecting all of culture. He never gives a
reason for why the human body becomes more massive, but he relates
that tendency to so many aspects of life that we are left feeling that we
understand the trend even if we cannot identify its causes.

 Wölfflin's ideas have many sources in psychological theories then
current in the German-speaking world, but his tone is perhaps
shaped above all by his need to make art history as independent as

possible of other disciplines. While Hegel, and later Burckhardt, his own teacher, had seen art as a symptom of culture, Wölfflin wanted to see art as one aspect of a general tendency in *Lebensgefühl* (life feeling) in which no element had a predominant influence. Indeed, if the way people experienced their bodies was ultimately the key to experience, then an artist such as Michelangelo, by establishing a new physical type, might be seen as having a decisive impact on that experience. Wölfflin never goes this far, but by playing down culture and playing up art he makes such an approach possible, giving art not only a new autonomy but a new opportunity to take on a leading role in *Lebensgefühl*.

Having developed this approach as a young man, Wölfflin continued to develop it throughout his life in works such as *Die Klassische Kunst* and *Kunstgeschichtliche Grundbegriffe* (Principles of Art History) (1915). Concentrating above all on developing a language of formal description, he was able to give generations of students of art history a feeling that they had mastered a tool as analytically effective as the language of the scientist. He was also in harmony with a contemporary trend in the visual arts that more and more tended to see 'form' as having a life of its own, independent of meaning, and moving from representation to abstraction. In texts from Adolf Hildebrandt's *Das Problem der Form in der bildenden Kunst* (The Problem of Form in the Representational Arts) (1893) to Wilhelm Worringer's *Abstraktion und Einfühlung* (Abstraction and Empathy) (1908) form became an ever more important concern in its own right. Soon abstract art itself was to emerge, making form seem a subject of such importance that it transcended the manifest variety of nature. The interest in form led away from visual nature. It also led away from the human body and the theory of *Einfühlung*.

Only rarely did Wölfflin later return to psychology. One case was in his discussion of the unease provoked by the reversing of an image, as frequently happened with wrongly inserted lantern slides.[20] Another was in his even later *Italien und das deutsche Formgefühl* (1931), translated in a post-Second World War climate nervous of such nationalistic formulations as *The Sense of Form in Art* (1958). In this work, in a discussion prompted by the fourth centenary of Dürer's death in 1528, Wölfflin returns to one of the themes of the 'Prolegomena', beginning with a paragraph that recalls the remarks of earlier writers:

To the traveler arriving in Italy from the North, the world appears all at once more tangible, simpler, and more definite. With what clarity the prism of the first campanile stands next to the Church!

How distinctly expressed are the proportions of the form of the church itself! What a simple cube is the villa on the hill of cypresses, as definite in its contours as are the nearby cypresses in form and direction! Everything down to the single column, is firmly self-contained; and the forms seem set apart from one another in more explicit contrast than in the North.[21]

Wölfflin does not say in so many words that the difference between Italian and German art derives ultimately from the difference in their natural environments, in the light, the trees, the hills, but the suggestion is planted in the reader's mind. Ruskin would have recognised a characterisation similar to his of the Florentine environment with which Turner had such difficulty.[22] Göller would have appreciated the nod in the direction of his collective 'sense of form'.

There are in fact substantial parallels between Göller and Wölfflin, despite all the latter's protestations. Both tried to give art as much autonomy as possible and probably both did it for the same reason. Both were teachers, one of architecture and the other of art history. In both, a powerful new influence on the formation of their neural networks was a concern to increase the independence of their field and so of their profession, at a time when professionalisation was increasing everywhere in Europe. Other influences were the ideas they picked up from conversations, lectures and readings. But the most important influence of all was their absorption of a much larger body of visual material than any of their predecessors. Partly because of the increased ease of train travel and partly because of the increased use of photography, they had a richer store of what Göller would call 'memory images' than any of their predecessors. The repetition of attentive viewing had inevitable effects on their neural development, allowing them to sense and articulate laws whose neurological basis is only now being revealed.

Riegl

Alois Riegl (1858–1905) was, like Wölfflin, a trained art historian, though born not in Switzerland or Germany, but in Austria. He was also, like his slightly older Swiss contemporary, critical of materialist and functionalist accounts of art, such as that offered by Gottfried Semper. But he was much less interested than Wölfflin in the biological and psychological relation between the maker or viewer and the work of art, and this is partly because his concern was less with architecture, painting and sculpture, arts which had direct and indirect references to the body, and more with the decorative arts, where the connection was less obvious. Indeed, his first job in 1886 was working for Vienna's Museum of Applied Arts and his first book was on oriental carpets.

His first important publication, however, did try to bring the decorative arts closer to the so-called fine arts by giving them an elaborate theoretical treatment. This was entitled *Stilfragen: Grundlegungen zu einer Geschichte der Ornamentik* (Problems of Style: Foundations for a History of Ornament) (1893)) and was based on courses he had just begun teaching at Vienna University. One of Riegl's core claims was that he wanted to abandon Semper's explanation of architectural decoration in terms of the adaptation of techniques from fields such as textiles, and replace it with an explanation that is closer to nature. For, as he says, 'the human desire to adorn the body is far more elementary than the desire to cover it with woven garments, and . . . the decorative motifs that satisfy the simple desire for adornment, such as linear, geometric configurations, surely existed long before textiles were used for physical protection.'[1] He then goes on to argue that 'all art forms are based on models in nature' and that this relationship is closest in sculpture, since both operate in three-dimensions.[2] On this basis he argues that we can make the a priori argument that the 'genetic' relationship between sculpture and painting is one in which the former preceded the latter: 'once human beings acquired a mimetic instinct, there was

nothing very complicated about modeling an animal reasonably well in wet clay, since the model – the living animal – already existed in nature. When, however, they first attempted to draw, engrave or paint the same animal on a flat surface, they were involving themselves in a truly creative act.'[3] This account, although deceptively matter-of-fact, raises a number of difficult issues.

The notion of a human mimetic faculty is not new, and goes back to Alberti and Aristotle, but the idea that it was 'acquired' is, and must reflect the influence of the Darwinian idea that abilities were gained during evolutionary history through a process of natural selection. The claim that sculpture preceded painting is new and appears to depend on the assumption that the mimetic instinct had an overriding power, with representations in three dimensions being more fully imitative than those in two. Significantly the claim is backed up in a footnote referring to recent ethnographic research: 'Travellers often describe how Hottentots and Australian aborigines fail to recognize their own image in a drawing or photograph: they can comprehend things physically, but not two-dimensionally – proof that the latter kind of perception presupposes an advanced stage of culture.'[4] This type of comparison, which is based on the erroneous idea that modern hunter-gatherer peoples can be treated as some sort of cultural fossils, was to be used again a couple of pages later when discussing the worldwide presence of the Geometric style: 'If, following the spirit of today's natural science, we are justified in assuming that contemporary primitive cultures are the rudimentary survivors of the human race from earlier cultural periods, then their geometric ornament must represent an earlier phase of development in the decorative arts and is therefore of great historical significance.'[5] Riegl is wrong in his conclusion, but the fact that he traces its source to 'today's natural science' is important because he is admitting that, if science changes its view, he must then change his.

In the following paragraphs, where Riegl discusses the origins of the Geometric style, he seems at first to move away from a natural framework, but in the end he returns to it: 'After sculpture came painting and out of painting came the line which became an art form in and of itself and was used without direct reference to any particular model in nature. Since, of course, not just any irregular scribble can claim to be an art form, linear shapes were made to obey the fundamental artistic laws of symmetry and rhythm. As a result, straight lines became triangles, squares, rhombuses, zigzag patterns, etc., while curved lines produced circles, undulating lines and spirals' in what art historians call a Geometric style.[6] This might seem

to take us away from nature, but only at first sight: 'The same laws of symmetry and rhythm that govern geometric shapes are apparent in the natural forms of humans, animals, plants and crystals as well. In fact it does not require any particular insight to perceive how the basic shapes and configurations of plane geometry are latent in natural things.'[7] Riegl here takes up an argument from Semper's prolegomena to *Der Stil in den technischen und tektonischen Künsten* (Style in the Technical and Tectonic Arts) where the origins of art were to be found in principles such as rhythm, symmetry and proportion, all extracted from nature, from both the mineral and plant world. He was, however, soon to part company with his source. Semper had moved on to use this approach to help to explain man's ready inclination to make use of the patterns of the woven clothes and fences on which his survival depended, but this view did not appeal to Riegl, who preferred to see nature itself as an autonomous influence on the earliest art. For him this art was less a product of some external materialist causation than a manifestation of human creativity.

Riegl did not disagree with the idea that the Geometric style was a worldwide phenomenon which had sprung up spontaneously in many places, but felt that the influence of what he called 'intangible psychological processes' had been wrongly rejected by the materialists. The materialists effectively dispensed with the idea of 'a conscious mental act' in favour of some sort of automatic adoption of the patterns, such as the zigzag, which are apparent in woven artefacts 'because the symmetry of its slanting bands and rhythmic repetition would surely have delighted the human beings who accidentally produced it. Of course, should the question arise at this point as to the source of this delight and what might have caused it in primitive people, it would have to be fastidiously ignored.'[8] Riegl is right to pose the question about the source of this delight, not because it would have floored his rivals, but because it does need answering, and can be today using the idea of neural plasticity. As a result of looking repeatedly at a vital object such as a textile, the viewers' neural networks and neurochemistry would indeed have been affected, giving them a preference for looking at such configurations wherever they found them.[9]

For Riegl, though, the notion of some unconscious preference generated by man-made artefacts is simply not convincing. However, as he admits, this idea 'was readily accepted in art historical circles. The historical, scientific spirit of our age, ever ready to probe in reverse the causal relationships of all phenomena, was more than charmed and satisfied by a hypothesis that could claim an origin so natural and so astonishingly simple for so eminent an intellectual

sphere as that of art.'[10] A few pages later Riegl expands his attack on the 'materialists' giving his own view of recent intellectual history. The fault lies in,

> the materialist, scientific worldview, first promulgated by Lamarck and Goethe and susbsequently brought to maturity by Darwin, which has left such grave consequences in its wake even in the field of art history. As a parallel to the effort to explain the evolution of the species by means of the purely physical drive for survival, there was also an effort to discover primary and intrinsically physical mechanisms for the intellectual evolution of the human race. Art obviously represented – or so one thought – a higher stage of intellectual evolution and therefore could not have been present from the very beginning. First came technology, which concentrated on purely practical matters; then, out of experience, and only after the culture had somewhat advanced, did art appear on the scene.[11]

Riegl's view here is to some extent a caricature, but he is right that evolutionists tended to favour the notion that human behaviours emerged in a series of stages, with practical activities such as weaving preceding higher artistic ones, and he is right in thinking that they were wrong. We now recognise that art, such as the paintings from the Grotte de Chauvet or the sculptures from Vogelherd, which date from around 30,000 BC, is at least as early, if not earlier, than complex technologies such as weaving, which appeared about the same time.

Riegl did not know these works, nor did he know the details of the dating of Palaeolithic art, but he did realise that Prehistoric art disproved the claims of the materialists. For him their whole theory collapsed in the face of the evidence not of ancient and primitive art, but of the earliest art in the form of the cave art from southern France. As he says, not only does this art, found especially in the Dordogne area, reveal little of the angular and the linear, there is no evidence that they were yet able to weave. Instead, the overwhelming majority of the art consists of representations of animals, and according to Riegl sculptural representations precede those in two dimensions. This of course fits with his view that the main drive is mimetic: 'all artistic activity begins with the direct reproduction of the actual physical appearance of natural things in response to an imitative impulse that has been spurred into action by a psychic process.'[12] Riegl was dealing with very incomplete evidence, but his observations are broadly in line with the information known today.

It is true that we now know, as just noted, that weaving was prac-
tised around the time of the earliest art, but we also know that it had
little influence on the earliest paintings, engravings and sculptures.
We also now know that Riegl was wrong in stating that sculpture
decisively preceded painting and engraving, but that does not inval-
idate his general point about the predominance of lifelike imagery.
Indeed, among the general points he makes that provide the basis
for building up a better system of explanation is his observation that
'the animals depicted on the various implements were either a
source of food or a source of danger.'[13] Riegl is talking only of the
animals carved on weapons, but his point could be as easily applied
to more monumental painted and sculpted works, and his division
of them into two categories based implicitly on the raw emotions
they would evoke anticipates features of a current explanation for
why early representations do indeed fall into these two categories.[14]

These facts of the history of art may suit Riegl's argument, but that
is not the reason he advances it with such passion. The main reason
why he objects to the materialist view is that it diminishes the role
of the human mind. As he says in summing up,

> The impetus did not arise from the technique but, on the contrary,
> from the particular artistic impulse. First came the desire to create
> the likeness of a creature from nature in lifeless material, and then
> came the invention of whatever technique was appropriate . . . It
> must have been an immanent artistic drive, alert and restless for
> action, that human beings possessed long before they invented
> woven protective coverings for their bodies.[15]

All of art history presents itself as a continuous struggle with mate-
rial; it is not the tool – which is determined by the technique – but
the artistically creative idea that strives to expand its creative realm
and increase its formal potential. 'Why should this situation, which
obtains throughout the history of art, have been any different during
its initial stages?'[16] Riegl's main objection to the materialist explana-
tion is that it diminishes the value of artistic activity. He is determined
to preserve the idea that it is the conscious mind that is in control,
carefully shaping the tools to express its 'creative ideas' according
to its *Kunstwollen* (will-to-form).

Riegl must have realised that this position was not a strong one.
His argument that the earliest humans approached their work with
all the conscious intentionality of a modern artist did not sound con-
vincing as an explanation of Palaeolithic representational art, and as
an explanation for what happened in his own field, the decorative
arts, it was not as persuasive as Semper's conception of the influen-

tial role of artefacts such as textiles. What he needed was a theory that sounded as scientific as Semper's, but which gave nature not artefacts the more important role in shaping the history of art.

By the late 1890s he was meeting this challenge, working on a manuscript *Historische Grammatik der bildenden Künste* (Historical Grammar of the Visual Arts), which became the basis for a lecture course in 1899. The text begins with a clear statement about the integration of art with nature: 'The human hand shapes its works out of dead material after exactly the same rules of form, as nature does hers. All human art-making [*bildende Kunstschaffen*] is in its foundation nothing other than a making in competition with nature. . . . The source of all pure aesthetic pleasure lies in the observation of the correspondence between the work of art and the matching work of nature [what Riegl later calls 'the motif']. Art history is the history of the success of creative humanity in its competition with nature.'[17] No one before had offered such a universal account of what art is both for the maker and the viewer, and no one had related art so directly to nature. The extreme character of Riegl's claim emerges even more forcibly in the next paragraph where we learn that the laws of nature that humans are trying to rival in their art are not those of familiar appearances, nor those principally embodied in man. The basic law according to which nature shapes all dead (that is inorganic) matter is that of crystallisation, the symmetry about a middle axis which is manifest in the smallest molecules. In living matter the principles may appear on the surface to be different, especially when the living thing, whether plant or animal, moves, but internally the principles are the same. Riegl's account of artistic activity is very different from that in the *Stilfragen* and the difference comes out most clearly in his repeated assertion that the maker of an artwork may be quite unconscious of his intention to rival a work of nature.

This is because the competition with nature is driven by an almost emotional reaction. As he says at the beginning of the first chapter, man was first intimidated by nature because everything that grew and moved regardless of human will appeared to have a life of its own. This primitive type of *Weltanschauung* (world view) led early humans to treat all living things as gods and it was this that led humans to try and rival them. Riegl admits that it is impossible to prove his claim, but equally he says it is impossible to deny it, since even the most savage communities no longer live in that primitive state. Where his argument becomes more persuasive, because it ties in with the later history of European art, is when he says that even as man became more conscious of his own powers and started to dominate nature, he still realised that the forces of nature could not

be controlled and so in order to represent their independent power he represented them through human figures, because it was in man that such autonomy was so clearly embodied. The popularity of human personifications of natural forces is explained in terms of our recognition that nature shares with us powers that we would like to think are ours alone.

What this all means for the history of art is explained in the section on *Die Motive*, (The motifs). There he repeats his division of matter into inorganic and organic and goes on to point out that the crystals out of which inorganic matter is made have two principal properties. They are made up out of angular planes and they are symmetrical about a central axis. These follow from the laws of nature and it is these laws that humans 'naturally' followed when they felt the 'drive' to shape such material for decorative or utilitarian pur- poses. He can only hypothesise about the process involved, saying that in those circumstances human beings 'unconsciously but nonetheless inevitably asked themselves: how would nature have proceeded faced with the same task'.[18] It was the equally inevitable answer that led them naturally to give their works a symmetrical basic form, to contain them within combinations of angular flat planes and to endow them with immobility. This is why it should be a principle of art history that this law applies right up to the present day. Since he realises this claim is a striking one, he goes on to note how Bur- ckhardt had noticed crystalline principles not only in architecture but in the composition of paintings. The advantage of following these laws is illustrated, as Semper had pointed out, by the elevated taste manifest in much art of the *Naturvölker*: 'Primitive peoples create inorganic products of eternal value in a state of unconscious cer- tainty, while *Kulturvölker* make mostly organic art works of limited tastefulness (*Geschmacksgiltigkeit*).'[19] Riegl's line of argument here is slippery but clever. Looking for a natural, as opposed to an arte- factual, origin for the properties that were omnipresent in the dec- orative arts, he found it in the building blocks of nature, crystals. The fact that these geometrical properties of crystals also resembled those long admired in the tradition that descended from Greek art gave them unimpeachable credentials and this allowed him to go on to claim that the 'primitive' peoples who embodied them most single-mindedly in their art often made works that were better than those produced by the 'civilised'.

One problem remains, however. The notion that the earliest art was based on the formal properties of inorganic crystals might seem hard to square with the evidence of representational Palaeolithic art that he had discussed already in *Stilfragen*. Riegl has several reac-

tions to this problem. One is simply to say that he thinks this Palae-olithic art was not the earliest and that it was preceded by one that was more inorganic and crystalline. Another is to point out that the opposition between the inorganic and the organic should not be overstated. For a start, if you look closely at organic things they too share many properties with the inorganic, as illustrated by trees, with their cells, growth rings and leaf patterns. Besides, growing things when at rest are in fact relatively symmetrical and angular and it is only when a plant is exposed to external pressure, or when an animal experiences fear, that the symmetry is broken and they take on curved forms. Again, animals in early art are shown not with the chance traits of individuals, but with the constancy of types. These points allow Riegl to imagine, without any evidence to support the claim, an earlier art form, like that found in some primitive tribes, with an idol, for example, represented by a square post, marked only by two holes for the eyes. It was only after this stage that men went over to the more organic art of the Dordogne and eventually that of Egypt because of new, more conscious conceptional goals related to the competition with nature.

This, though, did not mean that the inorganic was abandoned. People only introduced as much of the organic, in other words the rounded and the mobile, as was necessary to meet their concep-tional aims, preferring always to increase the inorganic, the closed and the symmetrical, as much as possible within the constraints of those goals. It is this tension that underlies the whole history of art, which can be seen as a constant oscillation between what Riegl calls *Harmonismus* and *Organismus*, or in the language of his contem-poraries, Idealism or Stylisation and Naturalism or Illusionism. This oscillation follows a clear pattern. The *Harmonismus* phases are always more traditional and conservative and last longer. The *Organ-ismus* phases are always shorter and more revolutionary and inven-tive. This does not mean that the former are less important than the latter, as not only laypeople but scholars are apt to think. Art goes on changing in the conservative periods, only more slowly.[20]

Riegl's argument in the *Historische Grammatik* has never received the attention it deserves. This is partly because it was not published until 1966, but its subsequent neglect has other causes. One problem is that it is founded in a desire to develop a theory of art that embraces both 'applied' and 'fine' arts and, because of this, it is sometimes unclear which types of work he has in mind. Certainly, what he says about the 'crystalline' aesthetic is more easily applica-ble to ornament and decoration. The larger problem, however, is his attempt to construct a theory that is based on assumptions about

human nature which are of a new universality, the most important of which is that it is in our nature to follow nature's laws in our artworks. Not only is his repeated reference to nature a challenge to those who always saw art as an integral part of culture, but the claims that art was motivated by a single drive to compete with nature, and that this rivalry was at its most intense not with the organic but with the inorganic, have proved particularly hard to take. Even putting such resistances aside, there were real difficulties with the theory. On his own admission, there was no evidence that 'inorganic' art had in fact preceded the more 'organic' art that was known from the Dordogne. More seriously, he offered no other basis than assertion for two of his principal claims, first, that all art exists in a rivalry with nature and, second, that the earliest and strongest competition was with the 'crystalline' structures of inorganic nature. It is hard to see how any humans before the crystallographic surge of the nineteenth century could have looked at nature in this way. This means that Riegl must have believed that the knowledge of the crystalline structure of matter derived only from some sort of empathy, with its roots in the nervous system.

20

Freud

An Austrian contemporary of Riegl was Sigmund Freud (1856–1939), who also spent most of his life in Vienna. Although he was born in Moravia, his family moved to the imperial capital when he was three and he lived there, apart from some months in Paris and Nancy, and shorter visits to Germany, Italy and elsewhere, until he moved to London in 1938. Though not an art historian he wrote extensive essays on Leonardo and Michelangelo and through his writings on psychology he had an extraordinary impact first on artists, especially the Surrealists, and later on art historians, especially feminists and Poststructuralists. It was what he said about images that most influenced the artists and what he said about words that most influenced the art historians. The writings that were the source of this influence date from the period after he was forty, when he had established himself as what he called a 'psychoanalyst', but the foundation of his psychoanalysis was his training in neurology and clinical psychology and it is this background which needs to be understood if his extraordinary contribution to twentieth-century culture is to be explained.

Freud began his training in biology and medicine in 1873, a propitious moment. Thanks to the application of techniques involving electrical stimulation and the careful observation of the consequences of damage to the brain, especially the more local damage produced by modern weapons, knowledge about the localisation of functions in the brain improved rapidly after 1850, with Paul Broca locating an area essential for speech in 1861, and Gustav Fritsch and Eduard Hitzig in 1871 reporting their more wide-ranging findings for the motor cortex. These glimpses of the previously invisible workings of the brain could then be related to the processes sustaining the expression of the emotions in man and animals, as presented by Darwin in his book of 1872 on the subject, which has an extensive section on 'the action of the nervous system'. Darwin stressed that these processes were 'independent of the will'[1] and his cousin, Francis Galton, shed further light on the unconscious mind through

his experiments showing that verbal 'associations' were equally inde-
pendent of 'free will'. Galton even went on to conclude that his
experiments, beyond showing the prevalence of certain common
associations, provided a valid reason 'for believing in the existence
of still deeper strata of mental operations, sunk wholly below the
level of consciousness'.[2] Galton first published his findings in 1879,
at just the time that the micro-structure of the mind, one that might
accommodate such 'deeper strata', was becoming visible through
techniques such as that published by Camillo Golgi in the year Freud
began his studies. This used staining to render the fine structure of
neurons and neural networks visible under the microscope. The
nervous system that people had been gesturing towards with
increasing energy for two thousand years suddenly started to reveal
its secrets.

Freud became a youthful leader in this new research. He worked
on the spinal cord of a primitive fish, he published a book on the
relation between brain injuries and different types of aphasia, the
disruption of the ability to speak, and he came close to being the
first person to recognise the anaesthetising properties of cocaine.
Then, in 1885, he took the step that led to his movement away from
clinical neurology towards medical psychology. Having spent several
months in Paris working with Jean-Martin Charcot, the leading
expert in the contentious phenomenon of hysteria, which he saw as
a condition rooted in the sexual problems of females, in 1889 Freud
visited Hippolyte Bernheim in Nancy, who had come to realise the
role in hysteria's manifestation of 'suggestion'. In between, Freud
married in 1886 and in order to secure his income he set up in private
practice and soon started to use hypnosis in the treatment of hys-
teria. It was to increase his success and recognition in this field that
over the next ten or fifteen years he developed the theories that
were to become the foundations of psychoanalysis.

The foundation for the treatment was a view of the neural basis of
the mind that he outlined in a collection of texts, whose aim was 'to
furnish us with a psychology that shall be a natural science'.[3] Drafted
in 1895, this so-called *Project for a Scientific Psychology* was only
published after his death. Freud founded his views in the latest neu-
roscience, seeing the nervous system as made up of neurons, a term
developed by Heinrich von Waldeyer-Hartz in 1891, each receiving
'excitation through a cell process [later called a dendrite as it still is
today] and discharging them through an axis-cylinder [later called an
axon as it still is today]; and furthermore that they have numerous
ramifications with diameters of different dimensions.'[4] Most impor-
tant are the so-called contact barriers by which neurons are sepa-

rated. These 'synapses', as they were to be labelled two years later by Michael Foster and Charles Sherrington, Freud thought were undifferentiated, unlike the neurons themselves which could become differentiated as a result of a current passing through them: 'there may be a connection between differentiation and capacity of conduction, so that we may expect to find that the process of conduction itself may create a differentiation in the protoplasm and consequently an improved capacity for *subsequent* conduction.' This has striking implications: 'One of the chief characteristics of nervous tissue is that of "memory": that is, speaking generally, a susceptibility to permanent alteration by a single process. This offers a striking contrast to the behaviour of a material that allows a wave-movement to pass through it and then returns to its former condition.'[5] Just how significant this process is becomes clearer two pages later where he relates the change involved to the process of learning: 'Here is the argument. These neurons are permanently altered by the course of an excitation; or (if we introduce the theory of contact-barriers) their contact barriers are brought into a permanently altered condition. And since psychological experience tells us that there is such a thing as progressive learning based on recollection, this alteration must consist in the contact-barriers becoming more capable of conduction.'[6] According to Freud such alteration only took place in what he called the central psi (or psychological) system, not the phi (or physical) system of sensory and motor neurons extending to the body's periphery. This psi-system was in turn made up of two subsystems. One is in touch with the real world through phi, the other, the endogenous system, is driven by the body's internal needs for things such as food and sex.

Freud's model anticipates in many ways the science of a hundred years later. It acknowledges that the nervous system is built up out of a myriad of tiny cells called neurons. It also recognised that these cells accommodated input at one end and output at the other, often involving many branches, allowing current to flow in several directions. It recognised that such flow was affected not just by sense perceptions arriving from the external world but by powerful internal drives relating to food and sex. But the most remarkable correspondence with modern neuroscience was the claim that neurons were affected by the passage of conduction. Freud was wrong in seeing the change as involving the storing up of something like a memory as a result of 'permanent alteration by a single process', and he was unaware that the locus of differentiation is precisely at the contact barriers, the synapses, where the terminations of dendrites and axons meet, but the basic idea that the passing of a current through a

neuron is liable to cause a change is fundamentally right. So too is the notion that if such conduction was caused by a painful stimulation it could in certain circumstances lead to the formation of traumatic memories, which would affect later behaviour, although modern neuroscience explains the process differently. Equally astute is his notion that our perceptions often operate sympathetically because

> it is on our fellow-creatures that a human being first learns to cognize [that is to get to know a perceptual image]. The perceptual complexes arising from this fellow-creature will in part be new and non-comparable – for instance its features (in the visual sphere); but other visual perceptions (for instance, the movement of its hands) will coincide in the subject with his own memory of quite similar visual impressions of his own body – a memory with which will be associated memories of movements experienced by himself. The same will be the case with other perceptions of the object; thus, for example, if the object screams, a memory of the subject's own screaming will be aroused and will consequently revive his own experiences of pain.[7]

Freud's awareness that sympathy, or rather empathy, has a neural basis is well founded.

For all its compatibility with modern neuroscience, however, his model has many weaknesses. One of these is the separation between a visual unconscious and a verbal conscious, as in the statement 'one shuts one's eyes and hallucinates, one opens them and thinks in words'.[8] Another is the way in which his thinking of the communication between neurons in terms of 'flow' led him to give an excessive importance to the notion of 'quantity'. It is this emphasis on quantity that allows him to treat the flow as liable to build up behind the barriers between neurons until the accumulation is released. Essentially the metaphor of flow, which he sometimes described as a flow through a pipe, as if of a liquid, allowed him to develop a stilted image of the psyche, in which the unconscious was a place where the memory of harmful, typically visual, experiences could become 'cathected', that is held back, or repressed, until a guided conversation with the psychoanalyst brought about their release.

In the following years, Freud was to progressively abandon his neural model of the psyche, but it still sustained the argument of *The Interpretation of Dreams* published five years later in 1900. This book, which Freud considered his most important, reflected the way in which convergences in his experiences had changed his opinions. Much of his time was spent working with females, whose distur-

bances could often be related to much earlier sexual experiences, and following his own father's death in 1896 he recovered his own similarly painful memories, principally of his early jealousy of his father and the memory of seeing his mother's naked body. As he said in 1897: 'A single idea of general value dawned on me. I found in my own case too, the phenomenon of being in love with my mother and jealous of my father, and I now consider it a universal event in early childhood.'[9] In the ensuing years, Freud was to develop the core ideas on which psychoanalysis rests, ideas such as the Oedipus complex, the repression of early sexual memories, cathexis, sublimation (the way in which an energy derived from an instinct when it is denied gratification is displaced into a more socially acceptable interest or activity), projection, regression, free association, and so on.

These ideas start to take form in *The Interpretation of Dreams*, which in its revised form contains both the genesis and conclusions of his proposal. In it he repeats some of the bolder and more misconceived ideas found in the *Project*, such as the claim that all dreams, whatever their content or mood, are about 'wish-fulfilment'. As he boldly asserts: 'The dream is the (disguised) fufilment of a (suppressed, repressed) wish',[10] the repression being because the wish is sexual in character. This schematic view allows him to begin to treat the symbols that occur in dreams in exclusively sexual terms, a trend that only intensifies in successive editions of *The Interpretation of Dreams*. Typical entries in his list are:

> All elongated objects, such as sticks, tree trunks and umbrellas (the opening of these last being comparable to an erection) may stand for the male organ (1909) – as well as all long, sharp, weapons, such as knives, daggers and pikes (1911). . . . Boxes, cases, chests, cupboards and ovens represent the uterus (1909), and also hollow objects, ships and vessels of all kinds (1919). . . . Steps, ladders or staircases, or, as the case may be, walking up or down them, are representations of the sexual act.[11]

He continues this theme in a later passage:

> A woman's hat can very often be interpreted with certainty as a genital organ, and, moreover, as a man's. The same is true of an overcoat. . . . In men's dreams a necktie often appears as a symbol for the penis. . . . It is highly probable that all complicated machinery and apparatus occurring in dreams stand for the genitals (and as a rule male ones (1919)) . . . Nor is there any doubt that all weapons and tools are used as symbols for the male organ: e.g.

ploughs, hammers, revolvers, daggers, sabres, etc. (1919). In the same way many landscapes in dreams, especially any containing bridges or wooded hills, may clearly be recognised as descriptions of the genitals.[12]

What is remarkable about this list is that, although the claim that all symbols are sexual is now seen as overstated to the point of absurdity, the underlying assumption that the mind may mistake one thing for another with which it shares some signal property is correct. Any long thin object may indeed in different circumstances be mistaken for any other long thin object, because of the way our neural apparatus works. The visual part of the brain can now be broken down into different areas, such as those primarily concerned with such attributes as colour, movement or form, and it is by passing through those areas that the signals coming from the retina lead us to identify the object to which they have been exposed. Usually the signals are rich enough, and have sufficient correspondence with signals received earlier following exposure to a similar object, and so our judgement about them is correct. Sometimes, though, this does not happen and we make a mistake. More often, without us knowing it, the case is not so clear cut, and, although we are able to correctly identify the object, some aspect of it, such as its colour, form or movement, may suggest at the same time something else. Often such suggestions are critically influenced by context, since that is another element guiding our neural apparatus in its process of identification. This is why in some circumstances an umbrella may indeed suggest a penis, while in others it may as easily suggest either a lethal weapon or an innocent post. Freud's experience of using the latest technology to study the extraordinary branching of the brain's networks may well have unconsciously alerted him to the complexity of the process of identifying an object. His mistake was to allow patients' stories from the consulting room and his own reflections following his father's death to lead him to see that process, when occurring in the context of a dream, as principally guided by sexual hopes and fears. As a consequence his dream theory is 'seriously skewed and unfaithful to most people's experience'.[13]

Besides the insights he gives us into the then current state of neuroscience, Freud has a particular interest for art historians. Like a true neuroarthistorian he attempted to apply the theories he developed based on his neuroscientific knowledge to the study of the works of two of the most famous artists, Michelangelo and Leonardo. His work on Leonardo, being the most wide ranging, can serve as an example here. *Leonardo and a Memory of his Childhood*, (Eine

Kinderheitserinnerung des Leonardo da Vinci), was published in Leipzig and Vienna in 1910. He begins his study of this genius at first cautiously, but soon asserts that psychiatric research 'believes there is no one so great as to be disgraced by being subject to the laws which govern both normal and pathological activity with equal cogency'.[14] Freud's starting point is the identification in Leonardo of a whole series of unusual traits, including an incapacity to finish works, a tendency to experiment, a certain feminity, and an apparent insensitivity to the violence of war or to the evil of the reprobate duke Cesare Borgia. He then goes on to broach another subject observing, 'If a biographical study is really intended to arrive at an understanding of its hero's mental life it must not – as happens in the majority of biographies as a result of discretion or prudishness – silently pass over its subject's sexual activity or sexual individuality.'[15]

This prepares for a review of Leonardo's comments on sex and drawings of sexual activity, including the surprising comment on a drawing of a copulating couple that: 'when it comes to a drawing of the sexual act being performed standing up, we must surely suppose that there was a sexual repression of quite special strength to have caused it to be represented in this isolated and grotesque way. If one wants to enjoy oneself it is usual to make oneself as comfortable as possible: this, of course, is true for both the primal instincts, hunger and love.'[16] Having established, to his own satisfaction, Leonardo's sexual repression, Freud then goes on to use it as an explanation for his extraordinary craving for knowledge:

> Our psychoanalytic studies of neurotic people have, however, led us to form two further expectations which it would be gratifying to find confirmed in each particular case. We consider it probable that an instinct like this of excessive strength was already active in the subject's earliest childhood, and that its supremacy was established by impressions in the child's life. We make the further assumption that it found reinforcement from what were originally sexual instinctive forces, so that later it could take the place of a part of the subject's sexual life.[17]

This causes Freud to want to find out more about Leonardo's childhood, which leads him, like the conventional historian, to check contemporary written records. These reveal only that his mother was a certain Caterina and his father one Ser Piero da Vinci, who had a childless marriage to a Donna Albiera.

In pursuit of more information about his subject's youth Freud next turns, in his second chapter, to the testimony of Leonardo himself. He finds only one text, but, for him, a crucial one: 'It seems I was

always destined to be so deeply concerned with vultures; for I recall as one of my very earliest memories that while I was in my cradle a vulture came down to me, and opened my mouth with its tail, and struck me many times with its tail against my lips.'[18] For Freud this adult fantasy relates to Leonardo's experiences as a child. His word for the vulture's tail, *coda*, points to a reference to the penis, also known by the same term, while underlying the whole story is a memory of his mother's nipple. So, behind an allusion to Leonardo's homosexuality lies in fact a reference to his relation to his mother: 'What the phantasy conceals is merely a reminiscence of suckling – or being suckled – at his mother's breast, a scene of human beauty that he, like so many artists, likes to depict with his brush, in the guise of the mother of God and her child.'[19] For Freud, this story was suggested to Leonardo by his reading of ancient texts in which vultures were said to be all female and so symbols of maternity, and what it tells us is that Leonardo sensed that the search for knowledge which fuelled his energies had its origin in an intense relation with his mother.

Freud then moves on to an elaborate account of psychoanalytic theory, claiming that a male child's love for his mother may be so intense as to become a source of repression, out of which emerges a tendency for homosexuality. This, however, is not particularly important for the development of his art. More significant is the fact that the vulture story 'may be translated: "My mother pressed innumerable passionate kisses on my mouth" ',[20] a memory which helps to explain the strange smile on the face both of the *Mona Lisa* and of the *Virgin and St Anne* in the Paris painting and the London cartoon. For Freud the representations of the *Virgin and St Anne* not only recall Leonardo's own affectionate stepmother and stepgrandmother, but in the similarity of their ages they also evoke the pairing of Leonardo's stepmother with his true mother. This observation he then elaborates in a 1919 footnote by reference to a discovery by Oskar Pfister that the Virgin's robe in the Paris painting has been so arranged as to suggest the silhouette of a vulture (fig. 19). Freud has certainly been carried away by the 'vulture' story, since the bird in Leonardo's manuscript is described as a *nibio*, that is, not a vulture, but a kite. This, though, need not invalidate the speculative reconstruction of Leonardo's early emotional life on which he bases his final argument. According to this it was Leonardo's exceptionally positive relationship with both his mother and stepmother which lies behind the beauty of his women. Nor was this Leonardo's only critical parental relationship. He also, as a manuscript reference to his father's death suggests, had oedipal feelings in that direction too,

and that had further complications for his artistic activity. It was because the father with whom he identified sexually abandoned him that he repeatedly abandoned his masterpieces, leaving many unfinished. Not only, then, did the problems in his sexual relations with his mother and father result in a 'repression' from which he could only find escape in the 'sublimation' of his intellectual and artistic activity, they also help us to understand why his art is both so beautiful and so unfinished. For Freud, psychoanalysis helps us explain not only the subject matter, the style and the condition of his paintings, but the extraordinary intensity of his researches.

19 Drawing after Leonardo's *Virgin and St Anne*, showing vulture concealed in drapery, from Sigmund Freud, *Art and Literature*, 1985

Freud was well aware that many, even of his friends and allies, thought he was going too far in basing his study of one of the most famous artists in psychoanalysis. Indeed, he understands their reservations. But this does not stop him from making an impassioned 'in principle' plea for the approach he is using. He thus teasingly mocks those biographers who are unwilling to face up to the reality of the individuals they write about. In his view their refusal to look honestly at their subjects stems from their own idealisation of their fathers:

> They thus present us with what is a cold, strange, ideal figure instead of a human being to whom we might feel ourselves distantly related. That they should do this is regrettable, for they thereby sacrifice truth to an illusion, and for the sake of their infantile phantasies abandon the opportunity of penetrating the most fascinating secrets of human nature.[21]

And he goes on challengingly, 'Leonardo himself, with his love of truth and his thirst for knowledge, would not have discouraged an attempt to take the trivial peculiarities and riddles in his nature as a starting point for discovering what determined his mental and intellectual development.'[22] What Freud pleads for is a fearless enquiry into all the factors that might influence the formation of an individual.

The most important of these factors for him are certainly those susceptible to discussion in terms of psychoanalysis, but he is clear that others lie beyond treatment within that framework:

> Since artistic talent and capacity are intimately connected with sublimation we must admit that the nature of the artistic function is also inaccessible to us along psychoanalytic lines. The tendency of biological research to-day is to explain the chief features of a person's organic constitution as being the result of the blending of male and female dispositions, based on [chemical (word added in 1923)] substances. Leonardo's physical beauty and his left-handedness might be quoted in support of this view.[23]

In his reference to 'chemical substances' Freud, who was aware of the importance of genetics, might almost be looking forward to DNA. In the same spirit he acknowledges the importance of chance:

> we are all too ready to forget that in fact everything to do with our life is chance, from our origin out of the meeting of spermatozoon and ovum onwards – chance which nevertheless has a share in the law and necessity of nature, and which merely lacks any connection with our wishes and illusions. The apportioning of the determining factors of our life between the 'necessities' of our constitution and the 'chances' of our childhood may still be uncertain in detail, but in general it is no longer possible to doubt the importance of the first years of our childhood. We all still show too little respect for Nature which (in the obscure words of Leonardo which recall Hamlet's lines) 'is full of countless causes (*ragioni*) that never enter experience'. Everyone of us human beings corresponds to one of the countless experiments in which these *ragioni* of nature force their way into experience.[24]

With these words Freud goes beyond Ruskin's assertion of the importance of youthful experience, beyond Pater's talk of brain-building, and beyond Wölfflin's plea for a scientific psychology of architecture, to make a more reasoned claim for the desirability of a natural, and ultimately a neural, history of behaviour, including the most complex artistic behaviour. His claim is more reasoned because it is informed by much greater scientific knowledge. His awareness of the importance of inheritance is one area, but far more important is his knowledge of the way in which neurons are linked to each other by multibranched dendrites and axons. It was his sense that repeated conduction between neurons led to learning

20 Drawing of a 'network of cathected neurones', from Sigmund Freud, *Project for a Scientific Psychology*, 1895

and the laying down of memories that required him to take account of all the chance interactions between the individual's nervous system and the world.

This, however, is the most favourable interpretation of his point of view. A more critical assessment would admit that the open perspective outlined above, which is based on the theory developed in the *Project*, was soon narrowed in order to better support the claims of psychoanalysis. While the neuroscience of the *Project* would, like the neuroscience of today, allow for a myriad of influences from all the worlds to which an individual was exposed, Freud, in pursuit of a theoretical foundation for his business as a psychiatrist, was to argue for the overriding importance of sexuality and wish fulfilment, repression and regression. The contrast between the potential openness of the neuroscience of the *Project* and the more restricted system of *The Interpretation of Dreams* and later works is well expressed in the difference between the organic diagram of branching neurons in the former work (fig. 20)[25] and the scheme in the *Interpretation* showing how perceptions lead to memories, memories to the unconscious, the unconscious to the preconscious and the preconscious to motor activity (fig. 21).[26] It is the later stilted view which shapes his study of Leonardo. Freud provides the most salutory lesson for anyone seeking to found a study of art in knowledge of the brain. The path from hard science to the interpretation of art is

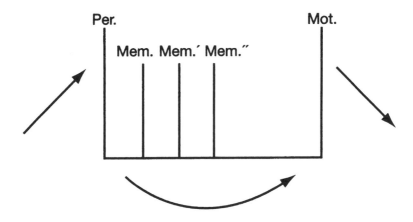

21 Diagram of the relationships between the perceptual system, the memory, the unconscious, the preconscious and the motor system from Sigmund Freud, *The Interpretation of Dreams*, 1900

extremely risky and the closer the art is to the science the better. Freud was one of the first people who had the opportunity to see the complexity of the neural structures that support all our actions and he might have used that knowledge to understand the complexity of the influences affecting art making. He certainly had the mental resources to do so, but these were 'cathected' by his overriding professional concerns.

Dewey

John Dewey (1859–1952), the American philosopher, was power-fully influenced by the account of the direct response to art pre-sented by such earlier English language writers as Ruskin and Pater, and in his book *Art as Experience* (1934), the publication of a series of lectures delivered at Harvard University, he went even further than they in playing down the role of abstract intellect. In this he was partly guided by the ideas of William James (1842–1910). James had originally trained as a doctor and in his *The Principles of Psychology* (1890) he had sought to assimilate the mental to the biological, before going on to develop the philosophy of 'prag-matism'. This too had an ultimately biological basis, based on the argument that we should understand life as a series of experiences and the responses they evoke. It was this pragmatic approach that inspired Dewey, when head of the School of Education at the Uni-versity of Chicago in the years around 1900, to develop a theory of education that was also biological, treating the human being as an organism functioning in a particular environment. It was out of this background that the conceptual framework of *Art as Experience* emerged.

His starting point was the observation that the more art is admired, the more it is 'isolated from the human conditions under which it was brought into being and from the human consequences it engenders in actual life-experience'.[1] This distancing has made it impossible to develop a valid theory of art. In the same way that if we set out to understand the flowering of plants we would need to find out some-thing about the interactions of soil, air, water and sunlight which con-dition their growth, Dewey argues that 'in order to understand the esthetic in its ultimate and approved forms, one must begin with it in the raw; in the events and scenes that hold the attentive eye and ear of man, arousing his interest and affording him enjoyment as he looks and listens.'[2] He continues,

It is a commonplace that we cannot direct, save accidentally, the growth and flowering of plants, however lovely and enjoyed, without understanding their causal conditions. It should be just as commonplace that esthetic understanding – as distinct from sheer personal enjoyment – must start from the soil, air, and light out of which things esthetically admirable arise. And these conditions are the conditions and factors that make an ordinary experience complete.[3]

This means understanding our animal nature: 'Having the same vital needs [as animals], man derives the means by which he breathes, moves, looks and listens, the very brain with which he coordinates his senses and his movements, from his animal forbears.'[4] It also means understanding the importance of the environment.

Dewey is not precise in the consequences he draws from these claims, but he is clear that,

to grasp the sources of esthetic experience it is . . . necessary to have recourse to animal life below the human scale. The activities of the fox, the dog, and the thrush may at least stand as reminders and symbols of that unity of experience which we so fractionalise when work is labor, and thought withdraws us from the world. The live animal is fully present, all there, in all of its actions: in its wary glances, its sharp sniffings, its abrupt cocking of the ears. . . . As you watch, you see motion merging into sense and sense into motion. . . .[5]

Dewey the reflective philosopher wants to develop an esthetic theory founded on a new appreciation that the rational should not be separated from the instinctual:

A bird builds its nest and a beaver its dam when internal organic pressures cooperate with external materials so that the former are fulfilled and the latter are transformed in a satisfying culmination. We may hesitate to apply the word 'art', since we doubt the presence of a directive intent. But all deliberation, all conscious intent, grows out of things once performed organically through the interplay of natural energies.[6]

He later continues, 'The existence of art is the concrete proof of what has just been stated abstractly. . . . that man uses the materials and energies of nature with intent to expand his life, and . . . does so in accord with the structure of his organism – brain, sense organs, and muscular system.'[7] The nature of art is therefore determined by the inner organs. The most important is the brain where the sensory and motor systems meet.

Among the many ramifications of Dewey's theory of the natural roots of art one comes out in the chapter entitled 'The Natural History of Form'. There he describes the natural origin of our interest in rhythm and notes how our understanding of the rhythms of nature has changed through history. After the first awareness of the rhythms of day and night and rain and sunshine, came a realisation of the importance both of the large-scale natural rhythms of the seasons and the small scale man-made rhythms of patting, chipping and moulding, until we arrive eventually at the rhythms of 'astronomy, geology, dynamics and kinematics' and the mathematics of the molecule, atom and electron.[8] Such is the importance of this unfolding understanding of the rhythms of nature that 'Underneath the rhythm of every art and of every work of art there lies, as a substratum in the depths of the subconsciousness, the basic pattern of the relations of the live creature to its environment.'[9] The way in which Dewey conceives of the successive changes in that pattern affecting art is illustrated by his anticipation that one day even the latest discoveries of the rhythms of physics may become the subject of poetry and implicitly of art. While a writer such as Riegl saw the interest in rhythm as universal, Dewey saw it as something that changed its focus as the priorities of culture changed.

He already felt that the discovery of such underlying principles had created a climate more favourable than ever to the understanding of art: 'The fact that science tends to show that man is a part of nature has an effect that is favourable rather than unfavourable to art, when its intrinsic significance is realized and when its meaning is no longer interpreted by contrast with beliefs that come to us from the past. For the closer man is brought to the physical world, the clearer it becomes that his impulses and ideas are enacted by nature within him.'[10] The better we understand nature, the more we understand art.

This perception of the commonality of our biological nature does not mean that we all share similar 'impulses and ideas'. Expanding on his earlier general remarks about the importance of the environment and his detailed observations of the unfolding awareness of the rhythms of nature he points out that 'The noblest man living in a desert absorbs something of its harshness and sterility, while the nostalgia of the mountain-bred man when cut off from his surroundings is proof how deeply environment has become part of his being. Neither the savage nor the civilized man is what he is by native constitution but by the culture in which he participates.'[11] Dewey's reference to culture here reveals a slippage found in other writers discussed in this volume. When he talks of the desert and the mountain he is talking of the influence of nature, not of culture. The culture of the mountain or desert

man is different only because their natural environment is different. The reason why he avoids the word nature is the same one that causes coyness in others in this volume. It is because he is anxious to avoid any suggestion that the 'civilised' or 'savage' man is so by nature, in other words because of their own nature, that he avoids the word in this context. At a time when racism and eugenics claimed to be founded on the idea that there were natural differences between people, he wanted to emphasise that those differences are above all 'cultural', that is the product not of a genetic nature, but of experience after birth. Although he does not describe the mechanisms involved, he is sure that what makes us different is the way in which our 'brain, sense organs and muscular system' are affected by our environment. Those mechanisms are now clearly understood. The 'plasticity' of the brain does indeed mean that our behaviour and culture are necessarily influenced by our environment, not just the natural environment stressed by Dewey, but all of it, man-made and social.

Dewey did not understand the specificities of neural plasticity, but he was able to use his recognition of its impact as the basis for an explanation of the way in which art was developing in his own world:

> the habits of the eye as a medium of perception are being slowly altered in being accustomed to the shapes that are typical of industrial products and to the objects that belong to an urban as distinct from rural life. The colors and planes to which the organism habitually responds develop new materials for interest. The running brook, the greensward, the forms associated with the rural environment, are losing their place as the primary material of experience. Part at least of the change of attitude of the last score of years to 'modernistic' figures in painting is the result of this change.[12]

So powerful is the effect that 'Even the objects of the natural landscape come to be "apperceived" in terms of the spatial relations characteristic of objects the design of which is due to mechanical modes of production; buildings, furnishings, wares.'[13] One of the most crucial aspects of his argument is that just as he earlier played down the importance of the intellectual and the rational, now he minimises the role of the conscious. The reason for the change he describes has nothing to do with the artist's intentions. It is simply a consequence of the laws governing perception. If our environment changes, our way of seeing will change. Such is the remorselessness of the process that it will change not only the art that is made, but even the experience of landscape. The growth of the urban and the mechanical does not only mean that we acquire 'new materials for interest', it even changes the way in which we experience the previously familiar world of nature.

This is why, in 'modernist' art, man and the natural landscape were coming to acquire the properties of the machine-made.

Although Dewey acknowledges the importance of the brain as the place where the sensory and motor systems come together, like most people in the twentieth century, he was happier talking not of the brain but the eye. Still, it is really the brain that he is talking about and his understanding of the changes in perception that he divines in the world around him accords better with modern neuroscience than do the views of anyone earlier.

As to the origins of his ideas, the role of William James's thought is undeniable, but probably we should stress not so much the thought itself but the experiences it provoked him to go through. James saw the individual human as an organism responding with intelligent alertness to the specificities of his environment and it was because Dewey, following James, responded to his particular environment with extraordinary alertness that he developed his highly perceptive views. He may have sensed in his own mind's eye the way the experience of industrialisation changed the way in which he responded to the landscape.

He will also have imagined looking through the eyes of others. Living in an America, which was highly differentiated in its landscape, with contrasts between fertile plains, rocky mountains and dry desert that were far greater than those available in Europe, and which accommodated a much greater diversity of ethnic origins than any European country at the time, he was in an excellent position to observe the extent to which people transplanted from their original environment adapted to one that was completely new. Also, living in America, where the monuments of earlier cultures formed a much smaller proportion compared to those of the present which were often much more startlingly modern, as were the skyscrapers of New York and the stainless steel railway cars that he refers to at different times in his book, he was confronted much more directly with the way in which the modern world impacted those who inhabited it. Whether he just reflected on his own reactions or analysed those of his contemporaries, he could recognise much more readily than a European the way changes in the environment had transformed both ways of making art and ways of seeing, and he could accept that this occurred without the changes having registered on people's consciousness. It was because the contingencies of ecological variety, large-scale immigration and rapid industrialisation made unprecedented demands on his and his American contemporaries' neural plasticity that he came to understand so well the consequences of that property of our nervous system for the history of art.

22

Herskovits

An interest in the nature of visual perception can have many sources, and in the case of another American, the anthropologist Melville Herskovits (1895–1963), it grew out of his concern to understand the differences between the cultures he studied. The interest in such differences may well have been originally sparked by a childhood experience of a dramatic change in his own cultural environment caused by his mother's ill health. When, at the age of ten, he moved from Bellefontaine, Ohio, to El Paso, Texas, he would have experienced a contrast in natural and cultural environments as great as any available within the United States. What is certain is that a concern with cultural difference was later fuelled by a commitment, inherited from his teacher, the German Franz Boas, to combat ethnocentrism.

This tendency was particularly manifested in the habit among members of different social groups of unconsciously using their own customs and values as the standard against which those of other groups were to be judged. As he and other anthropologists had observed, the phenomenon was universal and in most cases was not particularly damaging, since communities often occupied separate geographical areas. The situation had changed, however, with the expansion of Europeans out of their own region. When they occupied and administered the territories of other groups the consequences of this unconscious prejudice could be very destructive. The more ethnocentric the Europeans were the more likely they were to adversely affect the peoples with whom they came in contact and over whom they had power.

Many anthropologists had attempted to describe and confront the manifestations of ethnocentrism, using tools such as the study of behavioural and linguistic difference, but Herskovits and others realised that psychology offered the opportunity of exploring the aspect that made it most dangerous, its roots in a process of 'enculturation' which was largely unconscious. The degree of this uncon-

sciousness was, they noted, made most evident in the typical state-
ment of the enculturated person that the members of their com-
munity behave in a way that is 'only natural'.[1]

One of the fields in which this is sensed most directly is that of
vision. People tend to think that seeing involves them in a process
of direct contact with the world, but psychologists such as J. J.
Gibson, who was powerfully affected by his work with pilots during
the Second World War, were increasingly showing how 'visual per-
ception is mediated by indirect inference systems' which are built up
as a result of experience.[2] Since differences in visual perception
could be established using test responses to diagrams that were
physical and did not require verbal formulation, they could be
studied transculturally. This meant that rigorous analysis of the out-
comes of such a study offered the possibility of demonstrating the
worldwide variation in such 'inference systems', and this in turn made
it possible to establish beyond doubt that seeing was not as 'natural'
as people thought but was liable to be culturally influenced.

It was to explore this aspect of perception that Herskovits and a
group of colleagues set up a meticulously planned study that resulted
in the publication in 1966 of a book called *The Influence of Culture
on Visual Perception*. The idea was to 'go into the field with the appro-
priate psychological instruments and techniques and attack the
problem empirically'.[3] Although the book was published after Her-
skovits's death, the project out of which it grew was one largely for-
mulated by him and the resulting interpretations followed his
guidelines. As Marshall Segal and Donald Campbell, his principal col-
laborators, wrote in the preface: 'One of his last professional activities
was to edit an earlier draft and plan the present form of this book.'[4]

The starting point was to follow up the observations of W. H. R.
Rivers, the British doctor and anthropologist, from over fifty years
earlier. Rivers, who had specialised in neurology, had become
involved in ethnography during the groundbreaking expedition to
the Torres Straits off northern Australia organised in 1898 by his
friend A. C. Haddon. Rivers had shown, by a series of tests, that non-
European peoples, first the Torres Straits islanders and then the
Todas from the Nilgiri Hills of south India, reacted differently from
Europeans when presented with potentially illusionary diagrams.
Thus, the non-Europeans were less susceptible to the Müller-Lyer
figure (fig. 22) but more susceptible to configurations consisting of
only two lines, one horizontal and one vertical (fig. 23). Rivers had
attempted to explain the discrepancies in response in terms of dif-
ferences of environment and Herskovits and his group were now
ready to offer a more coherent set of hypotheses. These were

22 (above) Müller-Lyer illusion diagram, test image from M. H. Segall, D. T. Campbell and M. J. Herskovits, *The Influence of Culture on Visual Perception*, 1966, fig. 2

23 (right) Horizontal-vertical illusion diagram, test image from M. H. Segall, D. T. Campbell and M. J. Herskovits, *The Influence of Culture on Visual Perception*, 1966, fig. 4

founded upon an assumption that people who live in different environments react to different 'ecological clues'.

The hypotheses were as follows:

1. The so-called optical illusions result, at least in part, from learned habits of inference that possess ecological cue validity.
2. In different physical and cultural environments, different habits of inference are likely to be acquired, reflecting the different ecological validities.
3. For figures constructed of lines meeting in nonrectangular junctions, there will be a learned tendency among persons dwelling in carpentered environments to rectangularize those junctures, to perceive the figures in perspective, and to interpret them as two-dimensional objects. Such a tendency produces, or at least enhances, the Müller-Lyer illusion [fig. 22] and the Sander parallelogram illusion. Since the tendency is assumed to have more ecological validity for peoples in Western, or carpentered, environments, it is predicted that Western peoples will be more susceptible to these illusions than peoples dwelling in uncarpentered environments.
4. The horizontal-vertical illusion [fig. 23] results from a tendency to counteract foreshortening of lines extended into space away from a viewer, so that the vertical in the drawing that is the stimulus for the illusion is interpreted as representing a longer line. Since the tendency has more ecological validity for peoples living mostly outdoors in open, spacious environments, it is pre-

dicted that such peoples will be *more* susceptible than Western peoples in urban environments. On the other hand, some non-Western groups should be *less* susceptible to the illusions, e.g. rain forest or canyon dwellers.

5. Learning to interpret drawings and photographs should enhance some of these illusions, whereas learning to produce drawings representing three dimensions should reduce the illusions.[5]

It was these hypotheses that they set out to test in a study of 'cross-cultural susceptibility to visual illusions' developed by a team that included psychologists and statisticians. The test at the heart of the study involved showing individuals a series of illusions, such as the Müller-Lyer figure, and asking each respondent a question, such as 'which line is longer?' The test was administered to fifteen different sample populations, thirteen 'non-western' peoples, twelve in Africa and one in the Philippines, and two other groups, one of South Africans of European descent, and one of Americans from Evanston, just north of Chicago, subdivided into the members of a suburban community and a cohort of undergraduates. Just as Darwin in *The Expression of the Emotions in Man and Animals* had described his method and published his questionnaire about human emotional responses from around the world, so the authors of this new volume not only gave an elaborate account of the group's methods, but also published all the test materials.

Since it was anticipated that the most important variable in the respondent groups would be their physical environment, this was also summarised.

> Five samples (Fang, Bete, Ijaw, Dahomean children, and Hanunoo) live in rather dense compressed environments that do not provide extended vistas . . . Six samples (Senegal, Ankole, Toro, Suku, Songe, and Zulu) live in open savanna, where they enjoy broad, though somewhat irregular vistas. Three samples (Evanston adults, Northwestern University students, and South African Europeans) live in highly carpentered urban environments lacking the extended vistas of the savannas, but with frequent long, flat streets. One sample (Bushmen) inhabits a desert.[6]

Other important variables noted were that in all the non-Western samples there was a considerable degree of rectangularity in the furniture except in the case of the Zulu, Bushmen, Senegalese and Hanunoo, and that the Zulu and Bushmen also tend, unlike the rest, to live in circular houses.

24 Rank order of
samples on each
of five illusions,
from M. H.
Segall, D. T.
Campbell and
M. J. Herskovits,
*The Influence of
Culture on
Visual
Perception*,
1966, fig. 4

Table **10** *Rank Order of Samples on Each of Five Illusions*

	M-L	Sander	H-V (⊥)	H-V (¬)	Perspective
Ankole adults	14	14	5	5	11
Ankole children	11	11	2	6	2
Toro adults	20	22	7	3	13
Toro children	4	13	14	1	16
Suku adults	19	23	3	13	9
Suku children	28	27	8	9	8
Songe adults	22	24	22	12	20
Songe children	16	15	10	14	21
Fang adults	21	12	6	16	10
Fang children	13	6	16	11	6
Bété adults	24	25	27	27	28
Bété children	25	17	26	28	19
Ijaw adults	23	8	11	18	25
Ijaw children	12	19	19	7	22
Ijaw school children	10	5	9	4	3
Zulu adults	18	9	28	22	15
Zulu children	8	1	25	17	12
Bushman adults	26	a	12	15	18
S. A. European adults	6	10	23	25	27
Mineboy adults	27	26	15	10	23
Senegal adults	9	21	1	23	24
Senegal children	5	7	21	24	26
Dahomey children	7	16	4	2	17
Hanunóo adults	15	20	24	26	4
Hanunóo children	17	18	17	8	1
Evanston adults	2	4	13	20	14
Evanston children	1	3	20	19	5
Northwestern adults	3	2	18	21	7

[a]The Sander parallelogram was not administered to the Bushmen.

After the tests had been administered in the different settings, the results were first tabulated before being analysed statistically (fig. 24). Conclusions were then drawn on the correlation between the responses and the different ecologies of the sample populations. The study's organisers thought that the most important result was the consistency in the responses of the South African Europeans and the North American samples.[7] Together they were the most susceptible to the Müller-Lyer and Sander figures, while occupying the median of all groups in their susceptibility to the two horizontal/vertical figures. This fitted with the predictions that the susceptibility to the first two illusions would be at its greatest in the populations living in the most 'carpentered environment' and that the potential susceptibility to the horizontal figure illusions in populations who frequently experienced lines running away from them into the distance would be reduced if they were also used to seeing two-dimensional representations of three-dimensional objects. The researchers were reassured by the fact that their findings corresponded with those of Rivers over half a century earlier.

Another result which matched those of Rivers was that the desert-living Bushmen, who had the least 'carpentered' environment were, as had been the Torres islanders and the Todas, the least susceptible to the Müller-Lyer and Sander figures. There was some surprise that the South African 'mineboys' also showed little susceptibility to those two illusions, since they did live and work in a 'carpentered' environment, and it was speculated that perhaps their perceptual habits were those that had been established in childhood before they had come to the 'carpentered' towns.[8] For the two right-angle illusions the results were not all so clearly predictable, but some were as expected. The adult Ankole, Toro and Suku, all of whom live in open savannah, were, as expected, the most likely individuals to have difficulty matching the lengths of the vertical and horizontal lines, since they would often have seen landscape features running into the distance as foreshortened lines. Equally, the Bete and Hanunoo, who lived in relatively compressed environments with few vistas, were, as expected, among the best at getting the two lengths right. At the same time other groups conformed less well with expectations.

Reflecting on the results, the team had various proposals for following it up. For example, they were interested by the fact that among the Evanston adults those individuals who had been brought up in towns showed, as might have been expected, a greater susceptibility to the Müller-Lyer illusion, and they considered carrying out further tests to explore the rural/urban divide. They were also anxious to test the hypothesis that susceptibility to the horizontal/vertical illusion varied in relation to the degree of exposure to foreshortened views by testing such deep-canyon and rainforest dwellers as the Havasupai Indians in Arizona and the Bambuti Pygmies in the Ituri Forest of the Congo at one end of the scale and Eskimos at the other.[9]

Throughout, although the team clearly felt that they were on the right track, they were aware that there were many alternative explanations for the variations in their test results. These ranged from such factors as 'differential failure to communicate the task' to 'behavioral or physiological differences of a nonperceptual nature'.[10] Nevertheless they knew that they had moved well beyond both the juxtaposition of miscellaneous data gathered in varying circumstances and the collection of anecdotal evidence. Above all they believed that they had advanced discussion of the main issue as they saw it, the proposition then current among social scientists 'that human perception is culturally influenced'.[11]

Their goals were in a sense remarkably limited, being above all to contribute to the debate on the merits of the concept of 'cultural

relativism'. However, in the post-war period when people in general were anxious to dispose of the 'racial' and other prejudices that had been widespread in the 'Western' world, which had been most virulent and destructive in Nazi Gemany, the concept offered new hope. One of the best examples of how their research created a more salutary climate was that it showed that while the most urban and educated groups were unable to see the true relationships in the Müller-Lyer figure, those often thought to be the most 'primitive' and least educated got them right. To put it another way, the most mathematically minded group were the least able to measure a line correctly and the least trained in that field the best. The authors never explicitly explain to what use their findings might be put, but they certainly formed a weapon in the hands of anyone wanting to expose the error of much racial stereotyping, and they greatly encouraged those who believed that if you change someone's environment you can change the way they think.

The authors' particular shared agenda helps to explain one of the oddest features of the study, the claim, announced in the book's title, that it is about the way in which perception is influenced by *culture*. This is certainly one aspect of their study, but much more important is the broader argument that perception is influenced by *environment*, whether cultural or natural. When they refer to the desert influencing the perception of the Bushmen or of the rainforest potentially influencing that of the Pygmies they are talking about features that are purely natural, in which human culture plays no part. Presumably the main reason that they never acknowledged this larger dimension to their enterprise is precisely because they were only really interested in 'culture', but it is likely that they, like Dewey before them, were also inhibited by a desire to avoid any discussion of nature as such. Quite simply, at that period, any discussion of nature was liable to evoke debates that had destroyed social life in Germany and that were still, at the time in the late fifties and early sixties, poisoning community relations in their own country, the United States.

Although the group tried to avoid discussing nature in their conclusions, in chapter one they made some acknowledgement of biology, indeed, of neurobiology, because they could use it to weaken their opponents' assumptions. As they said, 'The anatomy of the nervous system produces a preponderantly one-way transmission of messages from the eyes and other sense organs to sensory projection areas in the brain, then through the complex association areas to motor projection areas in the brain and finally to skeletal musculature in the execution of responses.'[12] The mistake people make, they point out, is to locate 'conscious experience as

a concomitant of central nervous system activity at some site prior to the association areas'.[13] It is more correct to think that such experience is located either in the association areas or even later, because that would acknowledge that previous learning can affect our response. They thus only use the brain to explain why their rivals are wrong. They are unwilling to use brain science themselves. Still, the introduction of the topic does prepare the way for others who are less cautious to ask more detailed questions about the more intricate workings of the separate areas.

The results of the Herskovits study were reviewed in 1980 by the psychologist, J. B. Deregowski, in a book entitled *Illusions, Patterns and Pictures: A Cross-Cultural Perspective*, which also addressed a number of the broader issues raised by the earlier study. Deregowski thus first presents the explanation for phenomena such as the Müller-Lyer figure offered by the neurologist Richard Gregory.[14] According to Gregory the angles at the ends of the Müller-Lyer lines are treated by the brain as the right angles of cuboid objects. Their acuteness or obtuseness allows them to function as 'depth cues'. In the real world they would play an important role in the first stage of the process of 'constancy scaling' which allows someone to adjust for the apparent difference in length between, for example, the nearer and farther legs of a table. In the flat illusion they produce an adjustment of the length of the line without producing an impression of depth. Deregowski then goes on to deal with objections to the 'carpentered world' hypothesis, such as the suggestion that it could be invalidated if some other influence could be demonstrated. As he says,

> This is not so. The hypotheses do not suggest that the particular environmental effects are sole determinants of illusions, but merely that the illusory effects are influenced by the environment. This means that other influences, both environmental and non-environmental, may be present and hence that the effect may vary even when those environmental influences which are explicitly stated in the hypotheses remain constant.[15]

In general Deregowski went along with Herskovits's team's interpretations of variation in the response to illusion and, in his use of Gregory, recognises the significance of the fact that they were supported by the latest neuropsychology.

Today it is possible to go further. Such is the brain's economy, that it often generalises from an individual's experience. This is most clear in our experience of escalators or moving staircases. Once the brain registers that staircases that look like that are not stationary, the brain

always prepares our body to move appropriately whenever our eye tells us we are approaching one, even when the mechanism is not in operation – as we have all found out to our cost. In just the same way, if we have spent enough time surrounded by cuboid objects, our neural apparatus will come to automatically adjust the lengths of lines with acute angles at the ends downwards and of lines with obtuse angles at the ends upwards – wherever we find them. It makes much more sense to explain our deception not in terms of logical 'inference' as did Herskovits and his team, but in terms of the automatic responses generated by neural networks whose configuration has become more or less permanent as the result of frequent exposure to particular features of our environment.

23

Gombrich

'My approach is always biological. I always try to go back to the beginning.'[1] Not everyone would recognise the first sentence as the words of Ernst Gombrich (1909–2001), but they are and, embedded in Didier Eribon's penetrating book-length interview, *A Lifelong Interest: Conversations on Art and Science* (1993), they appear to provide a clear summary of how he viewed his own enterprise. I say 'appear', because one of the secrets of Gombrich's success was his ability to say or write things that seemed to resolve problems and decide issues, only to move a few sentences later to some paradoxical complication or even to a denial of what we thought he had just claimed.

The present case is an excellent example. Didier Eribon takes him at his word and goes on to ask, 'But isn't it a problem, to mix up cultural explanations, biological explanations, sociological explanations and aesthetic explanations, all in the same book [*The Sense of Order*]?', a verbal trap from which Gombrich cunningly escapes by the evasive response: 'It is only a problem of presentation, not of theory.'[2] By lifting the discussion away from the dangerously hard terrain of theory into the softer air of rhetoric he creates enough space for himself to be able to move off in any direction he likes. We find a related example earlier in the interview. There Gombrich introduces the idea of a style having an ecology and goes on to explain what the word means for a biologist, only to add: 'Of course I am using the word as a metaphor.'[3] Taking advantage of this gloss he is then authorised to use the term as loosely or precisely as he wishes. And this is what he does when he goes on immediately afterwards to give it a hard sense, using it as a weapon against his tough Hegelian opponents. 'But', he continues, 'I think it [that is, ecology] is a little more precise than, let us say, the Marxist theory in which the primary production creates the superstructure that itself creates the particular style. I think there are many more factors interacting that make it more likely that a particular style will prosper. And when

these factors change, the art style may die out.'[4] Typically Gom-
brichian, he claims that his biological metaphor is superior to the
Marxist architectural metaphor because it is more 'precise', and yet
that precision consists entirely in the fact that it is more open, accom-
modating many more factors. The superficial precision of the Marxist
image is exactly what makes it inexact. It is just too simple and too
schematic. Gombrich wants more space to deal with complex phe-
nomena than the Marxist image offers and the biological concept of
ecology gives him that. Once again we have a clear statement of his
interest in biology, but once again there is uncertainty as to whether
his interest is truly scientific or just metaphorical.

 There are probably two main reasons for this uncertainty. One is
that, as we have seen, it allows him great flexibility in his approach
and makes it more difficult for others to prove him wrong. The other
is that he probably always felt a humanist's reluctance to come too
close to the world of science. To claim that he was only metaphori-
cally scientific, whatever that meant, allowed him to escape the con-
straints implied by the rigorous tests of the scientist and left him free
to set his own private standards for the enquiries he pursued. It is
worth remembering that for Gombrich this negotiation of the fron-
tier between the sciences and the humanities carried a particular
frisson because of his close personal relationship to Karl Popper. His
friendship with the prophet of scientific method gave him an excep-
tional ease with science, but it also made him realise what pitiless
judges its practitioners could be. Gombrich was not just ambiguous
in his relation to biology. He was ambiguous in his attitude to science
in general. This is why his writings cleverly exploit scientific knowl-
edge and theories, but rarely themselves sound scientific. The
rigours of Popperian scientific method may bind the processes of
history and even great artists, but not Gombrich himself, who prefers
to present himself less as a scientist than as a storyteller.

 We will return to the issue of Gombrich's relation to science as a
whole later on, but for the present we must concentrate more nar-
rowly on his relationship with biology and biological metaphor. As
we have seen his interest had two aspects. First, biology allowed him
to get to the origins of things and, second, it offered an explanatory
framework that acknowledged their complexity. He may not have
been a biologist, but when trying to understand art he saw the
advantages of a biological approach.

 Gombrich's interest in biology had deep roots. As a child in Vienna
he remembered being drawn to the Naturhistorisches Museum
when his father had wanted to take him to the Kunsthistorisches
Museum across the square, and, when he became a student of art

history in the same city, his teachers were pupils of the scholars such as Wölfflin and Riegl, whose lives had been changed by Darwin and the discoveries of neuroscience. Even when he came to Britain to the Warburg Institute, where he eventually became Director, his first task was to write a biography of its founder, Aby Warburg, who, when in Florence in 1889, wrote in his diary that in Darwin's *The Expression of the Emotions in Man and Animals* he had found 'at last a book which helps me'.[5] Gombrich had many reasons for being interested in the natural world.

At the same time, however, he had a number of reasons for not wanting to think biologically. One of the most important was that he had been made all too conscious of the dangers with which such thought could be associated. Brought up in Austria as an assimilated Jew, his experience, first, of anti-Semitism in the twenties and, then, of Nazism in the thirties, had made him wary of biology in general and a biology of inheritance in particular. As he says in his interview with Eribon when talking of Konrad Lorenz, 'because he was basically a biologist, I suspect he remained a racist all his life', adding with characteristic naughtiness that the proof of this was that when he met Gombrich in Vienna before he died he told him that he thought the Jews were the most intelligent people anywhere, 'which is racist'.[6]

This may be one of the reasons why he appears never to mention the discovery of DNA and never discusses its potential implications, but his avoidance of any discussion of the brain and its operations may have other reasons. So systematic is this avoidance that it must surely have been deliberate, with the few cases where he does use the word 'brain' or even refers to one of its areas, 'the visual cortex', being the result of a slip of security. In any case the avoidance is so systematic that it must be based on principle, and I suspect that principle is one of reverence. He simply preferred to treat the brain as if it was a 'black box', whose intricacies are too obscure, or a 'Holy of Holies', whose contents are too sacred. Or rather he preferred to treat the *human* brain in that way. It is probably not by chance that on the few occasions when he does use the word brain it is to refer to the mechanical stimulus/response of the animal central nervous system. Typical is his account of Niko Tinbergen's work with sticklebacks discussed in Gombrich's *Art and Illusion* (1960): 'Tinbergen's sticklebacks always postured in their aquarium when red mail trucks passed the window at some distance, for to their brains red stands for danger and rivalry.'[7] It was the *human* mind that he did not like to treat biologically or as a machine.

His horror of any assimilation of man to animals or of man to machine is best expressed in a passage that follows immediately on

from that just quoted. Having explained how Konrad Lorenz and Tin-
bergen had shown that animals, such as birds and fishes, will react
to man-made objects provided that they have enough properties in
common with those things to which evolution has adapted them to
react, and having suggested that we respond similarly in our deal-
ings with art, he adds an important reservation:

> Now I don't believe that the mystery of Raphael will one day be
> solved by the study of gulls. My sympathies are all with those who
> warn us against rash speculations about inborn reactions in man
> – whether they come from the racialist camp or that of Jung. The
> dignity of man, as Pico della Mirandola felt, lies precisely in his
> protean capacity for change. We are not simply slot machines
> which begin to tick when coins are dropped into us, for, unlike the
> stickleback, we have what psychoanalysts call an 'ego' which tests
> reality and shapes the impulses from the id.[8]

A similar aversion to mechanical reductionism in the name of
science is found in his discussion of Riegl in the introduction to *Art
and Illusion*: 'But this single-mindedness, which he took to be the hall-
mark of a scientific approach, made him a prey to those pre-scientific
habits of mind by which unitary principles proliferate, the habits of
the mythmakers. The "will to form", the *Kunstwollen*, becomes a
ghost in the machine, driving the wheels of artistic development
according to "inexorable laws".'[9] Just how deep – and how rationally
founded – is his antipathy to mechanical interpretations of science
comes out in his diatribe a couple of pages later against any simple-
minded use of evolutionism as an explanation of stylistic change:

> If every change is inevitable and total, there is nothing left to
> compare, no situation to reconstruct, no symptom or expression
> to be investigated. Change becomes the symptom of change as
> such, and to hide this tautology, some grandiose scheme of evo-
> lution has to be called in, as happened not only to Riegl but to
> many of his successors. There are few historians today, and even
> fewer anthropologists, who believe that mankind has undergone
> any marked biological change within historical periods. But even
> those who might admit the possibility of some oscillation in the
> genetic make-up of mankind would never accept the idea that
> man has changed as much within the last three thousand years, a
> mere hundred generations, as have his art and his style.[10]

On this basis he rejects any attempt to use genetically controlled
changes in the physiology of *Homo sapiens* as explanations for
changes in culture.

A similar aversion explains why, although he devoted some effort to the study of perspective and binocular vision, he hardly refers to the anatomy of the eye, only occasionally mentioning the retina. Similarly he gives no account of the retina's vital centre, the fovea. All that he could do, being most happy when discussing things in terms of behaviours, is to talk of 'foveal activity'. This shyness when it comes to dealing with the physiology of perception is the more surprising given that he was ready to collaborate with Richard Gregory in editing a volume entitled *Illusion in Nature and Art* (1973), where he published an important article by one of the young leaders in the analysis of neural activity, Colin Blakemore, about the detailed functioning of the networks of neurons in the brain.[11] His reluctance to use Blakemore's important conclusions was probably increased by his awareness that everything he inferred about the human brain was based on work with cats and monkeys. Gombrich may have preferred simply to disregard such research, much as he banned abstract art from early editions of *The Story of Art* (1950) because he felt it would taint the higher products of artistic intelligence in the same volume. There were some lines Gombrich refused on principle to cross, even when it might have been in his interest to do so.

Fortunately, we no longer need to be so cautious, and it is possible now to revisit his arguments and note where neurobiology and neuropsychology either support or weaken his claims. We can take as a first example a few observations in his first book on art history, *The Story of Art*. In the first chapter on prehistoric and primitive art Gombrich talks about the role of art in magic among the peoples he calls primitive. The connection between art and magic may seem a strange idea in the mid-twentieth century, but, as he reminds the reader, it is not so far from our own experience:

> All that is necessary is the will to be absolutely honest with ourselves and see whether we, too, do not retain something of the 'primitive' in us. Instead of beginning with the Ice Age, let us begin with ourselves. Suppose we take a picture of our favourite champion from today's paper – would we enjoy taking out a needle and poking out the eyes? Would we feel as indifferent about it as if we poked a hole anywhere else in the paper? I do not think so. However well I know with my waking thoughts that what I do to his picture makes no difference to my friend or hero, I still feel a reluctance to harm it. Somewhere there remains the absurd feeling that what one does to the picture is done to the person it represents.[12]

This passage is remarkable for the way in which Gombrich draws on his own experience, as he moves from talking about primitive

people, to talking about 'we' to talking about himself. Such assimi-
lation of the sophisticated modern art historian to a primitive man
will not have been easy for him, and he implies as much in his
description of his feeling as 'absurd'.

Still, the idea he presents is not new. In the late nineteenth
century, the period when his teachers were educated, one particu-
lar extension of empathy theory had led to the notion of sympa-
thetic magic as a key principle in the belief systems of early
civilizations and pre-literate peoples. One of the most familiar
examples was the widespread conviction that injuring a wax or
wooden image of someone could result in real injury to the person
him or herself. As with other aspects of empathy theory, we can now
see more clearly that the universality of the phenomenon is due to
universal attributes of human biology, the operation involved being
rooted in inherent characteristics of the neural networks of the
human brain. One aspect of the complexity of human mental activ-
ity is that our brain is able to develop networks linking a particular
object to any other with which we experience it as being in some
way associated. For example, neural networks may link an individ-
ual, not only to his or her appearance and name, but to objects he
or she possessed, people he or she knew, or places with which he
or she is associated, and so robust are these connections once
established in our brain that to hurt not just an image or a written
name, but anything strongly connected with someone, feels like an
injury to that person. This mechanism, whose power results in phe-
nomena such as the Roman *damnatio memoriae*, the obliteration
of someone's memory by destroying his representations and inscrip-
tions with his name, some iconoclasm, and much modern vandal-
ism, is fundamental to our neuropsychology. The notion that such
connections are biologically rooted is confirmed by the existence
of related behaviours in the great apes. For example, one of the
most revealing behaviours that has been observed in chimpanzees
is that, when one individual has been injured by another, the injured
party may some time later take vengeance by hurting not the indi-
vidual who hurt him but one of his close friends. Evidently the friend
is so closely linked in the neural networks of the injured party, and
probably of all members of the band, that an injury to him has the
same meaning as an injury to the perpetrator of the original afflic-
tion. We can now even identify the region of the brain where both
real and vicarious pain is experienced, the insular cortex. As so
often, Gombrich discovers by a simple act of self-reflection in a
domestic setting, reading a newspaper at home, a mechanism that
can now be much better understood as a result of scientists in lab-

oratories and in the field working in such specialist areas as neurobiology and ethology.

Apart from this passage, biology plays a very small part in *The Story of Art*. In *Art and Illusion*, published ten years later in 1960, it is still not much discussed directly, but there are many more gestures in the direction of the brain and of animal behaviour, and once again later science has shown that many of these gestures were well judged. Already in

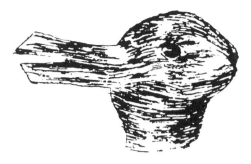

2. Rabbit or duck ?

25 'Rabbit or duck?', from E. H. Gombrich, *Art and Illusion*, 1960, fig. 2

the introduction and again later on Gombrich draws our attention to the implications of the rabbit and duck illusion.[13] As he points out, try as we may we cannot see both rabbit and duck at the same time (fig. 25). He uses this observation to refute those who claim that illusion is a simple matter. We can now go further in explaining the phenomenon by drawing attention to another aspect of neural networks. Without being too mechanistic or reductive it is possible to conceive of the brain as working rather like an encyclopedia that classifies similar things, such as types of animals, together, giving each its own neural equivalent of a page. In an extreme case a single group of neurons may only react to the sight of a single creature or the sound of its name. Visual information goes through the layers of the cortex before arriving in the temporal lobe. There it is first recognised as an animal before being sorted as cat or rabbit. Recognition of either is made by the firing of distinctive sets of neurons. It is physically impossible for both to be activated at the same time. The function of the brain is to organise our experience of reality and it would obviously create confusion if we recognised, for example, two animals simultaneously. As Gombrich says, we can move rapidly between two alternatives, but we cannot, for reasons revealed by later work on neurobiology, experience the recognition of both simultaneously.

Gombrich's reservations about research into the mechanisms underlying artistic activity held him back from pursuing this line directly, but he could allow someone else who had fewer problems with the mechanical, Sir Winston Churchill, to express almost a direct wish for research into the neurological analysis of his activity as an amateur painter. With justifiable admiration he quotes Churchill's

perceptive reflections on the process of painting. As the accomplished amateur says,

> It would be interesting if some real authority investigated carefully the part which memory plays in painting. We look at the object with an intent regard, then at the palette, and thirdly at the canvas. The canvas receives a message dispatched usually a few seconds before from the natural object. But it has come through a post office *en route*. It has been transmitted in code. It has been turned from light into paint. It reaches the canvas a cryptogram. Not until it has been placed in its correct relation to everything else that is on the canvas can it be deciphered, is its meaning apparent, is it translated once again from mere pigment into light. And the light this time is not of Nature, but of Art.[14]

Gombrich then follows up his hero's call, though with a different emphasis: 'I am not that "real authority" on memory to whom Sir Winston appealed for an explanation of this mystery, but it seems to me that we will be able to tackle this aspect only after we have learned more about that "transmission in code" which he discusses.'[15] Whatever the level of agreement between Churchill and Gombrich – and both had much contact with codes during the war – it is possible that the statesman may have been inspired to state his wish for enlightenment by his awareness of the difference in the effectiveness of the artistic memories of the amateur and the professional artist, and fortunately this particular phenomenon has been the subject of some remarkable recent research.

In 2000, within the framework of a project named Sciart, the Wellcome Trust in London funded research designed to explore the difference between the brain activity of a professional portrait painter, Humphrey Ocean, and that of an amateur when copying a portrait. What the research revealed was very exciting. Although both amateur and professional artists looked to the outsider as if they were both going through the same motions described by Churchill, the scanner monitoring their blood flow by functional Magnetic Resonance Imaging (fMRI) revealed a great divergence.[16] While in the brain of the amateur artist it was the visual cortex at the back of the head that was most active, in the professional, even when he appeared to be looking most intensely, it was not in the back, but the top and front, the area of the association cortex, where the strongest activity was found. In the scientific commentary on the experiment in the exhibition it was suggested that this was because, when the professional painter looked at his subject, he was able immediately to access networks already built up during previous

periods of attentive looking and so draw on a greater existing reservoir of knowledge.

What is true of portrait painting must be true of all other types of painting from nature. In a lecture given in 1965 and subsequently published as 'Visual Discovery Through Art', the first essay in *The Image and the Eye: Further Studies in the Psychology of Pictorial Representation* (1982), Gombrich approvingly repeats what Max Liebermann said, quoting his teacher: 'What you cannot paint from memory you cannot paint at all.'[17] Neurobiology has proved Liebermann's teacher, Liebermann, Churchill and Gombrich all to have been right. The answer Churchill looked for lay exactly where he expected it, in memory, and confirmation was also provided for Gombrich's claim for the importance for successful representation of prior knowledge.

Other experiments offer support for very different claims in *Art and Illusion*. At one stage, for instance, in a passage immediately following his sneers about the relevance of the study of gulls to the understanding of art, Gombrich grudgingly does mention evidence that humans are like animals in their biologically driven reactions:

> It can be argued, and has been argued, that we respond with particular readiness to certain configurations of biological significance for our survival. The recognition of the human face, on this argument, is not wholly learned. It is based on some kind of inborn disposition. Whenever anything remotely face-like enters our field of vision, we are alerted and respond. We all know the feeling when fever or fatigue has loosened the triggers of our reactions and a pattern on the wallpaper suddenly appears to look or leer at us with a threatening grin.[18]

His reluctance to acknowledge the phenomenon is evident in the phrases, 'it can be argued and has been argued', at the beginning, and his association of the experience with a loosening of conscious mental control at the end. Again, we still do not understand all elements of the neurobiology that underlies this phenomenon, but neuroscientists have claimed that facial recognition in humans can be localised to an area of the temporal lobe known as the 'fusiform face area', while it is certain that in monkeys there are individual neurons that only fire when confronted with the face of a member of the same species. These properties of our nervous system have been selected for by evolution because they endow us with abilities that are crucial for our socialisation and so for our survival.

The book in which Gombrich comes closest to the biological approach is *The Sense of Order* (1979). Though still apologetic, he

is certainly more forthright. Thus, in the preface to the first edition, while acknowledging that 'the sense of order is not a distinctively human prerogative', he asserts that 'it means no derogation from man's unique achievements to look for their roots in our biological inheritance', going on to point out that the biological approach has a noble model in the English eighteenth-century artist, Hogarth, who claimed, as we saw, that the human preference for the wavy line which he called 'the line of beauty' delights us because it reminds us of the pleasure of the chase. 'The love of pursuit is implanted in our natures, and designed, no doubt, for necessary, and useful purposes. Animals have it evidently by instinct.'[19] In the preface to the second edition of 1984 Gombrich is more direct in his statement that the book is designed 'to establish and test the theory that there exists a Sense of Order which manifests itself in all styles of design and which I believe to be rooted in man's biological inheritance.'[20] In the introduction he even comments on the changed climate of debate: 'We are no longer afraid . . . to use teleological arguments and to ask why our mental make-up favours simplicity both in perception and in making. If these tendencies did not have a strong survival value they would not have come to form part of our organic heritage.'[21]

There are two reasons for the new emphasis. One is associated with the book's subtitle, *A Study in the Psychology of Decorative Art.* Quite simply the book is a study *only* of ornament, especially the repetitive patterns that man has made for thousands of years wherever and whenever he has lived. This manifestation of the human spirit is much lower down Gombrich's scale of values than the heroic conscious attempt to represent all of reality, the subject of *Art and Illusion*. It is also closer to the artistic products of the animal world, that is it is more like birdsong and less like a Haydn quartet. This similarity between decorative art and animal art is well suggested by the three opening colour plates, which show first two Slovak embroidered bonnets and then a bower bird nest (figs 26 and 27), both of which have a role in courting. The other reason for the greater acknowledgement of human biology is more interesting. It is the result of Gombrich's realisation that progress in several areas of science, ranging from the study of animal behaviour to information theory, could shed light on ornament in a way that they could not on any other area of art.

A particular consequence of his interest in recent scientific developments, especially in information theory and the study of animal behaviour, is that for the first time he is encouraged to look optimistically to the future. For example:

the new intellectual disci-
pline of the theory of infor-
mation appears to hold
greater promise for psychol-
ogy than the earlier acc-
ounts of the Gestalt school.
For in this technique of the
communication engineer the
information is measured by
its degree of unexpected-
ness, while the expected
becomes in their terminol-
ogy 'the redundant'.[22]

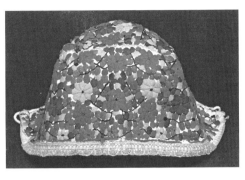

26 Bonnet from Slovak folk costume, 19th
century, from E. H. Gombrich *The Sense of
Order*, 1979, plate 1

Even more enthusiastically, he
contradicts Plato in the name of
the ethologists when he talks of
the phenomenon that he calls
'graded complication'. As he
says, 'we now know that such
manifestations of the "sense of
order" are not confined to
human beings.' He then goes on
to describe Desmond Morris's
account of the behaviour of the
chimpanzee, Congo, in *The
Biology of Art* (1962) and specu-
lates that, although the ape
never discovered true patterns,
this might one day happen:
'Whether or not another ape

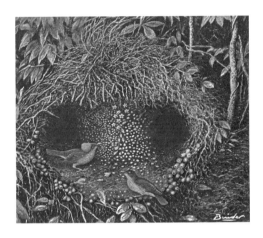

27 The nest of the bower bird, from E. H.
Gombrich, *The Sense of Order*, 1979, plate 2

may one day discover the pleasure of building more complex hier-
archies we cannot tell. After the achievements of the Gardners with
their chimpanzee, Washoe, nothing seems impossible.'[23] He even
comes close to talking of neurobiology. Thus, although in the intro-
duction he appears to put the issue on one side, saying: 'whatever
the fate of the Gestalt school may be in the field of neurology',[24] later
he takes it on directly. Speaking of the operations of the central
nervous system he states: 'Students of perception have discovered
what they call "feature detectors": these operate in the visual system
of certain animals such as cats, and respond to particular arrange-
ments such as horizontal or vertical lines, which must thus stand out
in the environment.'[25] Gombrich wonders whether humans are also

pre-wired for such coding. He apparently still hopes not: 'Maybe it could be argued that man is less in need of specifically inbuilt responses because he can code and hold simple forms in his memory, in language and in art.'[26]

Of the points Gombrich makes here some have turned out to be much more useful than others. Indeed, the one that is most important to him is perhaps the one that has yielded the least benefit to those studying art. Information theory's discovery of the importance of redundancies for the economic transmission of data has had much influence on computing, the field in which it is at home, but it has not revealed much about the visual arts, principally because they are little concerned with messages and certainly less with economy than Gombrich would have wished. On the other hand the point that he plays down, the discovery of 'feature detectors', is likely to have a major influence on the understanding of all aspects of vision, including art. The slow realisation of the extent to which the human brain, like the brain of other creatures, is equipped with neurons that may respond to particular 'features', such as those that respond to lines of a particular orientation discovered by Hubel and Wiesel in 1959, is extremely important. Knowledge that their functioning is improved by exposure even more so.

Where Gombrich was certainly right to look to the future is in his growing respect for chimpanzees. The work of Sue Savage-Rumbaugh with the bonobo chimpanzee Kanzi, presented in *Kanzi: The Ape at the Brink of the Human Mind* (1994), has not only revolutionised our opinion of chimpanzees but has changed our view of ourselves. Her demonstration that chimpanzees can use symbolism, language and even grammar, once thought to be exclusively human properties, although they do not have anything like language themselves, dramatically challenges the assumption that it is by the use of language that humans have acquired these distinctive abilities and in doing so it undermines the whole concept that human thought depends on our unique rationality (*ratio* from *oratio*, Latin for 'speech').[27] The 'speechlessness' of chimpanzees is particularly significant because it makes it virtually certain that the only field in which they could have acquired these abilities is the visual, and this increases the likelihood that art has been as important a vehicle for the development of human culture as speech and literature.

Another area in which Gombrich came down on the right side is in his increasing acceptance of psychological explanations for the worldwide appearance of such artefacts as pots which are anthropomorphic, that is thought to possess human traits. As he says of

the general problem of the recurrence of formal types throughout the world and through time,

> The decorative arts pose this problem with particular urgency, and we might be spared many more strained explanations if we could attribute all intriguing parallels to the spontaneous generation of similar forms for similar functions. I do not believe we are entitled to do this in every case, but I side with those who think that the reaction against the psychological bias of the generation of Frazer, Freud, Loewy and Jung has perhaps overshot the mark.[28]

In support of his idea he calls on Claude Lévi-Strauss who says that when diffusion cannot explain the similarity between forms: 'we must turn to psychology or the structural analysis of forms and ask ourselves if inner connections of a psychological or structural nature do not allow us to understand such frequent and simultaneous occurrences which cannot possibly be the result of the simple play of probabilities.'[29] However, his support for Lévi-Strauss is not unreserved. He is sceptical about his social explanations, whether represented by the anthropologist's support for Carl Schuster's theory that South-East Asian embroideries reflect marriage relations or his own interpretation of split representation in several cultures in terms of kinship patterns, but he approves of Lévi-Strauss when he finds 'the twin roots of our response to music in such biological rhythms as breathing and in the acquired language of musical culture.'[30]

There are many other cases in which things that Gombrich observed have recently been given neurobiological support. Take for example his account, described in the article 'Visual Discovery Through Art' referred to earlier, of the way 'a hungry rabbit catcher will scan the field for his quarry with such intensity that a clod of earth or a clump of leaves may tempt him, unless he has learned to hold his imagination in check.'[31]. Gombrich discusses this phenomenon using the terms through which it had been studied by psychologists of perception, talking of 'mental set' and 'projection', but we can now trace the origin of such mental sets, showing how the more often we look at a configuration the more the neurons in our brain that support this act of seeing will be activated and connected; so that with time we will have a greater readiness to see it. The 'mental set' is really a neurological phenomenon.

This is hardly a surprise, but it has been much more of a revelation to discover the specific neurological basis of another phenomenon noted by Gombrich: 'Unless introspection deceives me, I believe that when I visit a zoo my muscular response changes as I move from the hippopotamus house to the cage of the weasels.'[32]

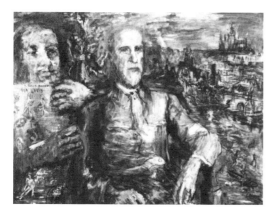

28 Oskar Kokoschka, *Thomas G. Masaryk*, 1934–6, 29 Photograph of Oskar Kokoschka
Pittsburgh Museum of Art, Carnegie Institute

Gombrich relates the phenomenon to earlier psychological notions:

> I am here led back to the old theory of empathy, which played
> such a part at the turn of the century not only in the aesthetics
> of Lipps and Vernon Lee but also in the writings of Berenson,
> Wölfflin and Worringer. This doctrine relies on the traces of mus-
> cular response in our reaction to forms; it is not only the percep-
> tion of music which makes us dance inwardly, but also the
> perception of shapes.[33]

As we have already seen, we can agree with him, relating both
Gombrich's experience and the theory of empathy to a whole set
of recent discoveries about the neural basis of our visual response
to other humans and even other animals, of which the most remark-
able has been the identification of the so-called mirror neurons,
which may cause us to be unconsciously influenced by every pose
or movement that we see. When, for example, we see someone else
moving their right hand the neurons in our motor cortex that control
our own right hand also become activated. Our hand may not move,
but, without our knowing, the neurons in the premotor cortex that
control it follow the movements made by the other person. Such
'mirror neurons' explain much of how we rapidly learn from watch-
ing other people and they may also explain another phenomenon
noted by Gombrich following Leonardo. This is the way painters
make the people they paint look like themselves, as in the example
of Oskar Kokoschka's portrait of Tomáš Masaryk which ended up also
looking like the artist himself (figs 28 and 29).[34] If when we look at
someone else's face the muscles controlling our own face are also

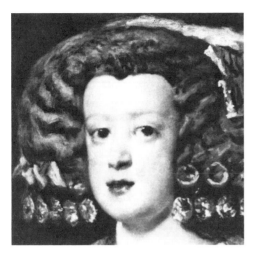 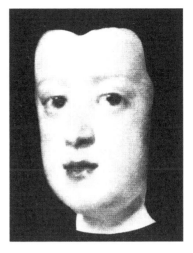

30 Diego Velázquez, *Infanta Maria Theresa*, c.1651, Musée du Louvre, Paris

30 Diego Velázquez, Infanta Maria Theresa without coiffure, from E. H. Gombrich, *The Image and the Eye*, 1982, fig. 106

activated, it becomes more understandable that when we paint someone else we are liable to paint ourselves. Mirroring neurons certainly lie behind the miracle noted by Gombrich that babies can learn how to make expressions from watching their mothers.

There are only a few cases where neurobiology works against Gombrich's argument. One relates to another observation in the same essay where he uses his understanding of the Müller-Lyer effect to explain why when the coiffure is removed from Velazquez's painting of the Infanta Maria Theresa her eyes look closer together so making her appear more intelligent (figs 30 and 31). He may be right in his observation, but it cannot be because of the Müller-Lyer effect (fig. 21). As noted earlier, our susceptibility to the Müller-Lyer illusion is caused by the way in which our neural networks have been formed as a result of spending our lives in cuboid spaces surrounded by cuboid objects. As discussed earlier, we are so used to experiencing obtuse angles at the ends of these lines parallel to the picture plane which are farther away and acute angles at the end of those lines which are closer that our neural networks automatically lengthen the farther line with its obtuse angles and shorten the nearer one with its acute angles.[35] It is thus not the extension of the line that is important, as Gombrich suggests, but the change from acute to obtuse angles at the ends. As in other cases where science may now prove him wrong, Gombrich would surely be only too

happy that an argument he was advancing could be falsified in good Popperian terms, so providing a stronger foundation for later scholars to work on.

Many of Gombrich's insights came from his reading of other people's theories, but an important extra dimension is his constant reference to anecdotal personal experience, such as that concerning his response to different zoo animals. Indeed, since this is such a distinctive strength of his research, it is worth reflecting on its sources. Why were such experiences so important for him? After all we are apt to think of academics such as Gombrich as getting their ideas partly out of conversations and listening to lectures, but above all out of books. We tend to think of their intellectual development in terms of what they have read, their bibliographic history. However, in Gombrich's case everyday experience seems to have been just as important, which suggests that if we want to understand him we have to follow his biological history. Why should this be the case? One suggestion could be that his personal history confronted him with so many new and demanding experiences which had such an influence on the formation of the connections in his cortex that he genuinely became more alert to his environment than most of his contemporaries. The history of his intellectual development offered here thus places a special emphasis on the history of a particular type of progressive complication of his neural networks.

The main stages of this are clear. Born in 1909 into a comfortable Viennese family of converted Jews, most of the assumptions with which he had been brought up were shattered in the two decades between his tenth and thirtieth birthdays. Some of the assumptions challenged were among the most basic. After the First World War his situation changed from being that of someone who was privileged to one of someone who was almost starving. To rebuild him physically and psychologically he was sent to Sweden to live with a woodworker's family. There everything was new, not only the food, but the language, the landscape, the typical activities and the social relations. Back in Vienna again a year later he found that the state of which he was a citizen had changed from being an empire ruled by an emperor with vast dominions to a parliamentary democracy. Also within a few years he was confronted with violent anti-Semitism. He was able to escape for a time to Italy, another country with a different environment which was also in the course of rapid transformation with the rise of Mussolini. But he was soon back in Vienna where his career prospects rapidly collapsed and where the chance invitation to write *Eine kurze Weltgeschichte für junge Leser* (A Short

World History for Young Readers) (1935) required that he rapidly familiarise himself with countries, cultures and periods which would otherwise have remained virtually unknown to him. A subsequent invitation to go to another country, England, with his Czech-born wife to work in a German institution, the Warburg Institute, would have placed further strains on his existing neural resources and when the Second World War broke out he was confronted with further changes of perspective. His new assignment for the BBC World Service to listen to German radio broadcasts demanded very different skills from those of the art historian, and, although his long-standing interest in music and his experience of living with several languages would have helped him, he would certainly have had to develop many new neural resources.

The fundamental role of this last experience, that of listening to German broadcasts, in stimulating some of his most important theoretical reflections was formally acknowledged by him several times. He made a clear statement to Eribon that this was the source of his interest in perception and especially the origin of his realisation that auditory perception depends on prior knowledge of what is likely to be said.[36] Listening to crackling indistinct German broadcasts he was reminded again and again of how much his ability to make sense of the noise depended on his knowing what the speaker was talking about. The same lesson could easily be applied to vision. Indeed, nothing was more fundamental to his work on the psychology of perception from *Art and Illusion* to *The Sense of Order* than his insistence that the eye is not a passive instrument, and that our ability to make sense of our environment depends on a combination of inherited inclinations and acquired experience. He liked to quote Popper's mocking characterisation of the passive eye point of view as the 'bucket theory of the mind', as in the introduction to *Art and Illusion*,[37] and spent much of his time defining the more active view of perception that he dealt with in part three of the same work under the heading 'The Beholder's Share'.

All this he admitted to have been provoked by the one particular and repeated experience, listening to indistinct broadcasts, and we are entitled to extend his line of reasoning. His extraordinary personal history seems to have affected all his work in ways that ranged from the unimportant to the crucial. Of course, Gombrich was not alone in the variety of his experiences. The turmoil of the inter-war period forced many people, especially refugees, to change their environment a number of times, and I suspect that in a number of their cases too such biographical interruptions were critical for later intellectual achievements. Among people of similar interests,

however, the range of his experience was probably exceptional. He also had a particular interest in psychology, which can be traced back through his Freudian friend, Ernst Kris, with whom he worked on caricature, to figures such as Riegl.

Speaking more generally it is also possible to draw attention to the amount of time he would have spent in London waiting for and travelling on buses and underground trains while the city was being destroyed around him. As an already exceptionally visually and aurally alert person, his responses to the changing human and material environment would have become increasingly complex and, taken together, these experiences may have played a vital role in enhancing his self-reflectivity. They certainly made such an impact on his consciousness that he encouraged others to expose themselves to similar circumstances, as in his request in the introduction to *Art and Illusion*: 'I can only appeal to the reader . . . to train himself a little in the game of self-observation, not so much in museums as in his daily commerce with pictures and images of all kinds – while sitting on the bus or standing in the waiting room.'[38] Gombrich could not have known the extent to which his personal history was endowing him with a distinctive neurobiology, but throughout his writings we sense he was aware that he was more sensitive and analytical in processing what came to him through his eyes and ears than were most people.

One consequence of this was that he was constantly able to test the theories and apply the arguments of the many scientists with whom he was in contact, so becoming informally an experimental scientist himself. This enabled him not just to use the ideas of scientists, but to extend them. During his long life he moved from Freudian psychology to Gestalt psychology and then to Gibsonian environmental psychology, as well as from earlier Darwinian evolutionary theory to the latest in animal ethology, ending up with information theory. Each new idea he put to the test and often came up with observations that impressed the original scientists. This is why he could justifiably proclaim in a late preface to *The Story of Art*, not that he had learned from scientists, but that he had influenced them:

I am fully aware that speculations, as yet unsupported by controlled experiments, cannot qualify as psychological theories. But what starts as a mere 'hunch' can sometimes be turned into a scientific hypothesis in expert hands, and I have been so fortunate as to see this happen with informal suggestions I have put forward in the past.[39]

Gombrich was amazed at the influence his judicious perceptions had on the scientific world of psychologists and biologists. Perhaps his influence was in some ways greater in those fields than in that of art history because in the end a biological approach was simply of greater interest to scientists than to humanists. Richard Gregory, the influential professor of neuropsychology, confirmed his status as an authoritative figure on the fringe of science when he mentioned Gombrich, along with the great Ernst Mach, as one of the proponents of 'biologically based theories of aesthetics'.[40]

24

Baxandall

Gombrich's most important heir in the application of biology to the understanding of art is Michael Baxandall (1933–). Baxandall was his student at the Warburg Institute, before beginning a career as an art historian which has taken him from the Victoria and Albert Museum, back to the Warburg Institute, and then to the University of California at Berkeley.

Baxandall's biological interests will surprise some. Most readers never notice that his notion of the 'period eye' is presented as neurologically based. He begins chapter two of *Painting and Experience in Fifteenth-Century Italy. A Primer in the Social History of Pictorial Style* (1972), in which he launches that influential concept, with a paragraph that could be at home in a textbook of neuroscience:

> An object reflects a pattern of light on to the eye. The light enters the eye through the pupil, is gathered by the lens, and thrown on the screen at the back of the eye, the retina. On the retina is a network of nerve fibres, which pass the light through a system of cells to several million receptors, the cones. The cones are sensitive both to light and to colour, and they respond by carrying information about light and colour to the brain.[1]

Having described the universal properties of the visual system, he then goes on to explain how it becomes differentiated:

> It is at this point human equipment for visual perception ceases to be uniform, from one man to the next. The brain must interpret the raw data about light and colour that it receives from the cones and it does this with innate skills and those developed out of experience.

This stress on individual experience is crucial, because, as he goes on:

32 Woodcut plan of Holy Sepulchre, Jerusalem, Santo Brasca, from *Itiner-ario...di Gerusalemme*, Milan, 1481, p. 58v

each of us has had different experience, and so each of us has slightly different knowledge and skills of interpretation. Everyone in fact processes the data from the eye with different equipment. In practice these differences are quite small, since most experience is common to us all. Yet in some circumstances the otherwise marginal differences between one man and another can take on a curious prominence.[2]

Baxandall then takes the example of an apparently abstract diagram (fig. 32), in fact the ground plan of the Holy Sepulchre in Jerusalem, and gives a number of examples of how people in different places will see it differently, exemplifying what he calls contrasting 'cognitive styles', concluding 'so here are three variable and indeed culturally relative kinds of thing the mind brings to interpreting that particular "pattern of light" '.[3] In each case the brain responds by reference to three elements: a stock of patterns, training in a range of representational conventions and experience, drawn from the environment as we search for plausible ways of visualising what we have incomplete information about, noting with some desperation that 'the process is indescribably complex and still obscure in its physiological detail'.[4]

Baxandall here goes further than anyone previously in acknowledging the way in which different visual experiences make us see differently, but there are clear limitations to his approach which affect the tone of the rest of the book. His reference to *cognitive* – my emphasis – style reveals that he is primarily concerned with the discernment of objects, a function related to higher rational operations and this is why throughout the book Baxandall is principally inter-

ested in the way the brain is structured by formal training. This allows him to demonstrate how the study of rhetorical gestures, dance positions and so forth gave people in fifteenth-century Italy an expertise in hands which came out in their art. In fact he hardly acknowledges the purely passive exposure to the environment whose potential influence he implicitly alludes to. The main reason for this is that, in spite of his generalising claim about the nervous system, he still really only respects the conscious brain, but the other reason is that he quite simply did not have access to the discoveries of the last thirty years which show that our neural networks are being reshaped from minute to minute, not just by our training, but by everything to which we are exposed. What neuroscience now empowers us to do is to greatly extend Baxandall's theory of the period eye to a notion of each individual having different visual preferences depending on their experiences. The more we know about somebody's experiences the better we can reconstruct the ways in which these are likely to have influenced the formation of their neural networks, and that allows us to understand better how the operation of those networks will have influenced their behaviour, whether in the making of or response to art.

The best indicator of the limitation of Baxandall's perspective is that he has never, as far as I know, taken his idea of the way in which the brain itself is affected by experience any further, preferring instead to refine his understanding of the visual gateway of the brain, the eye, which is much less 'obscure in its physiological detail'. An example is provided by his article on 'Fixation and Distraction: The Nail in Braque's *Violin and Pitcher* (1910)' (1994) published in a volume in honour of his teacher, Gombrich. There he first picks up on Gombrich's reflections on Hogarth's earlier observation both of the decline in acuity of vision between the centre of the retina, the fovea, and its periphery and of the movement of the eye in 'saccades' to compensate for this.[5] He then takes advantage of his own much more detailed understanding of the physiology of vision to show how Braque had unconsciously exploited both phenomena to increase the effectiveness of his composition. Baxandall's starting point is a recognition that

> much psychophysical and neuropsychological experiment now suggests that perception involves two modes of attention: An 'endogenous' system would work with central, foveal vision: it is directed by cognitive demands for information about objects. But this can be overridden by an 'exogenous' system working with peripheral vision, operating more quickly, more automatically, and free of control by any higher-level search for enlightenment.[6]

177 Summary of the lateral synaptic system in the vertebrate retina. (**H**orizontal cells react both to and on **R**eceptors and **B**ipolars, on a graded intensity scale. **A**macrines react to and on Bipolars and Ganglions, but only on/off. Ganglions report to the visual cortex on specific sizes and placings of light in a specific receptive field.) From J.E. Dowling, 'Synaptic Organization of the Frog Retina: An Electron Microscopic Analysis Comparing the Retinas of Frogs and Primates', *Proceedings of the Royal Society of London, Series B*, 170 (1968), fig. 16, p. 223

33 Neural system of vertebrate retina, from Michael Baxandall, 'Fixation and Distraction: the Nail in Braque's *Violin and Pitcher* (1910)', in *Sight and Insight: Essays on Art and Culture in Honour of E. H. Gombrich at 85*, 1994, fig. 177

This leads him to reflect on the way in which the two systems interact in our response to the painting, with our attention to central objects, such as the nail and the violin, being constantly distracted by the stimulation offered by almost abstract properties such as a higher relative intensity of tone or sharpness of edge on the periphery, and this in turn leads him to detail the first stage of the mechanism involved, the retina's synaptic system. Commenting on the diagram of a section of the vertebrate retina (fig. 33), he notes that it is made up of a single layer of receptor cells, rods and cones, overlaid with four layers of processors and that this complex structure is not uniform throughout the surface. Not only are receptors concentrated in the fovea and then spread progressively more thinly towards the periphery, but the connections between receptors and processors are arranged in such a way that there is a further pattern of variation in neural response, with, for example, the ganglions that collect signals from the fovea to send up the optic nerve, serving receptive fields of different sizes, so delivering both coarse and fine-grain information. Baxandall here asks what is the point of so much variation in the grain of the information sent to the cortex and uses the results of those working on a machine model of this first stage of visual processing to answer that a mixture of coarse and fine filters prepares

34 Coarse registration in a machine model of vision, from Michael Baxandall, 'Fixation and Distraction: The Nail in Braque's *Violin and Pitcher* (1910)', in *Sight and Insight: Essays on Art and Culture in Honour of E. H. Gombrich at 85*, 1994, fig. 178

178 The utility of coarse registration in a machine model (MIRAGE) of early visual processing. (*From top down*: diagram of a 150-degree scene, parallel-lit from front; profile of reflected light values from a section across it; second derivatives of those values put through filters of *three* different degrees of fineness; sums of these values, peaks and troughs kept separate; analysis of zero-bounded values of these sums, indicative of objective features of the scene.) From Roger Watt, *Visual Processing: Computational, Psychophysical and Cognitive Research* (Hove and Hillsdale, NJ, 1988), Figs. 1.14, p. 21 and 2.7, p. 38

35 Georges Braque, *Violin and Pitcher*, 1910, Kunstmuseum, Basle

for a better representation of surfaces and forms than fine alone (fig. 34).[7] He then goes on to give further information on the different resources of the periphery and the fovea, noting principally that while peripheral vision is better at recognising solid closed forms the fovea is better at dealing with outlines. This in turn leads to the observation that while the painting's central violin and nail (fig. 35) work well as outlines, the pitcher, appropriately for an object typically perceived peripherally, is more solidly toned. This prepares for the final less certain move, the suggestion that there is a useful correlation between the length of time taken for cycles of scanning and fixation and short-term visual memory, a faculty that operates at the level below categorisation into objects, using something similar to what computational accounts of vision call a two and a half-dimensional sketch.

Having moved carefully backwards and forwards between near cer-
tainties about the operations of the retina and suggestions about the
operations of the cortex, Baxandall now proceeds to what he calls
the crux of the painting, 'the mysterious left flank'.[8] This consists of a
tall maze-like structure, the origins of which are revealed in other
paintings to be the fall of drapery over an object. Here, though, partly
as a result of uncertainties generated by cues elsewhere in the paint-
ing about the direction of lighting, it is left as a pattern of reversible
zigzags which is described as 'less lacking in reference to physical
forms' than 'ambiguous and contradictory'.[9] Because of this intract-
ability, while we can fixate easily on the two clearly outlined and
central features, the nail and the violin, stimulations of our peripheral
vision keep bringing us back to the left flank. And so we end up being
held in what Baxandall calls a 'perceptual lock'. From Braque's point
of view as a painter this is a good situation. While we lose interest in
the more determinate representations the left flank continues to
retain its freshness:

> Long after violin and jug have become old acquaintances one
> revisits with pleasure but no expectation of great new disclosure,
> and even after one has learned to accommodate and enjoy reshuf-
> fling the half-dozen or more possible pianos that the violin and jug
> are resting on, the left flank continues to challenge and arouse the
> cognitive itch. This is the side of the picture Braque and Picasso
> were going to move into next summer.[10]

Having, like a lawyer, painstakingly constructed his case that the
secret of the appeal of this area lies principally in the relation between
the eye's habits of scanning and the distinctive properties of the
retina's neural networks, Baxandall can come with his killer point, pre-
senting neuroscience as contributing directly to understanding the
history of art. It will be, he hints, an awareness of the attention-grab-
bing power of ambiguous forms that gives direction to Cubism's next
turn, with all that means for the future direction of art.

This then allows Baxandall also to suggest a new direction for art
history. In the final paragraph of the article he draws a broader con-
clusion from his exploration of the perceptual processes activated by
viewing the painting:

> A proper perception of *Violin and Pitcher* might be a state of
> having experienced many of the innumerable quantity of percep-
> tions within the picture's frame, having pleasurably exercised with
> them, and having come away with them still incompletely inte-
> grated or resolved. The picture is bracing, therefore, and in some

moods one is anxious to insist that its narrative theme is the intrin-sically moral one of the complexity and excitement of seeking true knowledge. However, the fabric of the performance is visual rep-resentation of visual knowledge, and that is a sign not transparent through to some paraphraseable semantic object somehow inside. The fabric is, precisely, scopic.[11]

In this view, perception is what the painting is about, almost its sub-stance. This places the neuropsychology of vision centre stage and in the reference to the 'state of having experienced many of the innumerable quantity of perceptions within the picture's frame' there is an echo of the statement that 'each of us has had different expe-rience, and so each of us has slightly different knowledge and skills of interpretation' which precedes the formulation of the concept of the 'period eye'. Baxandall's observation that the way in which the sequence of scannings and fixations that an attentive viewing of a painting calls for leaves us with an accumulated knowledge of the artist's enterprise is crucial. It opens the way to a myriad of microhis-tories of 'painting and experience'. Like each period, each painting forms its own 'eye'.

A book that exploits much of the same knowledge about the retina is *Shadows and Enlightenment* (1995).[12] The burden of this intrigu-ingly personal work is given in the preface. It is, 'a discussion of shadows and their part in visual experience. More particularly, it jux-taposes modern with eighteenth-century notions about shadows with a view to benefitting from a tension between them.'[13] The emphasis on the 'modern' is apparent from the second sentence of the intro-duction, which defines light as,

> the flux of mass-energy units emitted by a source of radiation. . . . These mass-energy units, or photons, are surplus energy, the surplus product of smaller particles combining together to become larger particles, and some of these photons are more energetic than others. *Visible* light consists only of photons in the middle of that energy range, which is plotted in terms of the pulse of elec-trical disturbance, or wavelength. These moderately energetic photons are visible in that cells on the retina of the eye have evolved to react to them.[14]

Here, perhaps for the first time, a major work of art history devoted to a particular period begins with an account of vision in terms of the interaction of the timeless laws of two fields of science, physics and biology, and throughout the book science, eighteenth century as well as modern, constantly enlightens history.

One consequence of this new relationship is that Baxandall becomes more ready to treat man as an animal with particular resources, an approach already suggested by the reference to evolution. It is thus relevant to his argument to refer to countershading as an adaptive resource in nature, with animals often protecting themselves by having uppersides darker than their undersides. The 'North American male bobolink', we learn, even reverses 'its shading tonality in the breeding season' in order to make iself more visible during that critical time.[15] Still, Baxandall is happier moving away from general animal nature to the observation, more strictly relevant to his

36 Sand shadows, from Michael Baxandall, *Shadows and Enlightenment*, 1995, fig. 9a

argument, that the human visual apparatus has an expectation that light should come from above, physically hard-wired into it: the expectation is not acquired, not even cognitive, but built into the retina, as can be demonstrated by the way in which a shaded image will reverse if turned upside down, with what were previously hollows becoming ridges (fig. 36).[16] Shadow perception is apparently 'evolutionarily primitive', which raises the interesting question about how accessible it is to conscious attention. This question is never answered but Baxandall's real problem is how do we read shadows and this he does deal with by reference in the first instance to 'machine vision' a resource he also used in the Braque study. Although he is highly sceptical about the ability of a machine to deal with such a complex task involving several independent variables, he does feel that the most sophisticated version using a parallel distributed processor with a learning algorithm has a sufficient degree of analogy with actual brain structures to be of some use at least as a model of the computation involved in the reading of relief, if not of a real human faculty (fig. 37).

Several other suggestive analogies with machine vision are then surveyed before he arrives at an overview:

To sum up schematically: The sensory elements in shadow perception are values of reflected light. These come to us through the receptor cells of the retina, an outstation of the brain, which pre-edits them, and so also the physical shadows, before onward transmission to the inner brain. The retina (1) is interested in luminance

37 Shape from
shading, using a
parallel
distributed
processor, from
Michael
Baxandall,
*Shadows and
Enlightenment*,
1995, fig. 13

13 Shape from shading by neural network. (a) The array of 122 receptors, on-centre and off-centre overlapping. (b) The processing principle: the receptors at the first level project to all of 27 units (3 × 9) at the second level which project to all of 24 output units (4 × 6) giving output in two dimensions, on positive/negative curvature magnitude across 4 rows and on curvature orientation down 6 columns. (From Sidney R. Lehky and Terrence J. Sejnowski, 'Network model of shape-from-shading', in *Nature*, 333, 2 June 1988, pp. 452–4, fig. 1 c. and a.)

discontinuities, not in what comes from them; (2) its standards for significance are both generally and locally variable in response to prevailing luminance levels; (3) it transmits separately to the cortex both fine and coarse takes of the same regions of the luminance array. This is what the visual cortex has to work with. At this point it becomes difficult to continue thinking about the process within the neurophysiological universe, though striking particular local-izations of function potentially relevant to shadow perception have been made. In particular, neurons responsive to quite complex and differentiated particular conformations of luminance gradation, which is to say areas of shading, have now been identified.[17]

He then takes us back to the computational universe of machine vision before a depressing conclusion:

At some point . . . hints or cues of suggestions of table and or tree or human figure must somehow offer themselves for matching. There is something bathetic about this moment, and there are notorious problems about the forms this imagery appears in – ana-logue and picture-like, or prepositional and specification-like, or two-dimensionally analogue and three-dimensionally proposi-tional, or whatever.[18]

Although we have learned much about the sort of information in rela-tion to shadows that the eye as an 'outstation' passes to the brain we are advised that, except in the case of the 'neurons responsive to . . . conformations of luminance gradation' noted in the previous para-

graph, it is virtually hopeless to reflect further on how the cortex deals with it.

The caution is well advised, but the reader may well wonder whether the degree of uncertainty does not partly depend on the way the enquiry was framed in the beginning. The resonances between the rather mechanistic eighteenth-century views of perception he discusses and modern attempts to engage machines in the simulation of that activity, which Baxandall exploits with such depth and subtlety, are ultimately constraining. A greater acknowledgement of the organic properties of the brain, and the importance of constant feedback between what is seen by the eye and neural resources built up by the viewer since birth, might still not yield robust results, but it would bring more to the table and would give more cause for optimism.

Another cost of the emphasis on the mechanical is that it inhibits discussion of a different aspect of perception which is important to him, visual pleasure, as alluded to in the reference to the 'pleasurable exertion in reading' the indeterminacies in the head of the figure in the sketch in the back of Jean-Baptiste Chardin's painting of the *Young Draughtsman*.[19] One of Baxandall's most important achievements is to identify, and almost quantify, the pleasure to be had from such visual experience and the last paragraph of the Braque article was substantially about the many 'pleasurable exercises' in perception that the *Violin and Pitcher* afforded the viewer.[20] The enjoyment to be had in perception as an activity in its own right had been suggested by earlier writers such as Hogarth and its importance as a drive had been acknowledged by the Gestalt psychologists, but Baxandall was the first art historian to recognise that such pleasure might be what a painting was ultimately about, and it is no accident that it emerges at the end of both article and book as the key to two of his favourite paintings. It is poignant that this pleasure, the importance of which he is the first to describe, has its source in a cerebral biochemistry that eludes expression in the machine models of perception on which he relies.

The other feature of the book that is at odds with the optical and mechanical view of perception that he presents is its acknowledgement of the importance of the vital rapport between the author and the changing ecologies in which he was working. Not only is there a long and sensitive passage in which Baxandall reflects on the experience of sitting outside a particular house, surrounded by particular furniture, under a particular tree on a particular day, but in the preface we are carefully informed that the book was written in two different seasons at two precise localties in England and two in France

'because in one way or another specific shadow landscapes from them enter the argument'.[21] The author's special, almost animal, alertness helps every sentence to transmit what seem the insights of a mobile hunting mind, its neural equipment constantly drawing on, working with and reworking the knowledge of things and ideas that has been carefully laid down by it over decades; but the model of perception offered is one that stops short of invoking such vital resources. The reader who waits to be given a tour of the brain as he has been taken inside the eye will be disappointed. The first level of perception is all that Baxandall has so far thought it responsible to present.

At the end of the Braque piece Baxandall came closer to acknowledging his reluctance to going further, admitting that in his study of attention he has only arrived at a 'low level':

> Higher levels of the attentive visual process introduce different kinds of problems, particularly when the attention is to complex paintings, and for various reasons I do not feel the cognitive sciences invoked here offer art criticism as much broadening suggestion for dealing with those higher levels: for that one must go elsewhere.[22]

He does not explain what that 'elsewhere' is, but one way of interpreting him is that when he writes of the limitations of 'the cognitive sciences invoked here' he is referring to the limited role in cognition of the eye's motor and neural attributes. In the article he only alludes to the vastly more complicated neural attributes of the cortex. Certainly, by his extraordinarily successful exploitation of an understanding of one aspect of neurobiology he challenges his readers to go further, extending that understanding to other areas. Just as Braque's handling of the left flank of *Violin and Pitcher* provided a key to the next phase of Cubism and to some extent of the history of art, so Baxandall's neuropsychological interpretation of that passage may provide a key to the future of art history.

25

Zeki

Aristotle was a scientist who was starting to realise the importance of biology for the understanding of human behaviour. Freud was a scientist who realised early on that such understanding could only come from a knowledge of the brain's structure, although he later abandoned a reliance on such knowledge to give his imagination, and his prejudices, more freedom. Semir Zeki (1940–) is the first scientist to both be familiar with the detailed workings of the brain and interested in applying that knowledge to the understanding of art. Trained originally as an anatomist at University College London, he worked with the leading neuroanatomist J. Z. Young before spending time in the United States. He then returned to University College where he became a leading pioneer in the study of the visual brain, eventually publishing *A Vision of the Brain* (1993). At the same time he was deepening his interest in music and art, and it was the convergence of these interests in his professional and private life that eventually led him to make the risky attempt to bring them together. As he found out more and more about the brain during the 1980s and 1990s, especially about the colour and motion areas, he realised that he was obtaining vital information about the processes underlying both the making and the viewing of art.

It is rarely easy to move between disciplines, and when Zeki's first article on the relation between art and the brain, 'The Neurology of Kinetic Art', which he wrote with Matthew Lamb, was published in a scientific journal, *Brain*, in 1994, it was principally thanks to the enthusiasm of its editor and treasurer.[1] It was only when he was invited to lecture on the subject at the Royal Institution in December 1995 by its then director, Peter Day, that he found himself on more neutral territory, following a long line of predecessors who had used the freedom offered by that season and location to cross academic boundaries. But he needed to go further, and after many conversations with artists, particularly Balthus, and an invitation from John Walsh, then Director of the Getty Museum, to spend some time in

Santa Monica as a museum scholar, he was ready to write *Inner Vision: An Exploration of Art and the Brain*, published in 1999.

Inner Vision, as the first extended treatment of its subject, is a landmark book. It is also significant for anyone working in the humanities who is considering making use of neuroscience, since it illustrates what a leading expert in the latter field believes can and cannot be achieved. Zeki's own mixture of ambition and caution is well illustrated by the opening words of the first chapter:

> This is not so much a book about art; it is more a book about the brain. It arises from my conviction that, in a large measure, the function of art and the function of the visual brain are one and the same, or at least that the aims of art constitute an extension of the functions of the brain; hence by knowing more about the workings of the brain in general, and of the visual brain in particular, one might be able to develop the outlines of a theory of aesthetics that is biologically based.[2]

This is a bold claim which he then qualifies:

> I say 'outlines' because our knowledge of how the brain works is still only very sketchy and we are therefore only able to account for how we see in an imperfect way. Given this imperfect knowledge, it is even more difficult to say much, if anything at all, about how and where the aesthetic experience that a work produces arises, nor yet about the neurology underlying the emotional experience that it arouses.[3]

This, however, he says, should not deter us. The limitation of our knowledge

> does not constitute a good reason for not trying to make a beginning in this direction. All visual art is expressed through the brain and must therefore obey the laws of the brain, whether in conception, execution or appreciation and no theory of aesthetics that is not substantially based on the activity of the brain is ever likely to be complete, let alone profound. And we have learned enough about the visual brain in the last quarter of a century, to be able to say something interesting about art, at least the perceptual level, which is what this book is mainly concerned with.[4]

After this rapid alternation between optimism and pessimism Zeki sets out to further lower expectations:

> Even here, however, one cannot be exhaustive; it is easier to write about some more modern movements in art, and I have therefore

concentrated on these. It is almost impossible to say anything beyond the most general about the relationship between brain physiology and the perception of some of the more complex, narrative and representational works, which is why I say less about them. My primary aim is to convince the reader that we are at the threshold of a great enterprise, of learning something about the neurological basis of one of the most noble and profound of human endeavours. Beyond that I hope that the pages of this book will constitute a modest contribution and a small step in laying the foundations of a neurology of aesthetics or *neuroesthetics*, and thus for an understanding of the biological basis of aesthetic experience.[5]

Zeki does not explain why it is easier to write about modern movements, but it is safe to guess that it is because he thinks that the experiments of neuroscientists, with their relatively schematic visual test materials, relate more closely to that kind of art. What does emerge clearly both here and in the preceding passages is that he regards his work as above all a contribution to the field of aesthetics. If he does not mention a possible contribution to art history, it is probably because he is genuinely more occupied with the loftier concerns of a branch of philosophy than those of a branch of history. He is thus a neuroaesthetician rather than a neuroarthistorian, but his writings clearly encourage art historians to take advantage of the knowledge he offers.

This is evident from his first statement that 'most painters are neurologists'. This initially startling claim he supports with the explanation that

they are those who have experimented upon and, without ever realising it, understood something about the organisation of the visual brain, though with techniques that are unique to them. . . . They do so by working and re-working a painting until it achieves a desirable effect, until it pleases them, which is the same thing as saying it pleases their brains. If, in the process, it pleases others as well – or pleases other brains as well – they have understood something general about the neural organisation of the visual pathways that evoke pleasure, without knowing anything about the details or indeed knowing that such pathways existed.[6]

What Zeki says here resonates with much that has been said in this book and he himself gives the example of how Leonardo's observation that the most pleasing colours are those that are opposed anticipates the recent recognition of colour opponency. But his

proposition goes beyond such conscious and verbally formulated reflection in its general claim that unconsciously artists are constantly reworking their paintings until they please their brains. Part of what is new here is the scientist's readiness to generalise about a humanist activity in biological terms. Another element is the emphasis on visual pleasure, which is inflected by Zeki's interest in contributing to aesthetics. What he is proposing is a new aesthetics based in neuroscience.

He then goes on to make more scientific points. One is that 'The artist can . . . only deal with those attributes of nature which his brain is equipped to see.'[7] For instance, the human visual system cannot deal with ultraviolet light nor with very fast movement, which is why no artist represents them. Few scholars in the humanities have the courage to acknowledge the extent to which biology can be a constraint on cultural activity, but for Zeki an acceptance of the brain's limitations are fundamental.

He knows that these limitations have their roots in man's biological history and in this first chapter, 'The Brain's Quest for Essentials', one of his priorities is to lay out the evolutionary reason why we have a powerful visual system in the first place. As he says, quoting his earlier book, *A Vision of the Brain*, 'We see in order to be able to acquire knowledge aboth the world.'[8] One of the reasons why he finds this definition worth exploring is because in it he finds

> the germs of a general and unifying theory that links the functions of the visual brain to the aims of art and that encompasses the views of philosophers such as Plato, Georg Hegel, Arthur Schopenhauer and Martin Heidegger, of artists such as Michelangelo, Cezanne and Matisse, and of the modern neurobiologist.[9]

There are several aspects to Zeki's claim here which are important. One is that it places him pleasingly close to philosophy and its search for truth. Another is that it enables him to put aside the whole area of enquiry into 'the emotional content of art, its ability to disturb and arouse and inspire. . . . these are subjects that have hardly been touched upon by neurology and therefore not at present worthy of a scientific description, which can only be so incomplete as to be entirely speculative'; however, this setting aside should be only temporary, as he hopes 'that it will not be long before we are able to look at the neurological foundations of aesthetics in a broader context',[10] a hope that he and others have since helped to some extent to fulfil as the new issues of neuroscience journals illustrate week by week. The most important aspect of his claim, however, is that, while neurology may not have much to say about response to the emotional, when it comes to the knowledge of objects it has

quite a lot to contribute that sheds light on the whole subject of visual experience.

The problem that the brain has to solve in its search for knowledge is outlined in the following paragraphs. The information reaching the brain from the outside world

> is never constant; it is instead in a continual state of flux. We see objects and surfaces from different angles and distances and in different lighting conditions. . . . Vision must therefore be an active process requiring the brain to discount the continual changes and extract from them only what is necessary for it to categorise objects. This requires it to undertake three separate but interlinked processes: to select from the vast and ever-changing information reaching it only that which is necessary for it to be able to identify the constant, essential properties of objects and surfaces, to discount and sacrifice all the information that is not of interest to it in obtaining that knowledge, and to compare the selected information with its stored record of past visual information, and thus identify and categorise an object or a scene.[11]

How the brain solves this problem is outlined in chapter three, 'The Myth of the Seeing Eye'.

This chapter begins with a trenchant critique of the traditional view that it is the 'eye' that sees, a view which Zeki rightly presents as extraordinarily persistent. As he shows, the erroneous view that the eye receives on its retina an image of an object which it then transmits to the brain, for the brain to work with as with a photograph, long outlived the discovery of the part of the brain that deals with such images. This was because it was soon discovered that the primary area of this part of the brain now known as V1 is itself laid out in the form of a 'cortical retina', so suggesting that the object was represented there too on something like a 'photographic plate'. This image could then be compared with similarly photographic images stored in the surrounding area, then called the 'association cortex'. Only in the last twenty-five years of the twentieth century did it become clear that this area surrounding V1 could be broken down into separate areas, V2, V3, V4, V5 and so on, each dealing with a different attribute of the visual scene, V4 for colour and V5 for motion, for example, all working together to process the signals from the retina (fig. 38). And even though this is now widely understood, he notes ruefully, it: 'has made no intrusion into the writing or thinking of art historians and critics, even those writing today'.[12]

Having identified a gap in the field of enquiry into art, Zeki then devotes the rest of the book to filling it, as in chapter seven, 'The

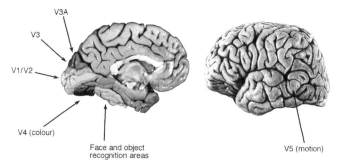

V3A

V3

V1/V2

V4 (colour)

Face and object
recognition areas

V5 (motion)

Figure 3.1(b)

The visual brain consists of
multiple functionally specialised
areas which receive their visual
input largely from V1 (yellow)
and an area surrounding it
known as V2 (green). These are
the best charted visual areas, but
not the only ones. Other visual
areas are being continually
discovered. For a better view of
V4 see Figure 9.2.

38 Specialised areas of visual brain, from Semir Zeki, *Inner Vision*,
1999, fig. 3.1b

Modularity of Vision'. Here he begins by adding more details to our
picture of the visual cortex. If we look at a section of area V1, for
example, he points out that it is possible to see so-called blobs
which indicate a column of cells of high metabolic activity that carry
information about the wavelengths of light which will eventually form
the basis of judgements about colour. This study of the specialisa-
tion in the response of cells can be extended:

The functional specialisation that is so prominent a feature of the
visual brain is, then, a consequence of the fact that the individual
cells which make up the visual brain are highly selective for the
kind of visual signal or stimulus that they respond to. A cell might,
for example, be selective for colour, responding to red but to no
other colours or to white; other such cells will respond selectively
to other colours. These cells are indifferent to the direction in
which the stimulus moves, provided it is of the right colour. They
are also indifferent to form, that is to say they will respond if a stim-
ulus of the appropriate colour is a vertical or horizontal bar, or if
it is a rectangle, circle or square. Or a cell might be selective for
another attribute of the visual scene, such as lines of a particular
orientation, or motion in a specific direction, and so on. . . . Again,
cells that are selective for lines of a particular orientation will

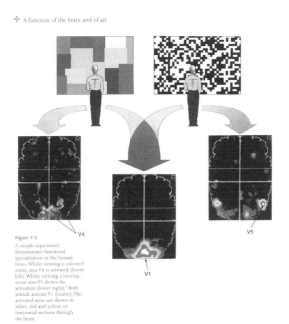

39 Experiment
showing
functional
specialisation of
the brain, from
Semir Zeki, *Inner
Vision*, 1999,
fig. 7.5

respond to that orientation regardless of the colour of the stimulus or the colour of the background against which it is presented.[13]

Given that these cells are located in different areas, such as V4 for colour and V5 for movement, the brain needs to find a way of coordinating this flow of signals. This it does by 'parallel processing . . . processing different attributes of the visual scene simultaneously and in parallel'.[14]

We are then presented with a description of the scientific experiments by which the separate identity of the different areas can be established. One of the ways in which this is done is by detecting changes of blood flow. When a particular cell responds to a signal it increases its metabolic rate, which boosts the demand for oxygenated blood, and this can be monitored by a procedure not actually named by Zeki, probably out of a desire not to 'frighten the horses' with too much technical detail, known as functional Magnetic Resonance Imaging (fMRI). Thus, for example,

> when a normal human being looks at a picture by Mondrian, that is one that is multi-coloured with no recognisable objects, the change in regional blood flow is restricted to area V1, which receives all the signals from the retina, and to a zone lying outside it, the V4 complex of areas (V4 in short) [fig. 39]. By contrast, if

human subjects look at a pattern of small black and white squares that move in different directions, one finds that the change now occurs again in V1 – because all visual signals pass through it first – and in another area quite distinct from V4, this one being referred to as area V5. Other experiments show that other attributes of the visual scene, such as the recognition of familiar faces, are processed by yet other areas of the visual brain.[15]

Zeki then goes on to use this knowledge to elaborate his hypothesis that artists are neurologists, introducing a cluster of observations on artistic movements of the twentieth century:

To a small and variable extent, which I discuss in greater detail in ensuing chapters, artists have tapped this specialisation in their work. Interesting in this regard is kinetic art, as well as Cubism. The development of the former is described in greater detail later but here it is interesting to point out that both Jean Tinguely and Alexander Calder, two dominant figures in kinetic art, often restricted their work to black and white. In his *Méta-Malevichs* and *MétaKandinskys*, Tinguely eliminated almost all colours to heighten and emphasise actual movement, while Calder thought that colour made mobiles more 'confusing' and, like Tinguely, eliminated colour in some, though not all, of the mobiles. Before them, Fernand Léger, always interested in motion but never making motion part of his work, nevertheless restricted his palette enormously. A similar restriction is a feature of many, though not all, Cubist paintings, especially the early ones belonging to the 'analytical' phase. Indeed, Picasso once defined Cubist art as: 'an art dealing primarily with forms, and when a form is realised it is there to live its own life'. More recent artists who have tried to realise form in their paintings, among them Ellsworth Kelly, have produced many works which are almost monochromatic, or at least in black and white. Although this fact is of some neurological interest, it is not a general rule. Cézanne, also interested in form, tried to modulate form by colour and David Hockney, a formalist, has also effectively rendered forms in violent colours.[16]

The proposal here is an intriguing one, that artists, being in some sense aware that different areas of their brains deal with different attributes, may restrict themselves to exploiting one area, such as that dealing with colour, or with form, or with movement.

This notion is supported by the observation that the signals from the retina not only go to different areas of the brain, but they take dif-

ferent lengths of times to arrive at their destinations. The differences
may be calculated in milliseconds, but they are significant in neural
terms. Colour is perceived before form, which is perceived before
motion, and it is important to stress that we are talking of conscious
perception here. This superimposition of a temporal on a spatial hier-
archy thus increases the inherent separation between the different
types of processing and allows us to talk of what Zeki calls 'mini-con-
sciousnesses'. In normal life we are not aware of this phenomenon
because the mini-consciousnesses are integrated in a larger con-
sciousness, but the existence of such a phenomenon would certainly
make it easier for an artist with a particularly alert mini-consciousness
in relation to a particular attribute to respond to it selectively.

In part two this approach is further refined, by looking at the brain
not in terms of areas but of individual neurons. In chapter eleven,
'The Receptive Field', Zeki explains how many cells in the brain
respond only when exposed to a particular colour, or a line of a par-
ticular orientation and in chapter twelve he suggests that some
artists, from Cézanne, to Malevich to Ellsworth Kelly and Barnett
Newman, can be seen to particularly exploit linear effects. Con-
necting this tendency to linearity with a search for simplification and
higher truths, such as was pursued in different ways by the Cubists
and the De Stijl group, he asks himself

> whether there is any relationship between the emphasis on lines
> that artists with the common aim of representing 'the constant
> truths concerning forms', have used and the neurophysiology of the
> visual cortex, where cells that are selectively responsive to lines of
> different orientation predominate (orientation selective cells).
> Again, this is my interpretation, not that of the artists, most of whom
> had finished their work before orientation selectivity in the human
> brain was discovered by David Hubel and Torsten Wiesel in 1959.[17]

The fact that the artists concerned often gave conscious intellectual
reasons for concentrating on lines does not convince him that that is
how they arrived at their artistic conclusions. It is their art that bears
the most compelling relationship to the neurophysiology of the organ
which is the most critical for producing visual art, namely the visual
brain. What he suggests, without claiming that it replaces other expla-
nations, is that a sensibility to the importance of these orientation
selective cells, which are found in large quantities not only in V1, but
in V2 and V3, and which are recognised to be crucial for our percep-
tion of forms, may have unconsciously strengthened the inclinations
of these artists to exploit linearity. He even points out that, since some
of these cells respond better to thin lines and others to thick ones,

and, since some of the configurations in the works of Malevich and others can, when viewed at a distance, be read as broad lines, this variation in receptivity may have promoted a parallel variation in form.

This argument is taken further in chapter thirteen, 'Mondrian, Ben Nicholson, Malevich and the Neurophysiology of Squares and Rectangles'. There he notes that the receptive fields (that is the arc of the visual field to which they respond) of cells in area V4, dealing with colour, are much bigger than those of the orientation selective cells in V1. He then goes on to point out that when he was testing for the receptive fields of these V4 cells he found that there were some that responded most vigorously to a blue square placed against a white, and not a black background. This leads him to suggest that artists such as Malevich or van Doesburg may have used such coloured squares in their paintings precisely because they provide such cells with maximum stimulation.

In chapter sixteen, 'Kinetic Art', the enquiry shifts from colour to movement. After pointing out that the cells in V5, the movement area, which are directionally selective are indifferent to the colour of their stimulus, he develops his earlier point that the kinetic art of artists such as Calder and Tinguely typically does not exploit that property. This he explains in terms of his earlier principle that there is a tendency for artists who are interested in a particular attribute of forms, such as colour or movement, to concentrate on exploiting only the area of the visual brain that deals with it and not another. The most intriguing observation, though, is found at the end of the chapter in the discussion of Isia Leviant's *Enigma* (fig. 40), a config-

uration of coloured circles superimposed on radiating lines. Although the image is completely immobile, the typical viewer will say that it appears to move, and when the brain of a viewer is scanned the flow of blood to V5 demonstrates that the 'movement' area of the brain has indeed been activated. Since Leviant arrived at his configuration through a series of modifications of the painting by which he sought to increase the sense of optical movement, there can be no doubt that in this case the artist has successfully experimented with his own neural apparatus.

Continuing his travels in the history of art, Zeki now moves, in chapter nineteen, to consider 'The Fauvist Brain'. As he says, the Fauvists sought to 'liberate' colour, so that it acquired greater expressive power, and this meant often liberating it from its usual formal associations, showing familiar things in unfamiliar hues. What are the neurophysiological correlates of such works? We have already been told that when we look at a highly coloured and completely abstract Mondrian, brain activity is concentrated in V1 and V4. Now we learn that when we look at a scene showing objects in their *natural* colours, blood can be seen moving to other areas of the brain. One of these is a new area, lying just in front of the V4 complex, extending well into the temporal lobe. Another is a structure buried well within the temporal lobe, the hippocampus, and, since the hippocampus is known to play an important role in memory, it is easy to see why it might be activated by the sight of the familiar. Yet another active area lies in the inferior frontal convolution of the right hemisphere. All of this shows, as he says,

> that viewing normally coloured natural scenes activates not only the same areas that are activated by viewing abstract coloured scenes, but others as well, demonstrating that there really is a neurological difference between viewing coloured abstract and coloured natural scenes, and abstract scenes do really seem to affect early visual areas without eliciting activity from areas which are active only when we view natural scenes. In a sense, it is an important neurological vindication of the efforts of Mondrian and others to put on canvas the constant elements of all forms and colours.[18]

Zeki rightly sees neuroscience as giving access to the mind of the artist in a way that reduces our dependence on the artist's words, but when he finds a neurological correlate of a verbally expressed goal he is delighted.

All of which introduces this chapter's final experiment, which involves scanning the brains of subjects looking at the same scene, but with the objects now in unnatural, that is 'Fauvist', colours:

Figure 19.3

The brain activity (shown in
black) that results when subjects
view abnormally coloured
objects. The grey squares
represent area V4, found using
abstract coloured scenes. (From
Zeki and Marini 1998, see
Note 4.)

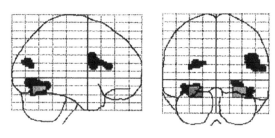

41 Brain activity during exposure to abnormally coloured objects, from Semir
Zeki, *Inner Vision*, 1999, fig. 19.3

> Once again, the V4 complex – apparently only concerned with
> constructing colours in an abstract way, without relating colours to
> any particular objects – is active. But there the correspondence
> between this and the preceding experiment ends. In the Fauvist
> experiment there is no hippocampal activity and the activity in the
> frontal cortex is not located in the same zone as that produced
> when we see natural colours; instead it is located in the middle
> frontal convolution [fig. 41]. . . . It is likely that it is the element of
> the unusual that is activating a different part of the frontal lobe –
> often referred to as a monitoring station.[19]

To which he adds, 'I should be most surprised if the unusual element
in the work of Magritte, for example, does not also activate the mon-
itoring system.'[20] He ends the chapter with the conclusion:

> Thus, just as there is a neurological difference in the kind of cell
> that is activated when we view a Malevich and a MétaMalevich, so
> there is a difference – this time actually demonstrated – between
> the neural activity elicited by a Mondrian and that by, say, a natural
> scene by Corot. But there is more to it than that; there is also a
> difference in neural activation when we view a natural scene by
> Corot and a Fauvist painting. It is yet more evidence to support

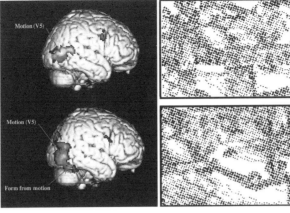

42 Differences in brain activity during exposure to meaningless and meaningful moving forms, from Semir Zeki, *Inner Vision*, 1999, fig. 20.1

Figure 20.1

The maximum change in blood flow (shown in yellow and red), which is an index of brain activity, is concentrated in area V5 (top left), when subjects see meaningless moving stimuli (top right). By contrast, the activity induced by meaningful moving forms (bottom right a motor car can be clearly seen when the image is moving) is not restricted to V5 but also includes an area inferior to it (bottom left). (Reproduced with permission from S. Zeki and A. Bork, unpublished results.)

the view that artists are unknowingly exploiting the organisation of the brain.[21]

In chapter twenty the same issue is viewed even more broadly. Here he presents an experiment that compares the difference in the response to the abstract and the representational not in the context of something coloured, but in the context of something moving. Comparing the brain scans of someone looking at moving white squares having no representational referent with the scans of someone looking at the same squares configured to represent a moving car, there is a clear difference:

> Just as abstract colour compositions activate a more restricted part of the brain's colour pathways, so abstract motion activates area V5 but meaningful forms generated from motion activate a further area, located in front of V5 (fig. 42). This latter area has also been found to be activated when subjects view similar forms but this time generated from the static distribution of the black and white squares, arranged in such a way that a recognisable form emerges.[22]

The next step is to pursue the difference in yet another field:

> Abstract colours and abstract motion also have a counterpart in abstract forms. The lines that constitute a feature of so many abstract paintings are frequently arranged in such a way that they do not signify any particular form. But these very same lines can also be re-arranged in such a way that they constitute a recognisable form. Once again, we find that the two compositions activate common areas, but the recognisable forms activate other areas beyond, again in the fusiform gyrus. In other words, abstract compositions activate a less extensive part of the brain than representational or figurative compositions, even when the two are made of the same elements. We can probably derive a general rule from this: that all abstract works activate more restricted parts of the visual brain than narrative or representational art.[23]

As he comes to the end of his book, Zeki becomes more courageous in his conclusions, He engages with art more and more directly and his observations about individual areas and cell types become the basis for more and more ambitious formulations.

All along, though, he knows that he is treading a tightrope between disciplines and may be criticised by either neuroscientists or art specialists, or both, and in his epilogue he expresses his own reservations about his enterprise:

> It is quite true that we know almost too little about the brain, and certainly not enough to account in neurological terms for aesthetic experience. It is true, as well, that there is no easy formula which one can invoke to account for, or explain, even one school of painting, say the Dutch genre painting of the seventeenth century, in neurological terms. It is also true that hard experiments in neurology cannot be applied to the problem of aesthetics, at least not at the present time. But I wrote this book primarily to satisfy my curiosity, rather than to seek to establish any neurological rule or formula for aesthetic experience. I wanted to learn whether there are any general statements that one can make about visual art in terms of what happens in the brain.[24]

Working across fields he knows he is likely to be judged from both sides. The scientists are likely to criticise him for dealing with a subject that is too 'soft' to be susceptible to 'hard' formulation, the art experts will blame him for dealing in cold scientific terms with a warm human topic.

He is rightly sensitive to such criticisms, but he also rightly asserts that it would be wrong not to pursue his attempt:

In this scientific analysis of the world of art, I plead above all for the indulgence of artists and art critics and art historians alike. I have explored a subject that has not been explored before, and have presented a largely personal view, though one derived from some, but imperfect, knowledge about the visual brain and its workings. I may have made mistakes in my analysis and I may turn out to be wrong in some, and possibly all, of the views that I express here. But better that than to leave such an exciting and important topic untackled.[25]

What is embarassing about these words is not that he wrote them, but that it was necessary for him to write them. None of the bold intellects discussed in this book who wrote about the biological and neurobiological basis of artistic activity, none of the scientists, from Aristotle to Freud, none of the art historians, from Winckelmann to Baxandall, felt a need to apologise for what they did, although they knew far less about both biology and the brain. Indeed, few of those whose criticism he anticipates would be so candid about the possible weakness of their own claims. It is poignant that, after nearly two and a half thousand years of writing on the topic, at the very moment when a wealth of new knowledge allows it to be handled with a new level of precision and sophistication, one of the principal authors of the new knowledge has to apologise for his attempt to do just that.

Zeki realises that his work is far from a definitive treatment of the subject. Even in the field in which he is a specialist, he is conscious of only making a beginning, with all the risks that entails, and he is well aware that research is advancing so fast that any claim may soon be reformulated or falsified. Besides, vast parallel fields such as those encompassing 'neural plasticity' and 'mirror neurons' he is content to leave to others. Crucially too, he is highly conscious that he is not an expert in art, and this is what makes his challenge to those who are, whether as art critics, aestheticians or art historians, all the more urgent. It is for them to take up the growing body of new knowledge and apply it with the courage and critical intelligence of a Ruskin or a Wölfflin, a Gombrich or a Baxandall. It would, indeed, be strange if this sudden burst of new knowledge about the relation between art and the brain did not allow a myriad of new insights into why humans have, for thirty thousand years, made and responded to art, and why they have done so in so many different ways at different times and places.

Notes

Bibliographic note:

This book could have had much greater bibliographic support, but that would have made it more like a conventional cultural history. Instead, bibliography and notes have been restricted almost entirely to the primary literature produced by the authors discussed. This is intended to make the account more vivid and the encounter with the authors more direct. The interest generated by these fragments will hopefully encourage readers to read the works in full and to seek out other commentaries.

Preface

1 E. de Bièvre, 'The Urban Subconscious: The Art of Delft and Leiden', *Art History* 18 (1995): 222–52.

Introduction

1 W. Neidich, *Blow-up: Photography, Cinema and the Brain*, New York, 2003, 11.
2 Ibid., 14.
3 Ibid., 6. D. H. Hubel and T. N. Wiesel, 'The Receptive Fields of Neurones in the Cat's Striate Cortex', *Journal of Physiology* 148 (1959): 574–91.
4 J.-P. Changeux, 'Art and Neuroscience', *Leonardo* 27, no. 3 (1994): 189–201.
5 'Art and the Brain', edited by Joseph A. Goguen, *Journal of Consciousness Studies*, special issue, vol. 6, 6 (June/July 1999).
6 E. H. Gombrich, *The Sense of Order: A Study in the Psychology of Ornament*, 2nd ed., Oxford, 1984, xii.
7 E. H. Gombrich, *A Lifelong Interest: Conversations on Art and Science with Didier Eribon* (English version of *Ce que l'image nous dit*, Paris, 1991), London, 1993, 133.
8 E. H. Gombrich, 'Concerning the Science of Art', *Journal of Consciousness Studies* 7, no. 8–9 (2000): 17.

9 M. Baxandall, *Painting and Experience in Fifteenth-Century Italy: A Primer in the Social History of Style*, Oxford, 1972, 29.

10 Ibid., preface.

11 For a discussion of the response to Baxandall see A. Langdale, 'Aspects of the Critical Reception and Intellectual History of Baxandall's Concept of the Period Eye', *Art History* 21, no. 4 (1998): 479–97.

12 D. M. Collins and J. Onians, 'The Origins of Art', *Art History* I (1978): 1–25.

13 J. Onians, 'Inside the Brain: Looking for the Foundations of Art History', in *Subjectivity and the Methodology of Art History*, ed. M. Rossholm Lagerlof, Stockholm, 2003 and the *Atlas of World Art*, ed. J. Onians, London, 2004.

14 D. Freedberg and V. Gallese, 'Motion, Emotion and Empathy in Artistic Experience', *Trends in Cognitive Sciences* (2007): 197–203. Another important book-length collaboration between an art historian and a neuroscientist is J. Allan Hobson and Hellmut Wohl, *Dagli Angeli ai Neuroni: L'Arte e la Nuova Scienza dei Sogni*, Fidenza, 2007.

15 Quoted in J.-P. Changeux, *Neuronal Man: The Biology of Mind*, New York, 1985, 26.

16 J. H. Breasted, *The Edwin Smith Surgical Papyrus*, 2 vols, Chicago, 1930.

1 Aristotle

1 H. Diels and W. Kranz, *Die Fragmente der Vorsokratiker*, 3 vols, 6th ed., Dublin and Zürich, 1952, vol. 1, 210–16. C. Huffman, 'Alcmaeon', in *The Stanford Encyclopedia of Philosophy*, ed. Edward N. Zalta, Summer 2003, URL http://plato.stanford.edu/archives/sum2003/entries/alcmaeon.html.

2 G. Mather, F. Verstraten and S. Anstis, eds, *The Motion Aftereffect: A Modern Perspective*, Cambridge, Mass., 1988.

2 Pliny the Elder

1 See T. M. Murphy, *Pliny the Elder's Natural History: The Empire in the Encyclopedia*, Oxford, 2004.

3 Apollonius of Tyana

1 For a discussion of the difficult problems relating to his life see M. Dzielska, *Apollonius of Tyana in Legend and History*, trans. P. Pienkowski, Rome, 1986.

2 K. Tanaka, 'Inferotemporal Response Rroperties', in *The Visual Neurosciences*, ed. L. Chalupa and J. S. Werner, Cambridge, Mass., 2004, vol. 2, 1151–64.

4 al-Haytham

1 Ibn al-Haytham, *The Book of Optics*, the first three books of which are published in *The Optics of Ibn al-Haytham*, trans. with introduction and commentary by A. I. Sabra, 2 vols, London, 1989. For a more general account of his life see B. Steffens, *Ibn al-Haytham: First Scientist*, Greensboro, 2006.
2 al-Haytham, 1989, vol. 1, 4.
3 Ibid., 209.
4 Ibid.
5 Ibid., 212.
6 Ibid., 214.
7 Ibid., 216.
8 Ibid., 221–3.
9 See N. Kanwisher, 'The Ventral Visual Object Pathway in Humans: Evidence from fMRI', in *The Visual Neurosciences*, ed. L. Chalupa and J. S. Werner, Cambridge, Mass., 2004, vol. 2, 1179–89.

5 Alberti

1 *De statua* 1, in Leon Battista Alberti, *On Painting and on Sculpture*, the Latin texts of *De pictura* and *de statua*, edited with translations, introduction and notes by C. Grayson, London, 1972, 120.
2 *De pictura* 3.58, ibid., 101.
3 *De pictura* 3.56, ibid.
4 *De pictura* 2.41, ibid., 81.
5 *De re aedificatoria* 9.4. English version in Leon Battista Alberti, *On the Art of Building in Ten Books*, trans. J. Rykwert, N. Leach and R. Tavernor, Cambridge, Mass., and London, 1988.
6 *De pictura* 2.36 in Alberti, *On Painting*, 1972, 75.

6 Leonardo

1 Leonardo da Vinci, *Leonardo on painting*, ed. M. Kemp, New Haven and London, 1989, 9. For a general discussion of Leonardo see M. Kemp, *Leonardo da Vinci: The Marvellous Works of Nature and Man*, 2nd ed., Oxford, 2006.
2 For a discussion of the drawings relating to the brain see Kemp, *Leonardo da Vinci*, 2006, 106–12.
3 C. Pedretti, *The Literary Works of Leonardo da Vinci*, London, 1977, vol. 1, 345.
4 Leonardo da Vinci, *The Literary Works of Leonardo da Vinci*, ed. J. P. Richter, London, 1970, vol. 1, 124.
5 Codex Urbinas 15v–16r, *Leonardo on Painting*, 1989, 20–1.
6 Cod. Urb.7r–v, ibid., 222.

7 Cod. Urb. 11r–v, ibid., 24.
8 Cod. Urb. 35v, ibid., 222.
9 Ibid.
10 Cod. Urb. 61v–62r, ibid., 222.
11 Cod. Urb. 17a, ibid., 34–5.
12 Cod. Urb 44r–v, ibid., 204.
13 Ibid.

7 Hogarth

1 W. Hogarth, *The Analysis of Beauty*, ed. R. Paulson, New Haven and London, 1997, 31.
2 Ibid., 32
3 Ibid., 25.
4 Ibid., 28.
5 Ibid., 29.
6 Ibid.
7 M. Wertheimer, 'Untersuchungen zur Lehre von der Gestalt', *Psychologische Forschung*, 4 (1923): 301–5.
8 Hogarth, *Analysis*, 1997, 32–3.
9 Ibid.
10 J. Locke, *Essay Concerning Human Understanding*, ed. P. H. Nidditch, Oxford, 1979, 7.
11 Hogarth, *Analysis*, 1997, 32, n. 45.
12 Ibid., 34.
13 Ibid., 33.
14 Ibid.
15 Ibid., 83.
16 Ibid., 84.
17 Ibid., 115.
18 Ibid., xxxvi.
19 Ibid., 111.

8 Burke

1 E. Burke, *A Philosophical Enquiry into the Origin Of our Ideas of the Sublime and the Beautiful*, ed.J. T. Boulton, London, 1958, Introduction, 11.
2 Ibid., pt 1, sect. 14, 45.
3 Ibid., pt 1, sect. 14, 44.
4 Ibid. See Philip L. Jackson, Andrew N. Meltzoeff and Jean Decety, 'How Do We Perceive the Pain of Others? A Window into the Neural Processes Involved in Empathy', *Neuroimage* 24, no.3 (February 2005): 771–9.

5 Ibid., 1958, pt 3, sect. 4, 100.
6 Ibid., pt 3, sect. 4, 103.
7 Ibid., Introduction, 15.
8 Ibid., pt 3, sect. 4, 103.
9 Ibid., pt 2, sect. 2, 58.

9 Montesquieu

1 Montesquieu, *The Spirit of the Laws*, trans. and ed. A. M. Cohler et al., Cambridge, 1989, 232.
2 Ibid., 233.
3 Ibid., 301.
4 Ibid., 310.
5 Ibid., 333.
6 Ibid., xlv.

10 Winckelmann

1 J. J. Winckelmann, *Reflections on the Imitation of Greek Works in Painting and Sculpture*, trans. E. Heyer and R. Norton, La Salle, Ill., 1987, 3.
2 Ibid., 7.
3 Ibid., 15.
4 A. D. Potts, *Flesh and the Ideal: Winckelmann and the Origins of Art History*, New Haven and London, 1994, 42.
5 J. J. Winckelmann, *History of Ancient Art*, 2 vols, trans. by G. Henry Lodge, New York, 1968, 14.
6 Ibid., 3.
7 Ibid., 10.
8 Ibid., 18.
9 Ibid., 22.
10 Ibid., 30–1.
11 Ibid., 52.
12 Ibid., 52–3.
13 Ibid., 58, quoting Gravina, *Ragion: Poet*, Book 2, 148.
14 Ibid.
15 Ibid., 56.
16 Ibid., 58.
17 Cicero, *On Fate*, iv.
18 Winckelmann, *History of Ancient Art*, 1968, 58.
19 Ibid.
20 Ibid., 59–60.
21 Ibid., 59.
22 Ibid., 190.

23 Ibid., 202.
24 Ibid, 195.
25 Ibid., 195.
26 Ibid., 196.
27 Ibid.
28 Ibid.
29 Ibid.
30 Ibid., 198.

11 Kant

1 I. Kant, *The Critique of Judgement*, trans. J. C. Meredith, Oxford, 1952, 165.
2 Ibid., 166.
3 Ibid., 168.
4 Ibid., 175.

12 Marx

1 K. Marx, *Economic and Philosophical Manuscripts*, 1844, reprinted in L. Baxandall and S. Morawski, *Marx and Engels on Literature and Art*, St Louis, 1973, 51.
2 Ibid., 52.
3 Ibid.
4 Ibid., 53, reprinted from *A Contribution to the Critique of Political Economy*, 1859.
5 Ibid., 55, reprinted from *The Part Played by Labour in the Transition from Ape to Man*, 1876.
6 Ibid.
7 Ibid.
8 K. Marx and F. Engels, *The German Ideology*, Part One, with 'Introduction to a Critique of Political Economy', ed. and introduction by C. J. Arthur, London, 1977, 47.
9 For thought and language see ibid., 118.
10 Ibid., 103.
11 Ibid., 51.
12 Ibid., 62.
13 Ibid.
14 Ibid., 63.
15 Ibid., 149.
16 Ibid., 150.
17 Ibid.

13 Ruskin

1 J. Ruskin, *Modern Painters*, vols 1–5 and index, Orpington, 1888, vol. I, pt 2, sect. 1, chap. 2, 50 (quoting J. Locke, bk. 2, chap. 9, sect. 3).
2 Ibid., pt 2, sect. 1, chap. 2, 51.
3 Ibid., pt 2, sect. 1, chap. 2, 52.
4 Ibid., pt. 2, sect. 1, chap. 2, 53.
5 Ibid.
6 Ibid.
7 Ibid.
8 Ibid., pt 2, sect. 1, chap. 7, 122.
9 Ibid., pt 2, sect. 1, chap. 7, 123.
10 Ibid., pt 2, sect. 1, chap. 7, 124.
11 Ibid., pt 2, sect. 1, chap. 7, 130–1.
12 Ibid., pt 2, sect. I, chap. 7, 126.
13 Ibid., pt. 2, sect. 1, chap. 7, 128–9.
14 Ibid., vol.5, pt 9, chap. 9, 292–3.
15 Ibid.

14 Pater

1 W. Pater, *The Renaissance*, London, 1910, viii.
2 Ibid., 130.
3 Ibid., 135.
4 Ibid., 231.
5 Ibid., 233.
6 Ibid., 236.
7 W. Pater, *Miscellaneous Studies: A Series of Essays*, London, 1895, 53.
8 Ibid., 173.
9 Ibid., 177.
10 Ibid., 185.

15 Taine

1 H. Taine, *Essais de critique et d'histoire*, 2nd ed., Paris, 1866, xxx.
2 H.Taine, *On Intelligence*, trans. T. D. Haye, New York, 1884, ix.
3 Ibid., 71.
4 Ibid., 170.
5 H. Taine, *De l'intelligence*, Paris, 1938, vol. 1, 88.
6 H. Taine, *Philosophie de l'art*, repr. Paris, 1985, 7.
7 Ibid., 17.
8 Ibid., 19.
9 Ibid.
10 Ibid., 33.
11 Ibid., 37.

12 Ibid., 285.
13 Ibid., 287.
14 Ibid., 273.

16 Vischer

1 See the discussion in H. F. Mallgrave and E. Ikonomou, eds, *Empathy, Form and Space: Problems in German Aesthetics 1873–1893*, Santa Monica, 1994, 9–10.
2 A. Schopenhauer, *The World as Will and Representation*, trans E. F. J. Payne, New York, 1969, vol. 2, 91.
3 See the translation, 'On the Optical Sense of Form: A Contribution to Aesthetics', in Mallgrave and Ikonomou, *Empathy, Form and Space*, 1994, 94–5, which also provides an introduction and biography.
4 Ibid., 98.
5 Ibid., 100.
6 Ibid., 104–5.
7 Ibid.
8 Ibid., 118.
9 Ibid.
10 Ibid., 119.

17 Göller

1 A. Göller, 'Was ist die Ursache der immerwährenden Stilveränderung in der Architektur?', in *Zur Aesthetik der Architektur: Vortrage und Studien*, Stuttgart, 1887. Translated with introduction 'What is the Cause of Perpetual Style Change in Architecture?', in H. F. Mallgrave and E. Ikonomou, *Empathy, Form and Space: Problems in German Aesthetics 1873–1893*, Santa Monica, 1994, 193–225, which also provides an introduction and biography.
2 Ibid., 193.
3 Ibid., 194–5.
4 Ibid., 200.
5 Ibid.
6 Ibid., 201.
7 Ibid., 202.
8 Ibid.
9 Ibid., 204.
10 Ibid., 206.
11 Ibid., 209.
12 V. S. Ramachandran, and W. Hirstein, 'The Science of Art: A Neurological Theory of Aesthetic Experience', *Journal of Consciousness Studies* 6 (1999): 15–51 and J. B. Bedaux, 'From Normal to Supernormal: Observations on

Realism and Idealism from a Biological Perspective', in *Sociobiology and the Arts*, ed. J. B. Bedaux and B. Cooke, Amsterdam, 1999, 99–128.
13 A. Göller 'Was ist die Ursache der immerwährenden Stilveränderung in der Architektur?', in *Zur Aesthetik der Architektur: Vorträge und Studien*, Stuttgart, 1887, 1–48, trans. with introduction 'What is the Cause of Perpetual Style Change in Architecture?', in H. F. Mallgrave, and E. Ikonomou, eds, *Empathy, Form and Space: Problems in German Aesthetics 1873–1893*, Santa Monica, 1994, 215.
14 Mallgrave and Ikonomou, *Empathy, Form and Space*, 1994, 216.
15 Ibid., 217.

18 Wölfflin

1 H. Wölfflin, *Prolegomena zu einer Psychologie der Architektur*, Munich, 1886, republished in H. Wölfflin, *Kleine Schriften (1886–1933)*, Basel, 1946, 13, translated as 'Prolegomena to a Psychology of Architecture', in H. F. Mallgrave and E. Ikonomou, eds, *Empathy, Form and Space: Problems in German Aesthetics 1873–1893*, Santa Monica, 1994, 149–90, which also provides an introduction and biography.
2 Wölfflin, 'Prolegomena', 1946, 18.
3 Ibid., 20.
4 Ibid., 31.
5 Ibid., 32–3.
6 Ibid., 33.
7 Ibid., 43
8 Ibid.
9 Ibid., 46.
10 H.Wölfflin, *Renaissance und Barock: Eine Untersuchung über Wesen und Entstehung des Barockstils in Italien*, Munich, 1888, trans. by K. Simon and introduction by P. Murray as *Renaissance and Baroque*, London, 1964.
11 Ibid., 73.
12 Ibid., 74.
13 Ibid., 74–5.
14 Ibid., 77.
15 Ibid.
16 Ibid.
17 Ibid.
18 Ibid., 79–80.
19 Ibid., 82.
20 H. Wölfflin, 'Über das rechts und Links im Bilde', in *Gedanken zur Kunstgeschichte: gedrucktes und ungedrucktes*, Basel, 1928 and 1941, vol. 2, 86–96.
21 H. Wölfflin, *The Sense of Form in Art: A Comparative Psychological Study*, New York, 1958, 21.
22 See p. 91.

19 Riegl

1 A. Riegl, *Problems of Style: Foundations for a History of Ornament*, ed. D. Castriota, Princeton, 1992. For a broader discussion see M. Olin, *Forms of Representation in Alois Riegl's Theory of Art*, University Park, Pa., 1992 and M. Iversen, *Alois Riegl: Art History and Theory*, Cambridge, Mass. and London, 1993.
2 Riegl, *Problems of Style*, 1992, 5.
3 Ibid., 14.
4 Ibid.
5 Ibid.
6 Ibid., 16.
7 Ibid., 14.
8 Ibid.
9 Ibid., 18.
10 K. Tanaka, 'Inferotemporal Response Properties', in *The Visual Neurosciences*, ed. L. Chalupa and J. S. Werner, Cambridge, Mass., vol. 2, 1151–64.
11 Riegl, *Problems of Style*, 1992, 18.
12 Ibid., 21.
13 Ibid., 29.
14 J. Onians, 'The Biological and Geographical Bases of Cultural Borders: The Case of the Earliest Prehistoric Art', in *Borders in Art: Revisiting Kunstgeographie*, Warsaw, 2000, 27–33.
15 Riegl, *Problems of Style*, 1992, 30.
16 Ibid., 33.
17 A. Riegl, *Historische Grammatik der bildenden Künste*, Graz, 1966, 21.
18 Ibid., 76.
19 Ibid.
20 Ibid., 88.

20 Freud

1 C. Darwin, *The Expression of the Emotions in Man and Animals*, London, 1872, 81.
2 Francis Galton, *Inquiries into Human Faculty and its Development*, London, 1883, 45.
3 S. Freud, *The Origins of Psycho-Analysis: Letters to Wilhelm Fliess, Drafts and Notes: 1887–1902*, New York, 1954, 355.
4 Ibid., 358.
5 Ibid., 359.
6 Ibid., 361.
7 Ibid., 393.
8 Ibid., 401.
9 Quoted in S. Freud, *The Interpretation of Dreams*, trans. J. Crick, introduction and notes R. Robertson, Oxford, 1999, x–xi.

10 Ibid., 124.
11 S. Freud, *The Interpretation of Dreams*, trans. and ed. J. Strachey, London, 1954, 354–5.
12 Ibid., 355–6.
13 J. Strachey in ibid., xx.
14 S. Freud, 'Leonardo da Vinci and a Memory of his Childhood', in *Art and Literature*, vol. 14 of The Penguin Freud Library, Harmondsworth, 1985, 151.
15 Ibid., 158.
16 Ibid., 160.
17 Ibid., 167.
18 Ibid., 172.
19 Ibid., 177.
20 Ibid., 199.
21 Ibid., 223.
22 Ibid., 224.
23 Ibid., 229–30.
24 Ibid., 230–31.
25 Freud, *Origins of Psycho-Analysis*, 1954, 385, fig. 14.
26 Freud, *Interpretation of Dreams*, 1999, 353, fig. 3.

21 Dewey

1 J. Dewey, *Art as Experience*, New York, 1934, 4.
2 Ibid., 4–5.
3 Ibid., 12.
4 Ibid., 13.
5 Ibid., 19.
6 Ibid., 24.
7 Ibid., 25.
8 Ibid., 149.
9 Ibid., 150.
10 Ibid., 338–9.
11 Ibid., 345.
12 Ibid., 342.
13 Ibid.

22 Herskovits

1 M. H. Segall, D. Campbell and M. Herskovits, *The Influence of Culture on Visual Perception*, Indianapolis, 1966, 10.
2 Ibid., 5.
3 Ibid.
4 Ibid., ix.

5 Ibid., 96–7.
6 Ibid., 100–1.
7 Ibid., 129.
8 Ibid., 192–3.
9 Ibid., 205.
10 Ibid., 174.
11 Ibid., 209.
12 Ibid., 20.
13 Ibid.
14 R. Gregory, *Eye and Brain*, London, 1968 and 'The Confounded Eye', in *Illusion in Nature and Art*, ed. R. Gregory and E. H. Gombrich, London, 1973.
15 J. B. Deregowski, *Illusions, Patterns and Pictures: A Cross-Cultural Perspective*, London 1980, 17–18.

23 Gombrich

1 E. H. Gombrich, *A Lifelong Interest: Conversations on Art and Science with Didier Eribon* (English translation of *Ce que l'image nous dit*, Paris, 1991), London, 1993, 133.
2 Ibid., 133.
3 Ibid., 76.
4 Ibid.
5 E. H. Gombrich, *Aby Warburg: An Intellectual Biography*, London, 1970, 69.
6 Gombrich, *Lifelong Interest*, 1993, 133.
7 E. H. Gombrich, *Art and Illusion*, London, 1960, 87.
8 Ibid.
9 Ibid., 16.
10 Ibid., 18.
11 C. Blakemore, 'The Baffled Brain', in *Illusion in Nature and Art*, ed. R. L. Gregory and E. H. Gombrich, London, 1973, 9–47.
12 E. H. Gombrich, *The Story of Art*, 15th ed., London, 1989, 20.
13 Gombrich, *Art and Illusion*, 1960, 4–5, 198 and 331.
14 Ibid., 34.
15 Ibid.
16 J. H. Tchalenko, J. H. Ocean and C. Miall, 'A Painter's Eye Movements', National Portrait Gallery, London, 1999.
17 E. H. Gombrich, 'Visual Discovery through Art', in *The Image and the Eye: Further Studies in the Psychology of Visual Representation*, Oxford, 1982, 18.
18 Gombrich, *Art and Illusion*, 1960, 87.
19 E. H. Gombrich, *The Sense of Order: A Study in the Psychology of Decorative Art*, Oxford, 1979, x.
20 Gombrich, *Sense of Order*, 2nd ed., Oxford, 1984, xii.

21 Ibid., 7.
22 Ibid., 9.
23 Ibid., 11–12.
24 Ibid., 5.
25 Ibid., 114.
26 Ibid.
27 S. Savage-Rumbaugh and R. Lewin, *Kanzi: The Ape at the Brink of the Human Mind*, London, 1994, 127–78.
28 Gombrich, *Sense of Order*, 1979, 259.
29 Ibid.
30 Ibid., 304.
31 Ibid., 36.
32 E. H. Gombrich, 'The Mask and the Face', in *The Image and the Eye*, 1982, 128.
33 Ibid.
34 Ibid.,132–3.
35 J. M. L. Dawson, B. M. Young and P. P. C. Choi, 'Development Influences on Geometric Illusion Sensibility among Hong Kong Chinese Children', *Journal of Cross-Cultural Psychology*, 4 (1973): 49–74.
36 Gombrich, *Lifelong Interest*, 1993, 85.
37 Gombrich, *Art and Illusion*, 1960, 23.
38 Ibid., 6.
39 E. H. Gombrich, *Story of Art*, London, 1950, ix.
40 R. Gregory, *The Oxford Companion to the Mind*, Oxford, 1987, 10.

24 Baxandall

1 M. Baxandall, *Painting and Experience in Fifteenth-Century Italy: A Primer in the Social History of Pictorial Style*, Oxford, 1972, 29.
2 Ibid., 29.
3 Ibid., 31.
4 Ibid., 32.
5 M. Baxandall, 'Fixation and Distraction: The Nail in Braque's *Violin and Pitcher* (1910)', in *Sight and Insight: Essays on Art and Culture in Honour of E. H. Gombrich at 85*, ed. J. Onians, London, 1994, 401.
6 Ibid., 402.
7 Ibid., 404.
8 Ibid., 409.
9 Ibid., 411.
10 Ibid., 413.
11 Ibid., 414.
12 M. Baxandall, *Shadows and Enlightenment*, New Haven and London, 1995.
13 Ibid., v.
14 Ibid., 1.

15 Ibid., 36.
16 Ibid., 38.
17 Ibid., 70–1.
18 Ibid., 71–2.
19 Ibid., 143.
20 Baxandall, 'Fixation and Distraction', 1994, 414.
21 Baxandall, *Shadows and Enlightenment*, vii.
22 Baxandall, 'Fixation and Distraction', 1994, 413.

25 Zeki

1 S. Zeki, *Inner Vision: An Exploration of Art and the Brain*, Oxford, 1999,
 vii; S. Zeki and M. Lamb, 'The Neurology of Kinetic Art', *Brain* 117, no.
 3 (1994): 607–36.
2 Zeki, *Inner Vision*, 1999, 1.
3 Ibid., 1.
4 Ibid., 1–2.
5 Ibid., 2.
6 Ibid., 3.
7 Ibid.
8 Ibid., 4.
9 Ibid., 5.
10 Ibid.
11 Ibid., 6.
12 Ibid., 16.
13 Ibid., 60–1.
14 Ibid., 61.
15 Ibid., 63.
16 Ibid., 64–5.
17 Ibid., 113.
18 Ibid., 201.
19 Ibid.
20 Ibid., 201.
21 Ibid., 203–4.
22 Ibid., 206.
23 Ibid., 207.
24 Ibid., 217.
25 Ibid., 219.

Index